The obscure reference in a Nevada guide book to
Bruno's homemade ravioli in the tiny town of
Gerlach first lured Barbara to the nearby
hot springs of Black Rock Desert.

Upon returning to San Francisco, she came across
a flyer for Burning Man happening in the same
desert. The rest, as they say, is herstory…

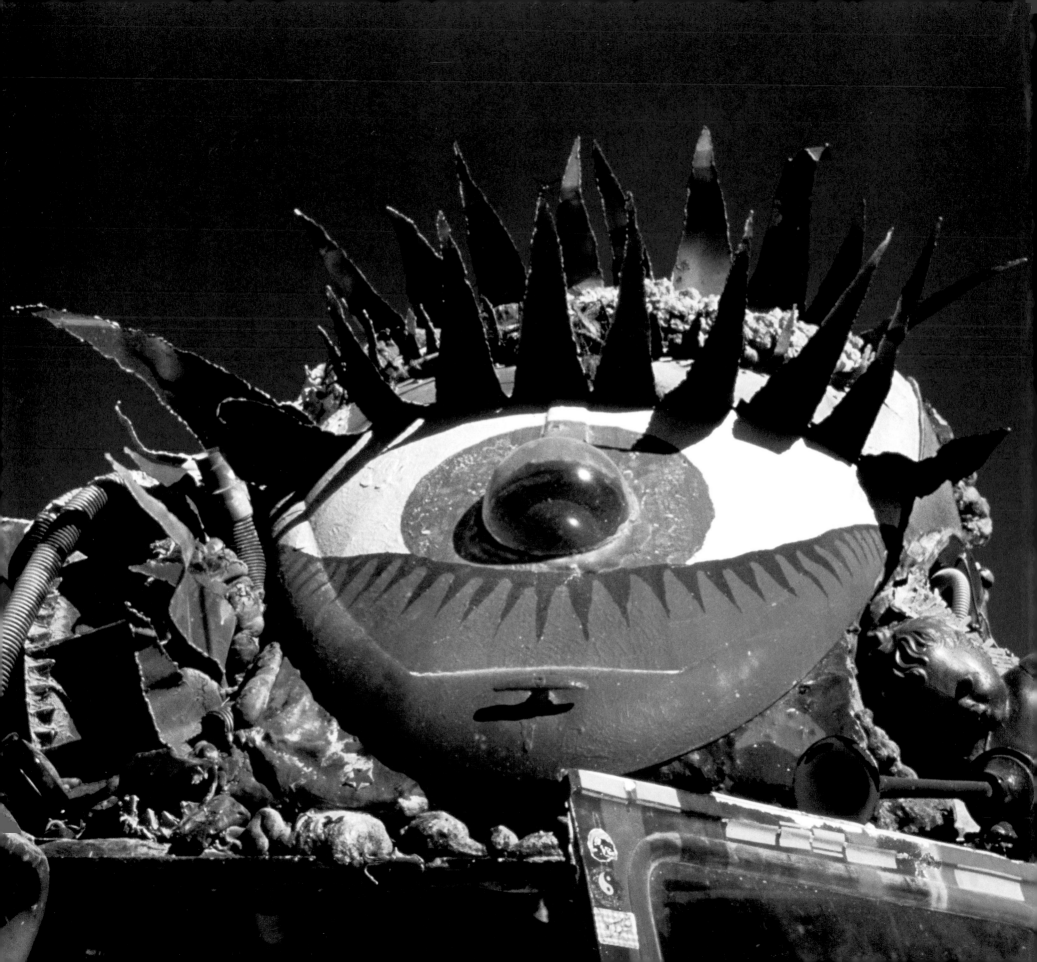

DESERT TO DREAM

A DOZEN YEARS OF BURNING MAN PHOTOGRAPHY

REVISED EDITION

BY BARBARA TRAUB

INTRODUCTION BY LES BLANK
FOREWORD + AFTERWORD BY LARRY HARVEY
CONTRIBUTION BY LEONARD NIMOY
EPILOGUE BY LAWRENCE FERLINGHETTI

immedium
SAN FRANCISCO, CA

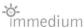
immedium

Immedium, Inc.
P.O. Box 31846
San Francisco, CA 94131
www.immedium.com

Library of Congress Cataloging-in-Publication Data

Traub, Barbara.
 Desert to dream : a decade of burning man photography / by Barbara Traub ; introduction by Les Blank ; foreword by Larry Harvey ; epilogue by Lawrence Ferlinghetti.--1st hardcover ed.
 p. cm.
 ISBN 978-1-59702-026-8 (hardcover)
 1. Portrait photography--Nevada. 2. Burning Man (Festival)--Pictorial works.
I. Title.
 TR680.T73 2006
 394.2509793'54--dc22

 2005034292

First hardcover edition published 2006.

Editor: Tracy Swedlow
Graphic Designer: Stefanie Liang
Photo Editor: Mia Nakano
Photoshop Digital: Daniel McNerney

Printed in Singapore
10 9 8 7 6 5 4 3 2 1

ISBN: 978-1-59702-026-8

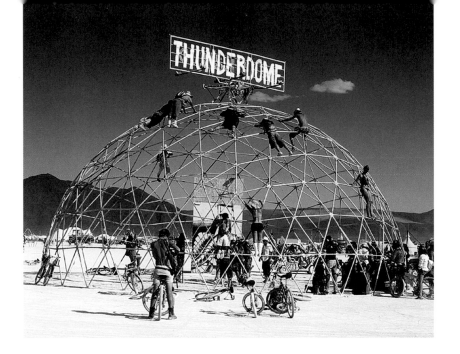

TABLE OF CONTENTS

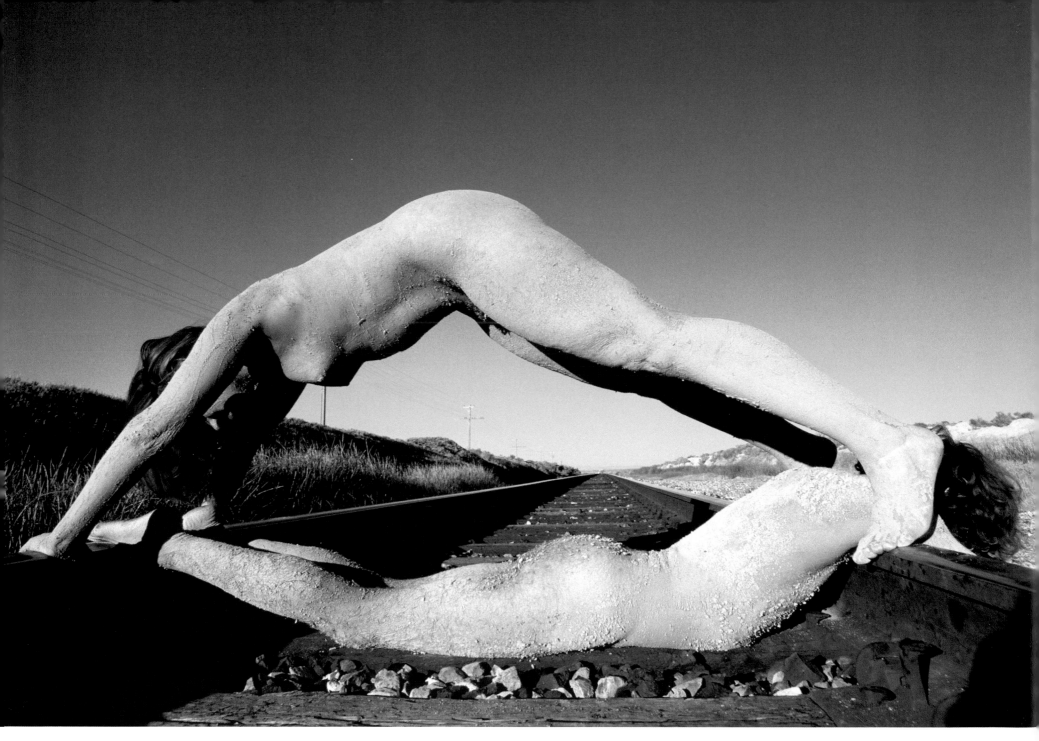

ARCH

Two figures covered in mud from nearby Trego Hot Springs straddle the old Western Pacific railroad tracks that are still in use and not far from camp. Oftentimes, a passing freight train will toot its horn to bathers and denizens of Burning Man.

INTRODUCTION
BLANK SLATE

I have given up on trying to successfully explain what Burning Man is: "twenty thousand plus people camped out at summer's end in a totally barren Nevada desert?"

Bringing with them their own food, water and shelter?

A place so hot at mid-day that two gallons of water per day is the recommended ration to bring?

Yet night can bring near-freezing rain blown by fierce, loud winds of near-hurricane strength?

When this happens for any length of time, the desert floor, known as "playa," sucks up moisture and becomes sticky like quicksand to several inches in depth. Walking becomes serious labor as the stuff adheres to shoe and sandal soles... Glop, Glop, Glop?

One year, as people were attempting to leave (in a scene-from-traffic-hell process that took 8 hours to travel 5 miles) it rained all day, causing several hapless vehicles to become so stuck, they couldn't be pried loose until nine months later.

And then there's the winds that fire playa dust like millions of needles for minutes at a time causing a "white out" so dense that one can't see his/her hands in front of the face.

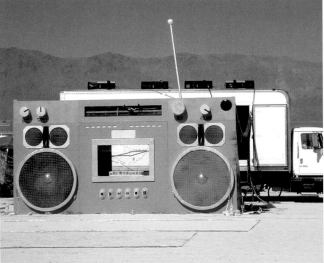
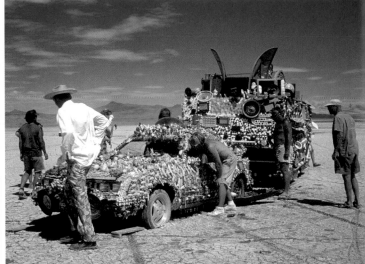

And oh yes, there is nudity. Lots of it. And art. All kinds. All ways.

Mucho creativity. Body painting, improvised theatre. Painfully loud Techno music (something I hesitate to bestow label of "Art" upon). Commissioned art. Grants of $10,000.00 to conceive and construct site-specific art (a gigantic block of ice full of clocks).

Art CARS. Theme camps. Groups of people camping together and creating a tight neighborhood of like-minded spirits, offering a dance club, or an after hours bar, or a massage parlor, or a photo studio.

The imagination has no bounds. World-renowned artist David Best has created a huge temple to the dead from tons of scrap wood-remaining from dinosaur-assembly kits sold in natural history stores. This splendid creation was torched on Sunday night, surpassing in wonder the burning of the Man the night before.

And so on and so on and still, what do you have?

A look of puzzlement is all I get from whomever I attempt to explain it to, just like my own reaction when my son tried to tell me about it after his first encounter. Even when I saw his film footage of nudes wallowing in the muck caused by a sudden shower, and acting out some kind of pagan creation myth crawling over one another in a gigantic seething writhing pile of undulating bodies lubricated with wet playa clay. I was far from getting the big picture.

Nevertheless, I decided to give it a try and ventured out to have a look.

It was so hot when I arrived at mid-day. I became immediately exhausted and spent the rest of the day in shock, hiding from the sun beneath a gerry-rigged tarp attached to the side of my car and peeking out at people passing by in a parade of surrealistic proportions. There was a nude Jesus nailed to the cross with wheels that made its way across the playa, followed by an entire living room on wheels loaded with laughing, cheering sybarites guzzling beer and daiquiris to loud disco bolting from the vehicle's generator-powered killer amp.

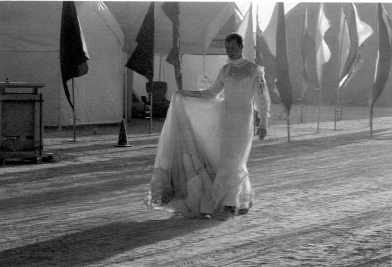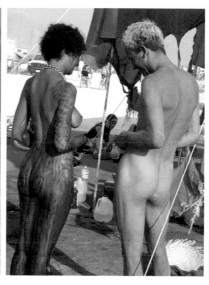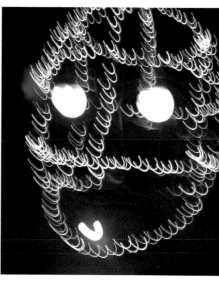

Plenty of people were just walking—their costumes and colorfully painted bodies becoming more glowingly rich in color and magic as the day's heat gradually receded and faded into the magic hour before dusk and darkness.

Night time here brings on a different mood, not unlike that I experienced as a seaman in my youth, arriving at a new port and venturing off the ship to see the sights: night club acts, live music. Dancing. Drinking. Every moment brimming with the possibility of creative surprise.

Lots of lights used in new ways. WAY more exciting than any carnival I've ever been to. And through all of this, there's no money exchanged, except for ice, tea, coffee and hot chocolate, sold only in one location at the center of camp.

Some people simply give away their goods such as beer, wine, mixed drinks, hamburgers, grilled albacore tuna. Others barter, even if for a dance, a song or simple smile.

Strange things are brought out there for barter purposes: Books, comics, yard sale knick knacks. shades of the love-ins in the late 60's.

What's going on? Why have I gone back six more times? I thought it was to assist my son, Harrod, in shooting the epic 16mm film he started making two years before my initial immersion. But last year, I was never called on to shoot.

This book's author, Barb Traub, tells me she sometimes leaves her camera behind at Burning Man in order to be a good trouper, integrating with the here and the now. More power to her. Yet, every year I've seen her often enough behind the camera taking photos and occasionally stopping by our camp for a slice of watermelon and a cold one in the shade to feel comforted that she'll have lots of wonder-filled observations to share when it's all done.

Les Blank

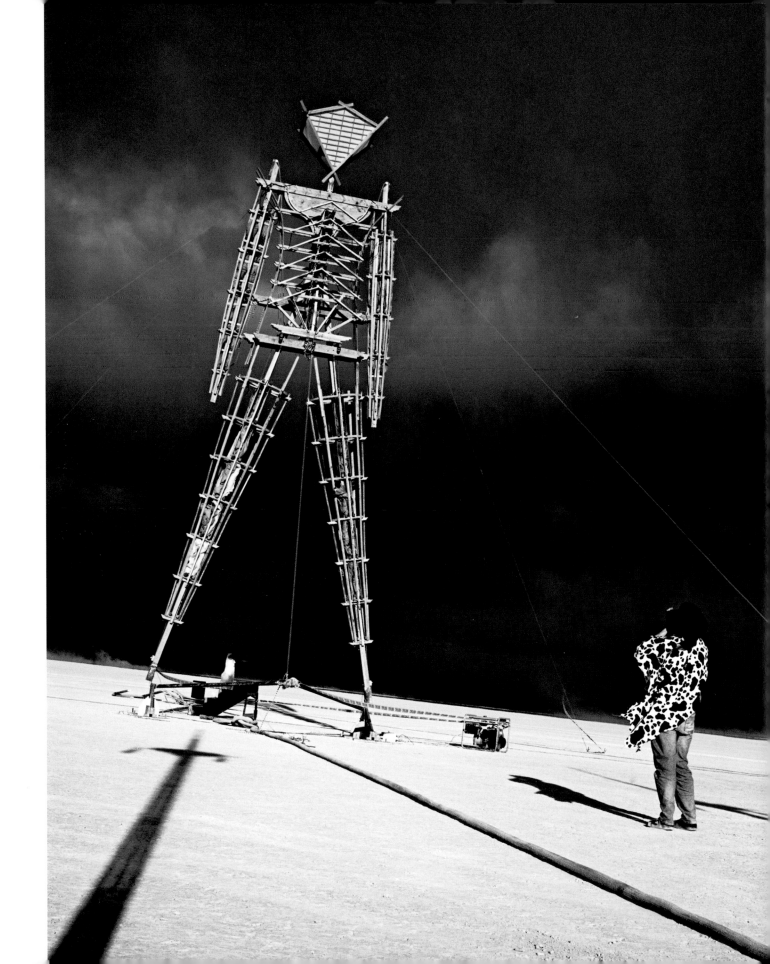

10

FOREWORD
OUT THERE

Imagine a completely abstract space, a world without context, a place that is no place at all apart from what you bring to it. Anyone may enter this arena. Distinctions of race, class, age, and wealth are irrelevant here. Participants are free to reinvent their own identities. Reality is what you make it on this ultimate frontier. It is a world wherein the boundary that divides the inner from the outer disappears.

The place is Northern Nevada's Black Rock Desert: the largest flat expanse of land in North America. The event is Burning Man. Since 1990 members of the Burning Man Project have crafted a four-story tall wooden man and installed it in the vastness of this awesome space. Erected by participants, it presides over an instantaneous community; a miniature civilization complete with clubs and cabarets, several radio stations, and a daily newspaper, *The Black Rock Gazette*. The masthead motto of this journal sets the tone of the ensuing weekend. "Welcome to Nowhere," it reads, "Its name is whatever you name it. Its wealth is whatever you bring. Next week it will be gone, but next week might as well be never. You are here now."

To fully understand this experience, one must contemplate the desert. The Black Rock Desert is the relic of a prehistoric lake bed. It forms a featureless alkaline plain devoid of both landmarks and life forms. At the bottom of its sky are distant mountains; in the foreground is the tip of one's nose. Between these two extremes lies an ambiguous zone. Advancing objects in this void loom suddenly as one approaches, as if magically materialized out of nothingness. The dancing dot that hovers indistinctly in the space ahead might instantly become a giant neon eyeball, a huge fiberglass dog head, or an oasis surrounded by paper palm trees. Visions such as these are common here. It is a realm of vir-

tual reality to which anyone can contribute. Participants mask and wear costumes, construct elaborate theme camps and art works, extemporize games and participate in spontaneous theater. Aided by a few expressive props, they program worlds entirely of their own devising.

But this is only half the story. There remains the Burning Man. Its towering presence looms above and beyond this postmodern carnival of the absurd. Located at the end of a monumental avenue of spires, it stands swathed in an eerie blue nimbus of neon light. And there are moments, as one wanders through this nighttime world, when earth and heaven seem to merge and Burning Man becomes the only orienting landmark. Car lights veer and drift at disconcerting angles, fireworks flash overhead, and the Man becomes a beacon, the ultimate gathering place and ceremonial center of this society suspended in a void. Taller than one's parents as remembered from some dream of childhood, emphatic as a child's first scrawled drawing of a human being, he waits with perfect patience to be burned.

There is no single interpretation of this event. It is a unique product of our age: pluralistic and complex, skeptical and yet completely open-minded. Pressed to explain their intentions, organizers cite a simple doctrine: "The Project," one is told, "never interferes with anyone's immediate experience." Only by direct participation, through one's own unique involvement, can any answer be found. Or to quote Danger Ranger, legendary protector of the Playa, "In the desert there are as many paths to heaven as there are stars in the sky."

Larry Harvey

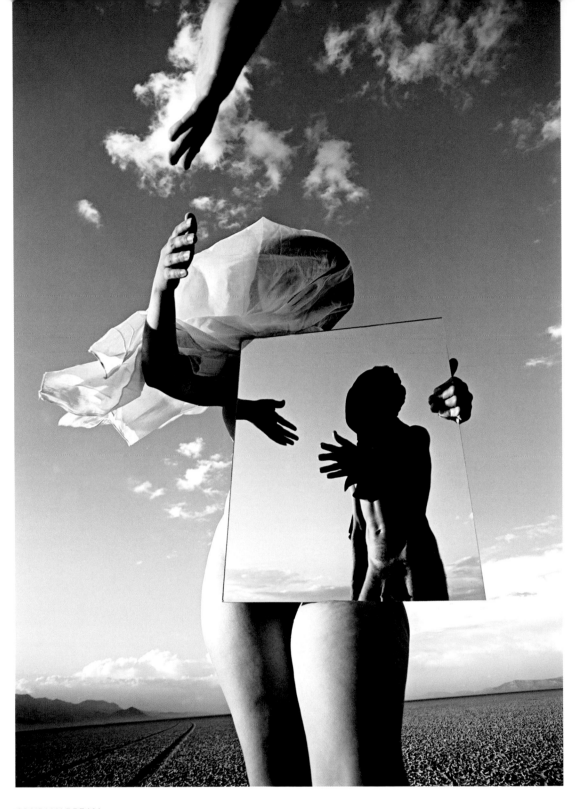

OBSIDIAN DREAM

PREFACE
PHOTOGRAPHY AS PERFORMANCE

When I came to Burning Man armed with bricks of film and gigabytes of memory, I wasn't sure what I was going to shoot. Something was definitely out there and I had to capture it on camera. I had to go from voyeur to provocateur to make things happen. There were fires and dancers, hail and mud, all the art and machines, the naked and the painted in the desert and neon light.

These were skeins that I wove into my work.

I became a part of the spectacle performing the part of the photographer. The spider dance of the camera around the photographed contributed to the total tableau vivant. For me the essence of Burning Man is performance—interacting and creating with people to see what happens in the intimate yet infinite expanse of the desert.

Barbara Traub

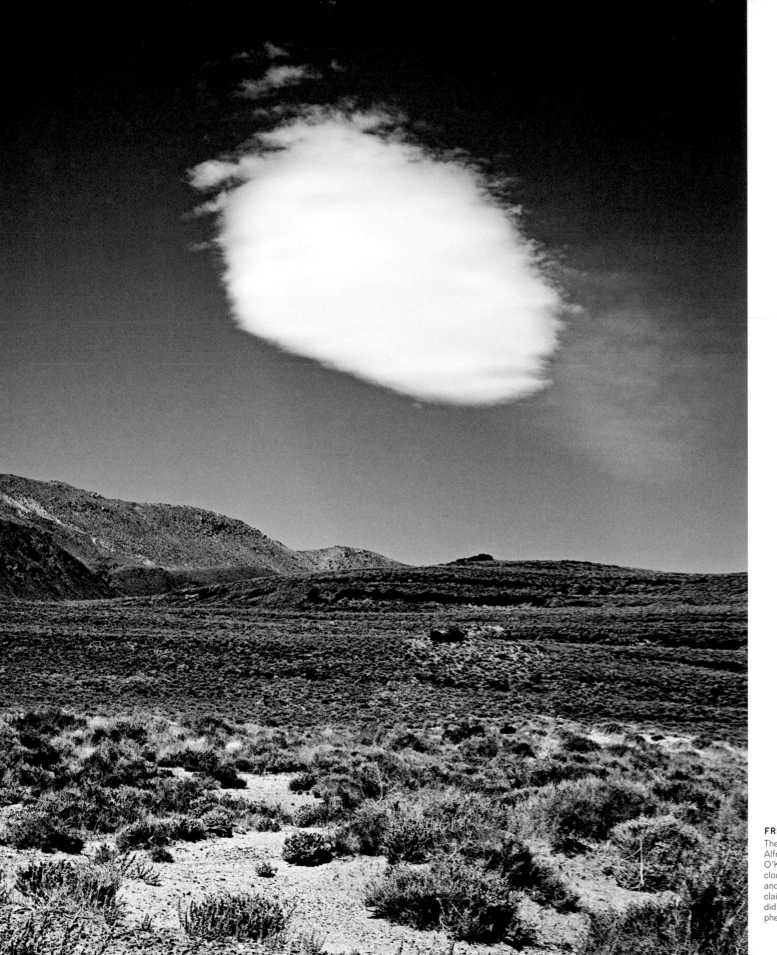

FREE CLOUD

The title of this piece is in homage to Alfred Stieglitz (married to Georgia O'Keeffe) who liked to photograph clouds because they were tax-free and available to everyone. Stieglitz claimed that the subject photographed did not matter as it was the photographer who made the picture interesting.

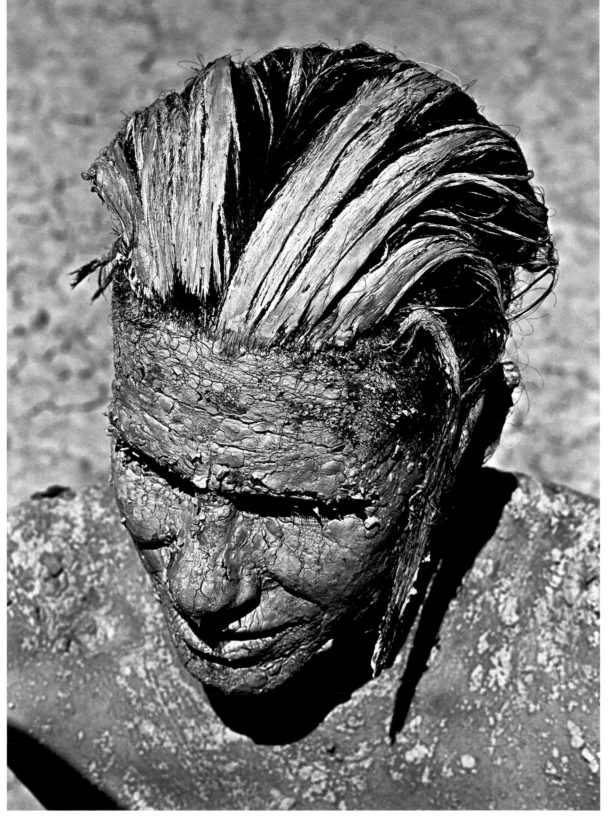

MUD MAN

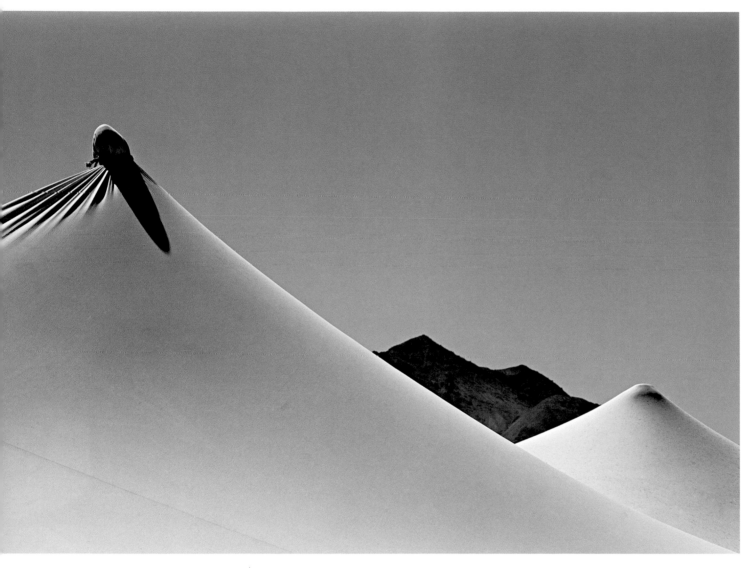

TWIN PEAKS
Tents in the foreground mimic and echo the shape of Trego Peak in the distance.

HMS LOVE
A World War II-style submarine, made by Andy Hill, appears to surface on the playa. The bow section is 50' x 12'. According to Hill, it's all about love... "Maybe a year and a half ago or so I fell in love. Hard. I was giddy with love. It was very surprising... it seemed to come from nowhere and it turned me around."

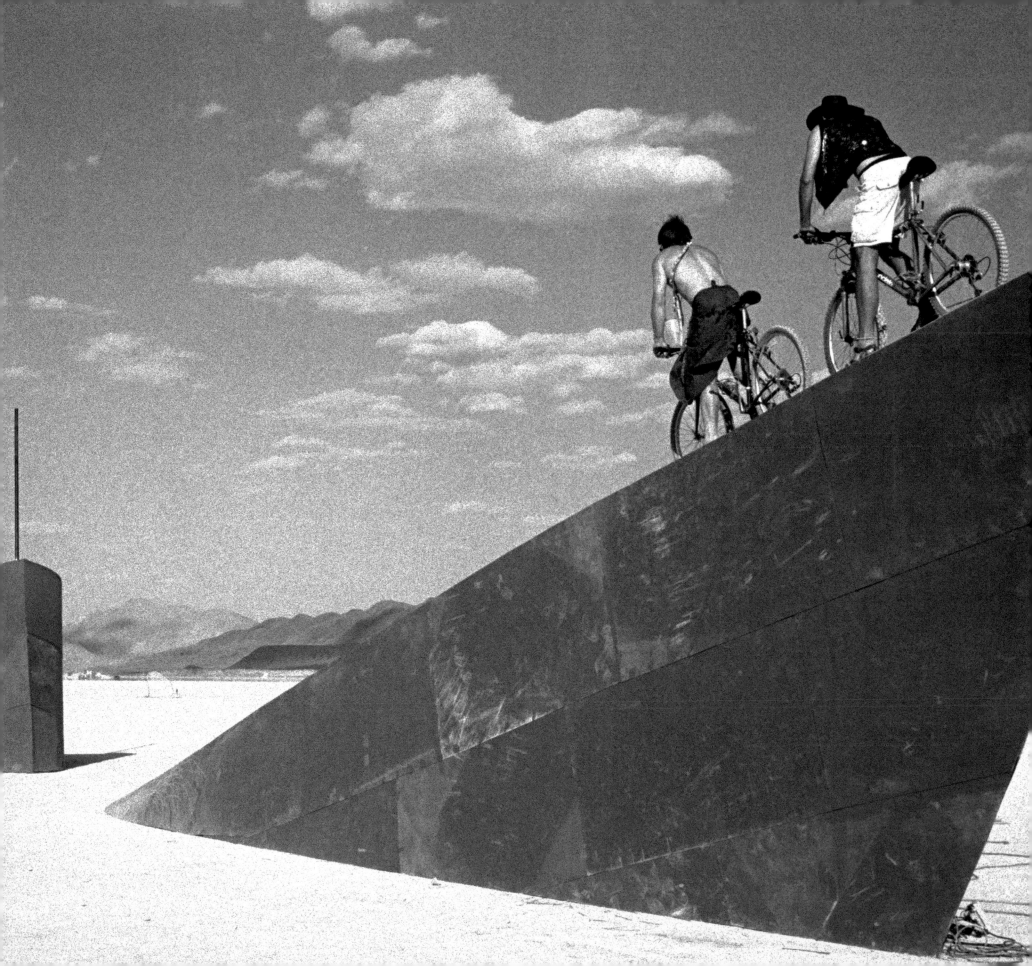

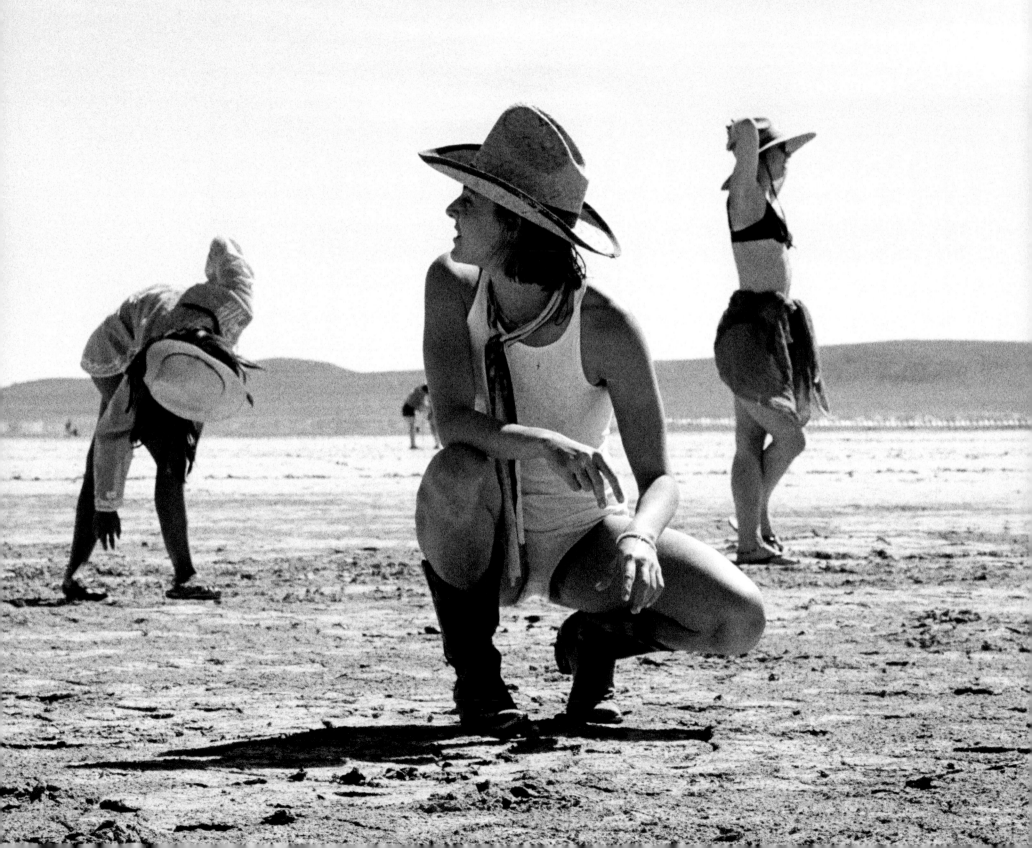

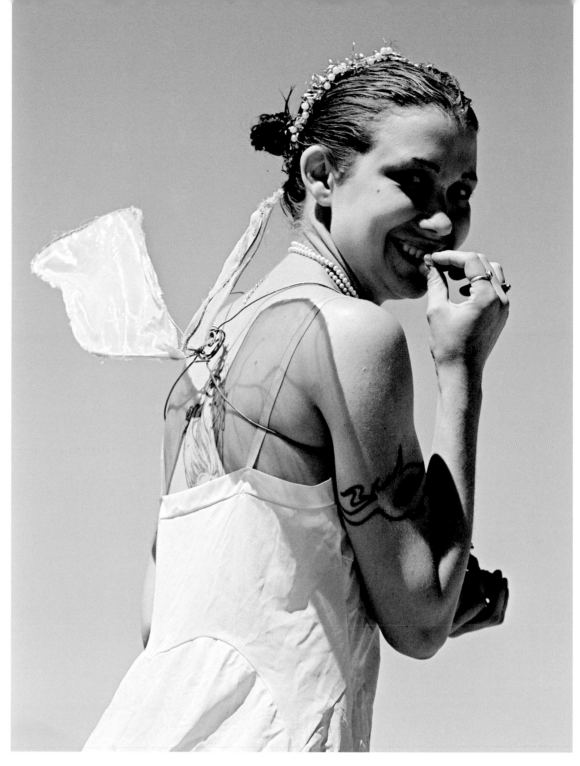

FAIRY MISCHIEVOUS

TERRA TIRZA
The playa, a dried-out and crackled, prehistoric alkali lake bed, is the largest continuous flat expanse in the U.S. It is located not far from where the government once tested atomic bombs.

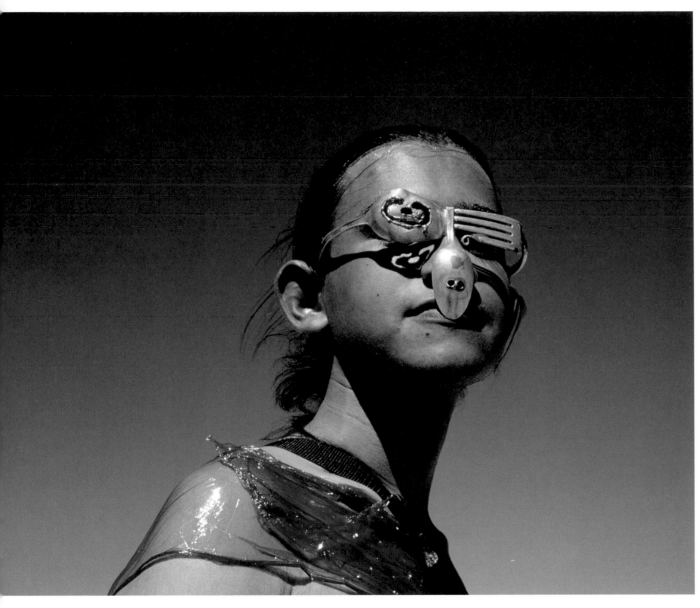

VISOR

ARMOR
The circular image is a
result of the fisheye lens.

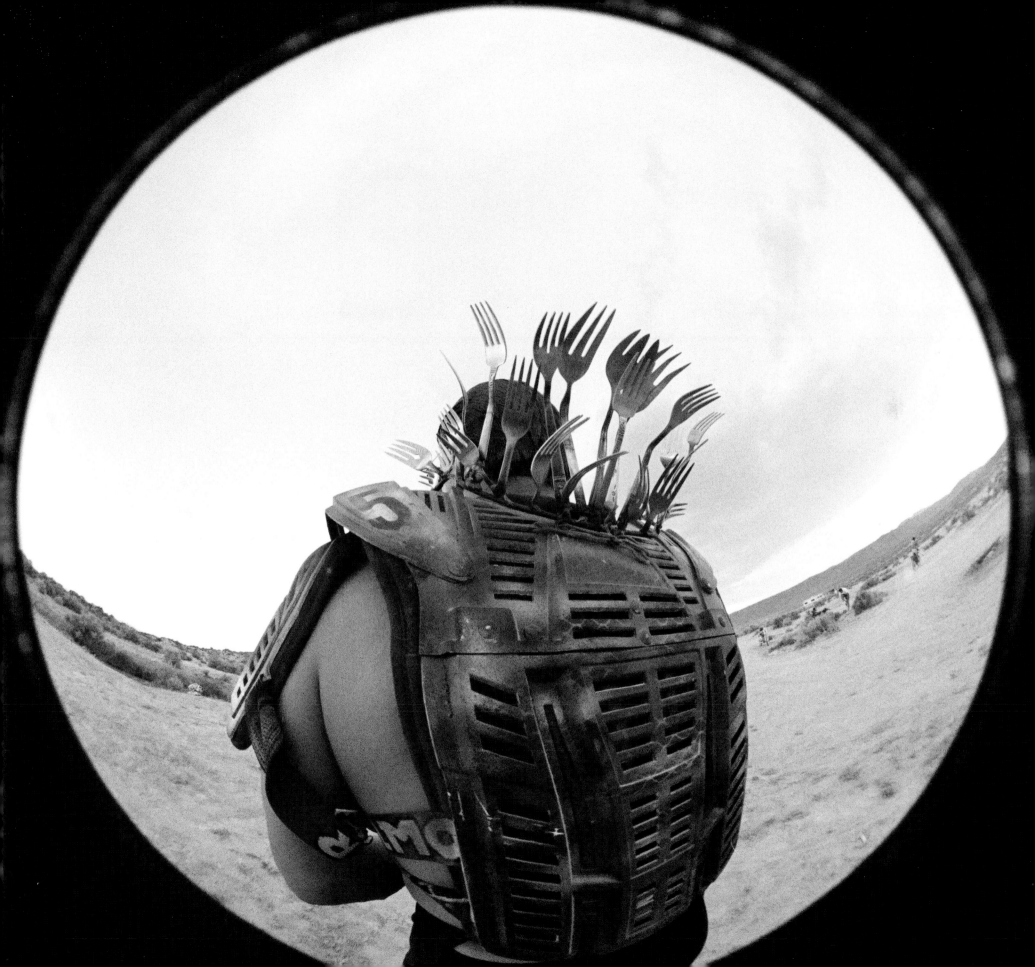

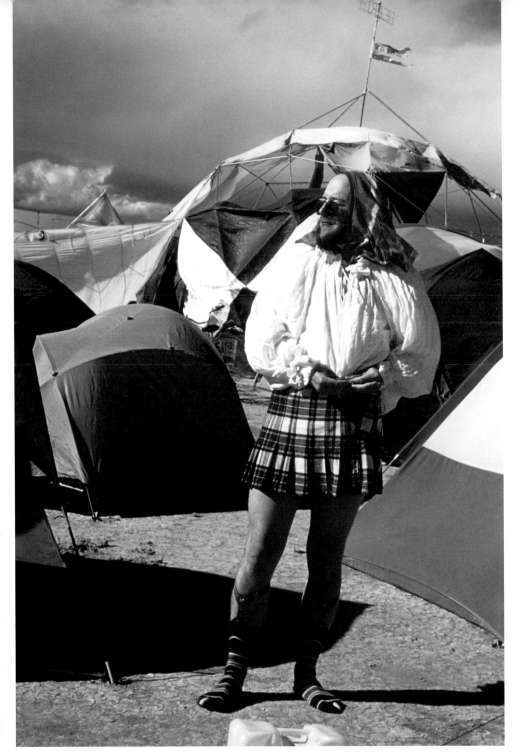

PLAIDED PETER

Back in the early 1990s, Peter Doty originated the idea of theme camps at Burning Man by dressing as Santa Claus and calling his *Christmas Camp*. They played carols 24 hours a day and served eggnog and fruitcake to visitors. Pictured here at *Hearth Camp* in 2000, Doty was clad more like a Highlander and subjected to rave music 24/7 from the neighboring camp *Aquarium*.

SPACE COWBOY
One of a group of performance cowboys who sport all silver wear for the length of Burning Man.

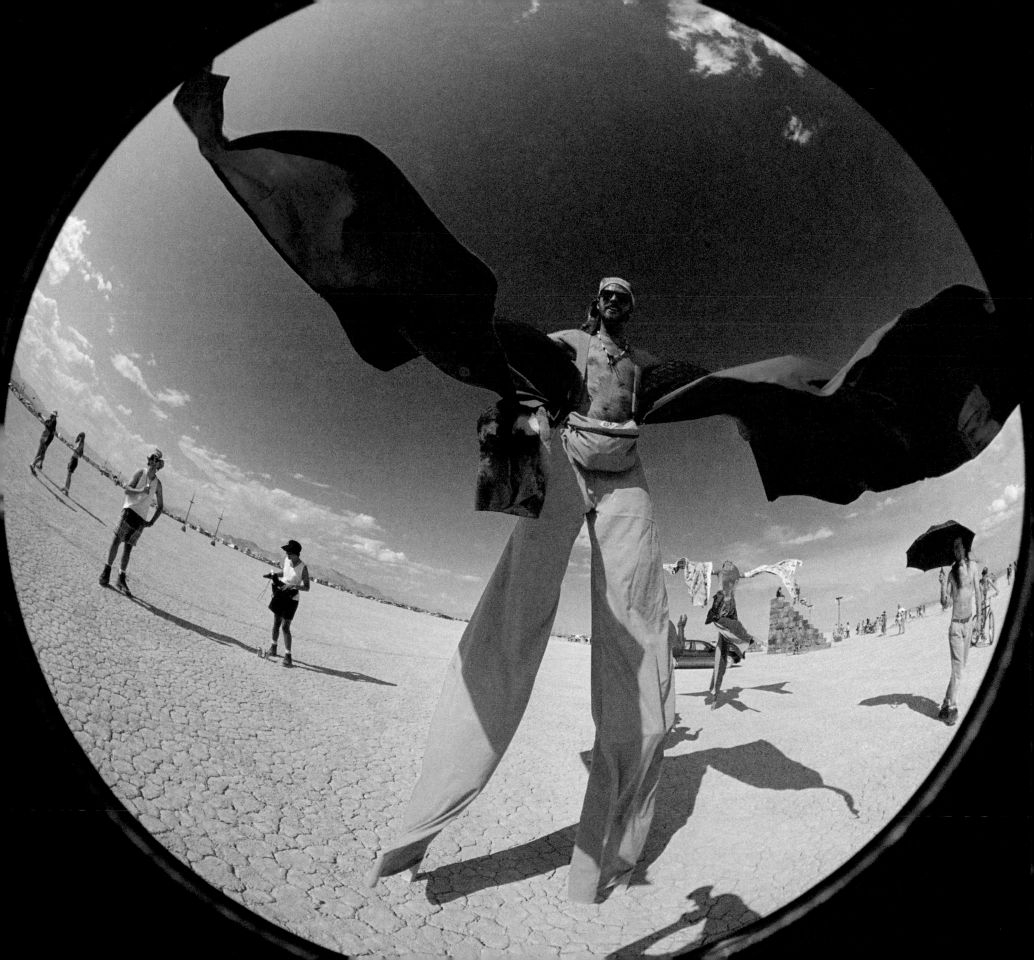

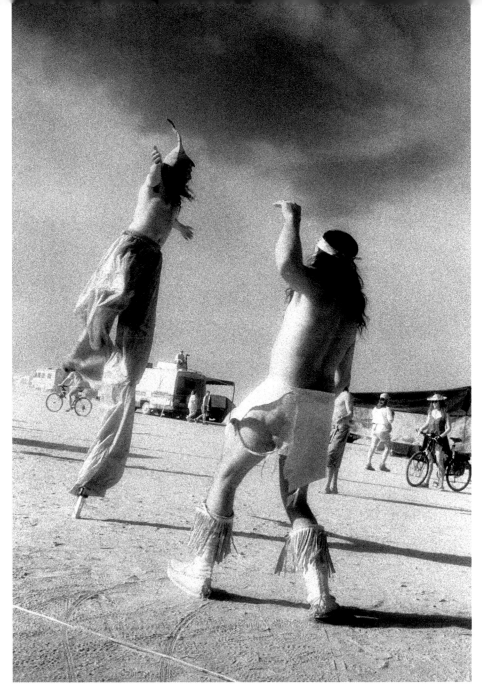

SUNDANCE
Infrared film used with a red filter makes this image really glow.

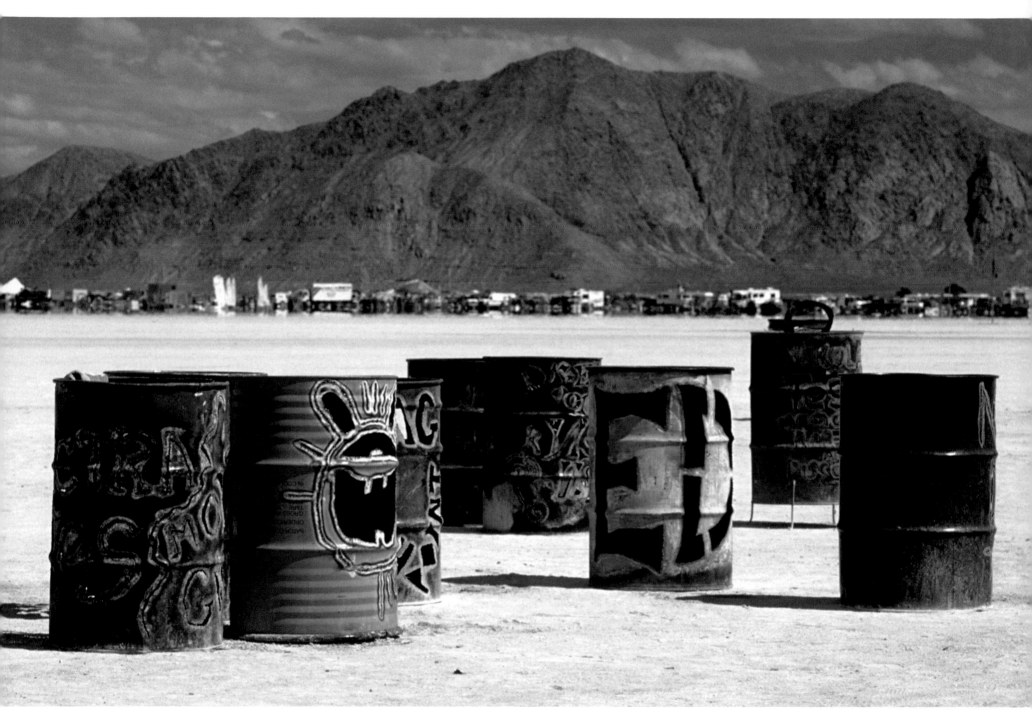

FIRE DRUMS
Situated in the high desert, the playa is nearly surrounded by mountain ranges.
These barrels are used for making fires at night to stay warm.

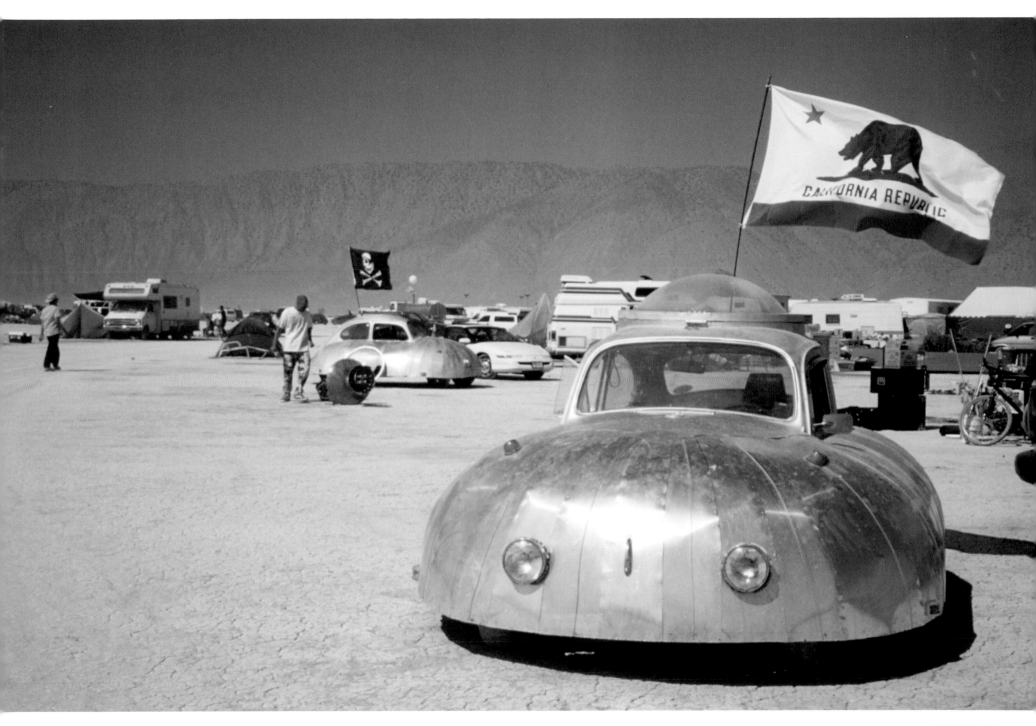

SPACE BUGS
Converted from a pair of old Volkswagen beetles, these art cars by
Carl Dekart are driven not only on the playa but also on the highway.

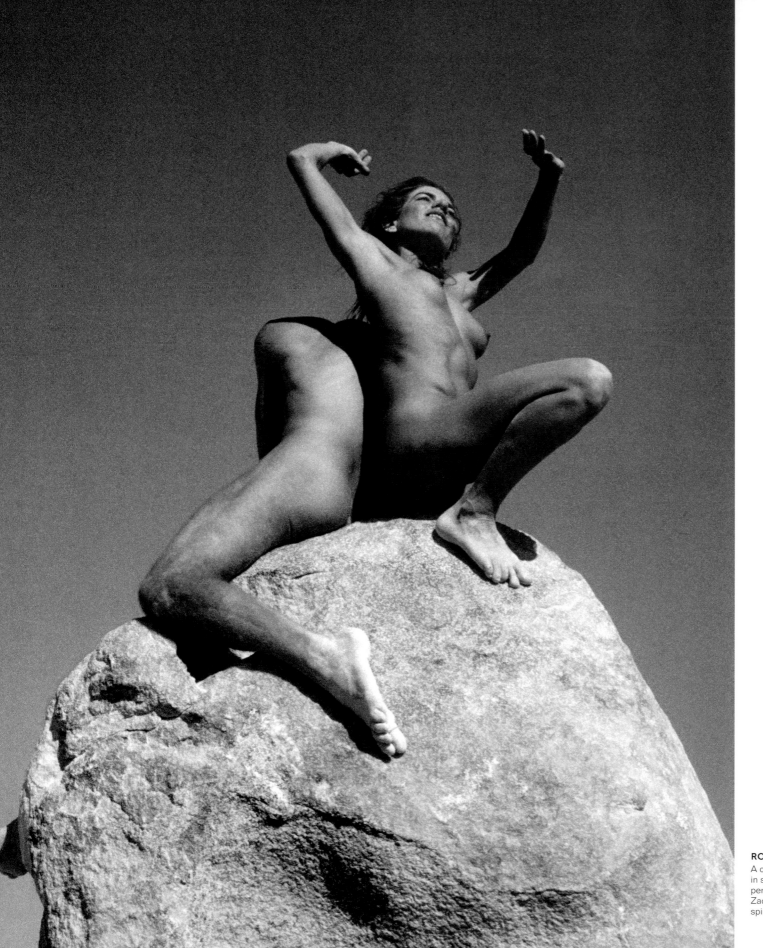

ROCK SPINNERS
A couple engage in spontaneous performance atop Zachary Coffin's spinning boulder.

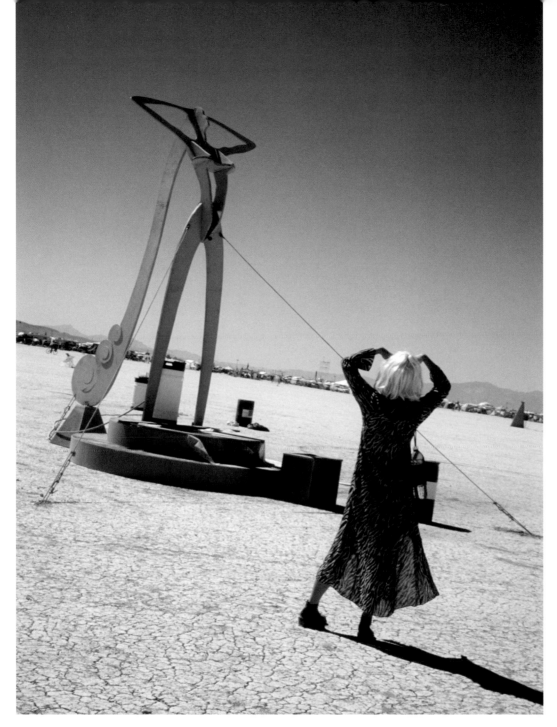

WATER WOMAN
Ray Cirino created this statue to launch the Age of Aquarius into the reawakening of the Goddess. Ray says he perceived that there was a need for a powerful antidote to the frenetic, creative explosion of Burning Man.

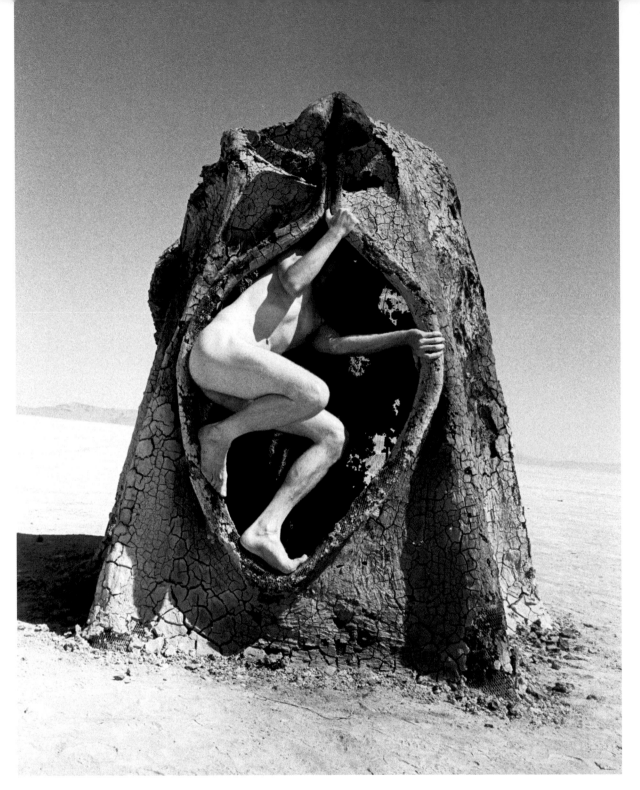

REBIRTH
Nude in the charred remains of a fire lingam.

WISHBONE
The Burning Man looks like a
wishbone due to the angle and
curvature of the fisheye lens.

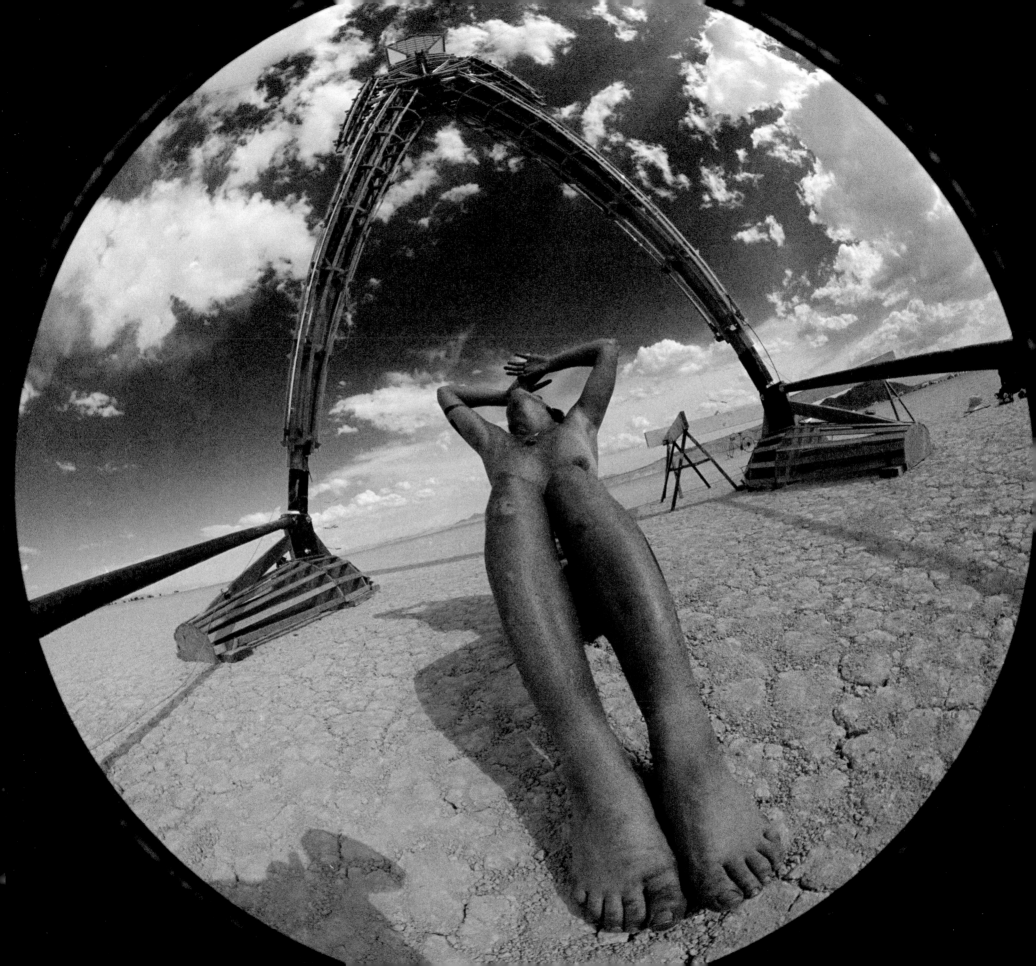

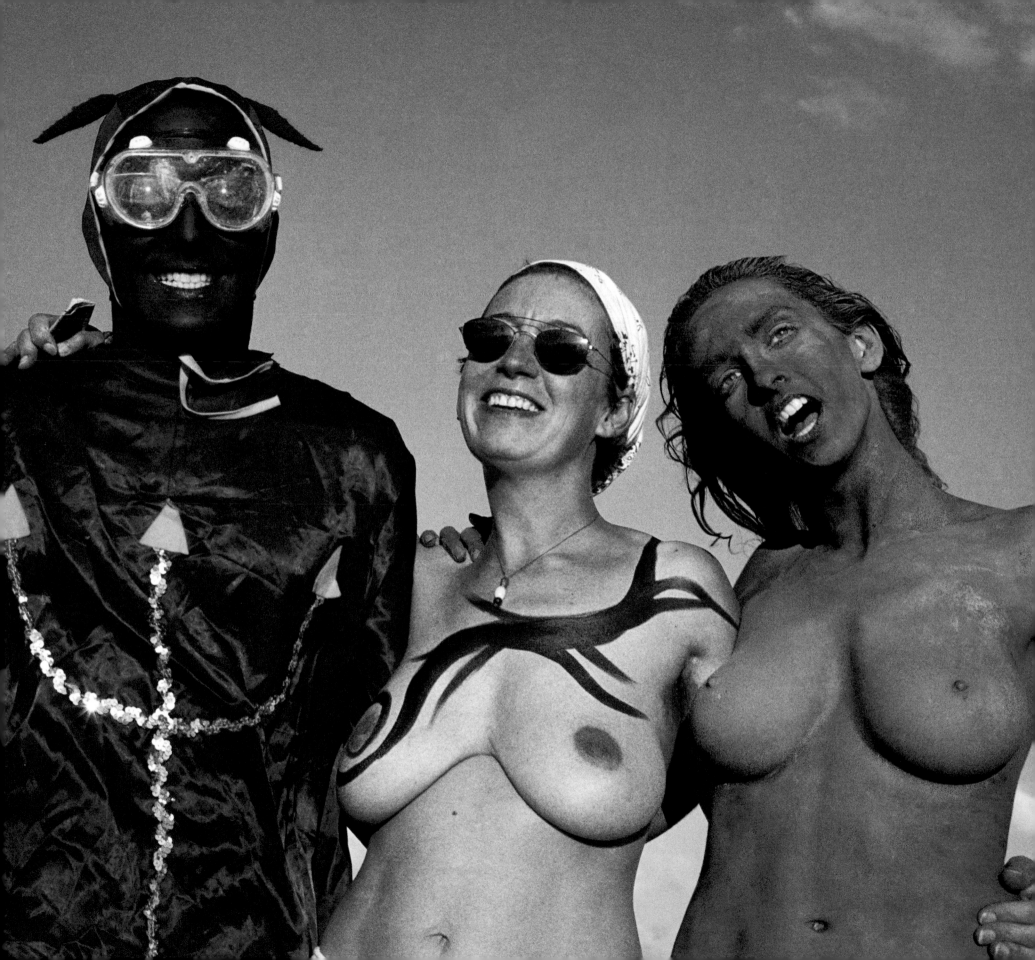

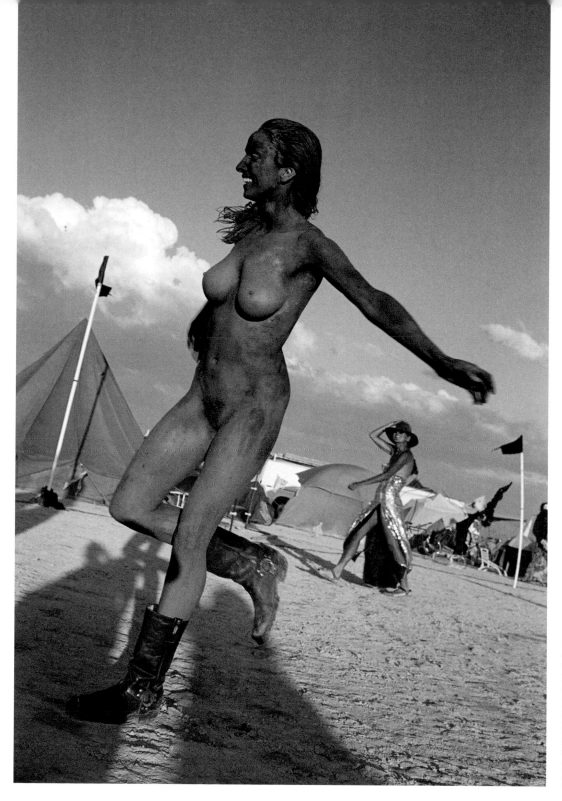

BLUE GIRL

Blue Girl claims to be a goddess from the 16th dimension who possesses her body and uses her natural talents to her own ends.... "I am the embodiment of Vishuddha, the throat chakra, which in Hindu culture represents transformation. Now we're at a fork in the road and we're either going to destroy each other or move into the next level of consciousness—the heart chakra."

SAGRADA FAMILIA

This photo was the lead image for *Wired* magazine's 1996 cover story on Burning Man. Writer Bruce Sterling described this "New American Holiday" as the Internet made physical with each camp like a Web page with different underlying concepts or ways of luring you in.

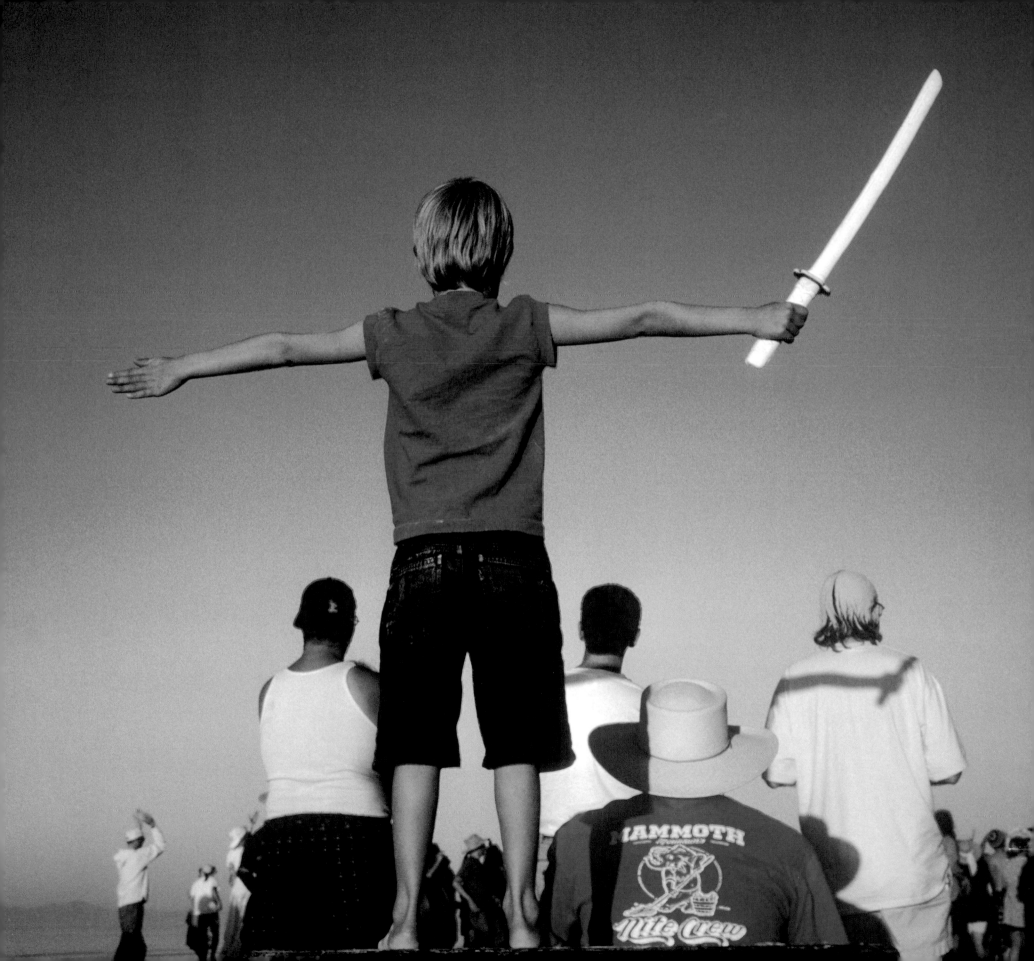

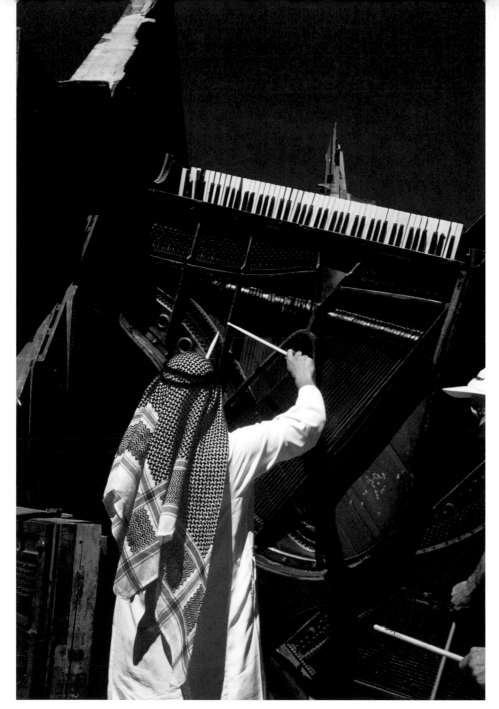

STRUMMER

Steve Hecht sculpted *Piano Bell* from lots of pianos that were hauled out to the playa after getting burned in an Oakland, California warehouse fire. Hecht converted them for use as string instruments that could be played with drumsticks. It is common to see surreal scenes such as this at Burning Man.

GLADIATOR

Although the majority of people at Burning Man are in their 20s and 30s, it is a multi-generational event. Now there is even a kids' theme camp for families.

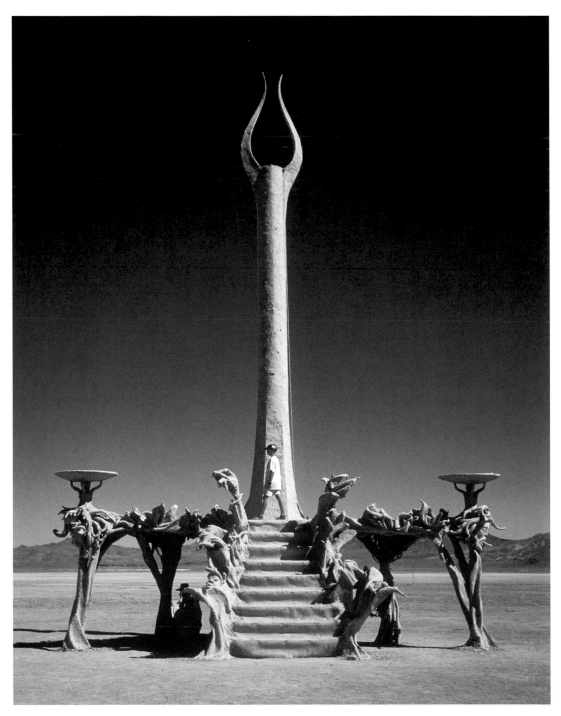

TOWER OF ISHTAR
Pépé Ozan and team created this sculpture for the 1997 opera *The Daughters of Ishtar* in honor of the Goddess of Love and Queen of Heaven and Earth. Ozan produced and directed operas for a number of years at Burning Man. Each one reflected uniquely on that year's theme and featured one or more burning towers surrounded by dancers, singers, fire-eaters, punks, nymphs, magicians, and other celebrants.

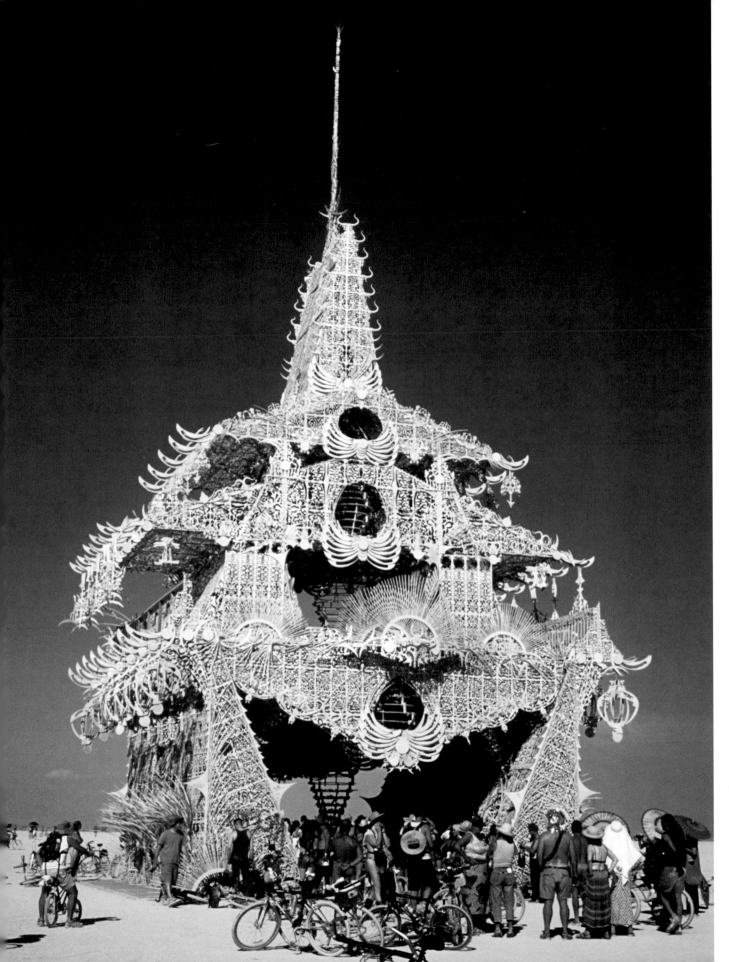

TEMPLE OF JOY

One of a series of temples created by David Best and team, *Temple of Joy* was built almost entirely of recycled wood and surfaced with elegantly carved panels. Visitors would come to meditate, commune with the passage of spirit, leave their wishes and prayers, bring tributes, hug, hang out, and admire this magnificent edifice. Measuring approximately 30' x 30' with a 100' spire, it was burned the night following the Burning of the Man.

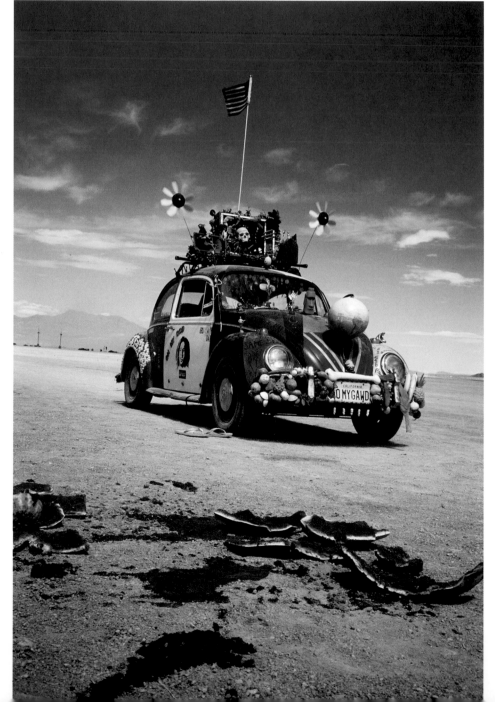

OMYGAWD
Harrod Blank, who
co-produces the annual
Art Car Fest, modified
this 1960's Volkswagen
beetle and made it the
subject of his independent
film *Wild Wheels*.

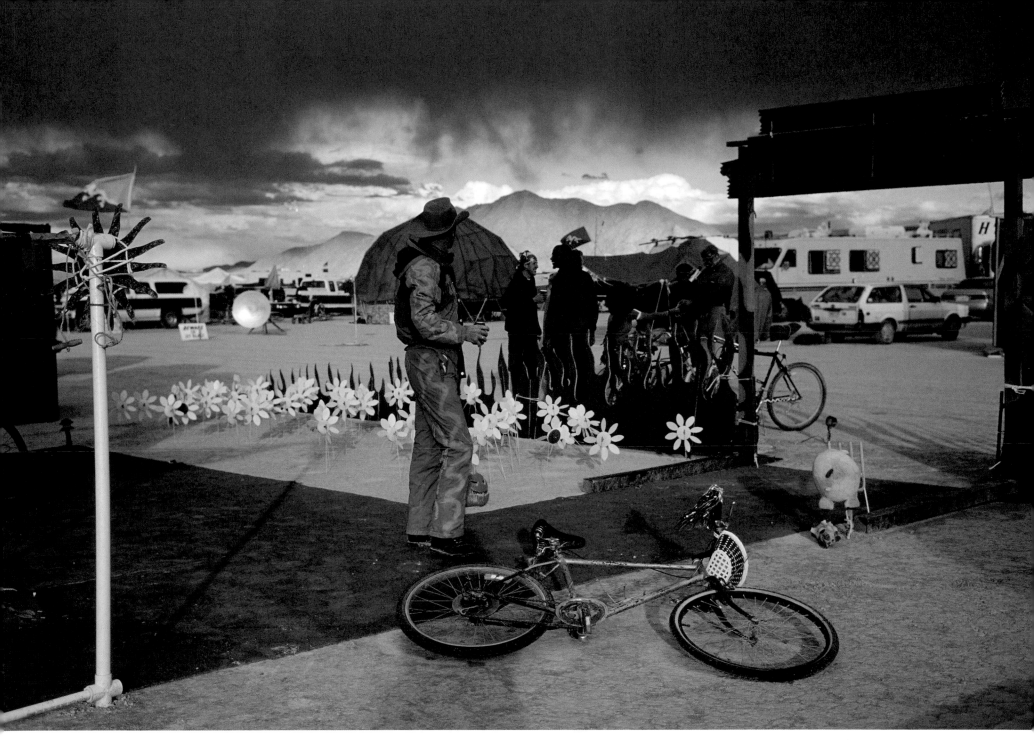

OOPSY DAISY
Storm approaching the playa.

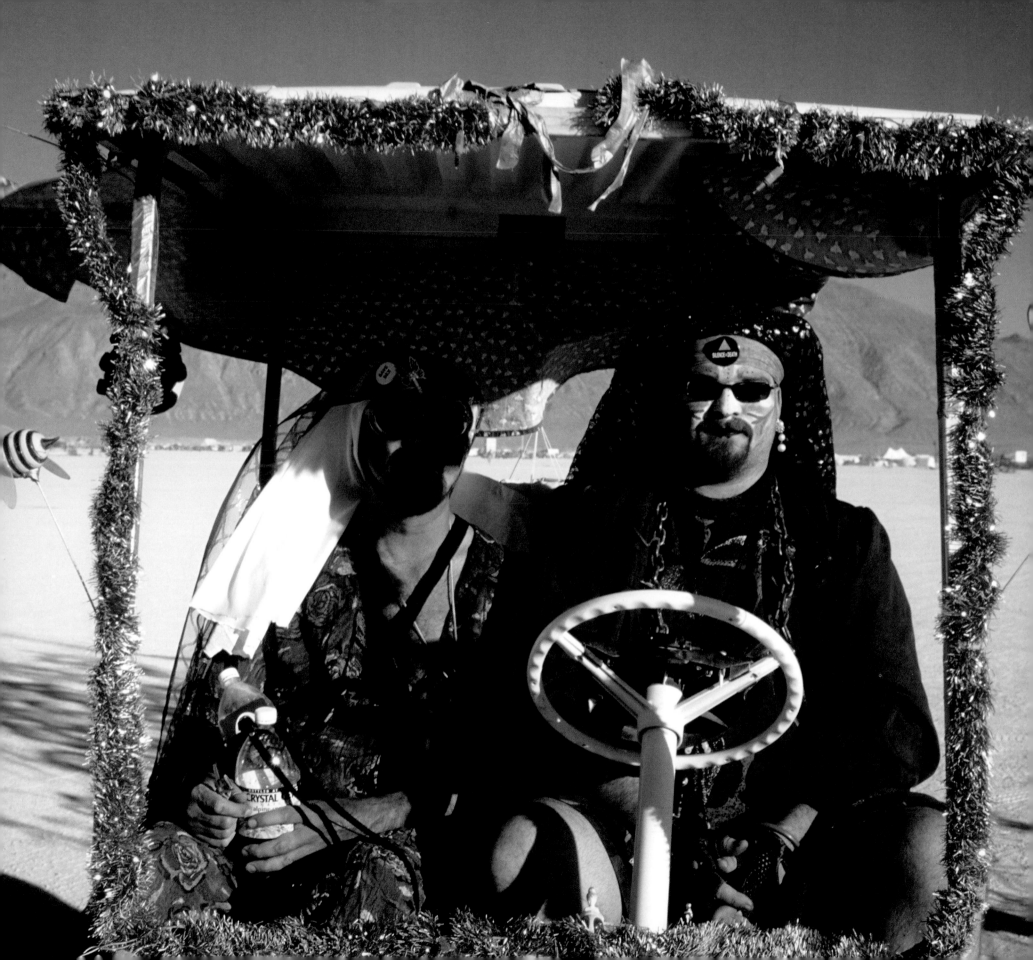

MELON HEAD

SISTERS
Kitty and Dana from
the Sisters of Perpetual
Indulgence, a group of
Bay Area performance
artists who have been
dressing as nuns in drag
since the late 1970's,
cruise the playa in their
decorated golf cart.

4I

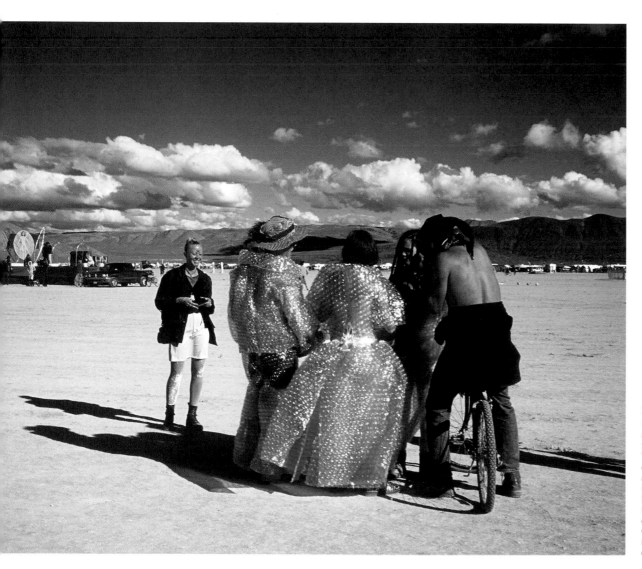

BUBBLE PACK

People on the playa dress up in all kinds of costumes including those made of bubble wrap. To highlight and focus that creative energy, there is an annual fashion show, which was initiated by Tracy Swedlow and her Semi-Real Production group in 1992 – 1994. The annual event is now hosted by Annie Coulter and Hal Robbins and it entertains a large group of eager participants and voyeurs.

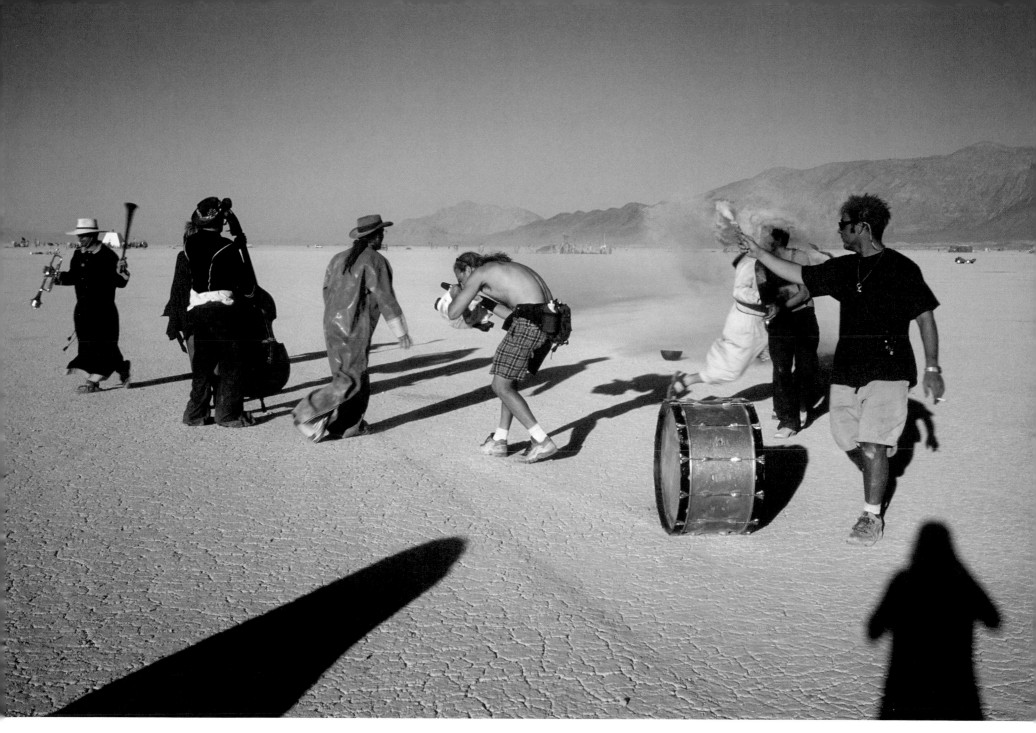

TROUPE
The cameraman in the middle, who is filming
the musicians, has become part of the tableau.

MENACING DENNIS
Red, yellow, blue... what do you do? With mouth full of whistles, eye see green dream, green dream.

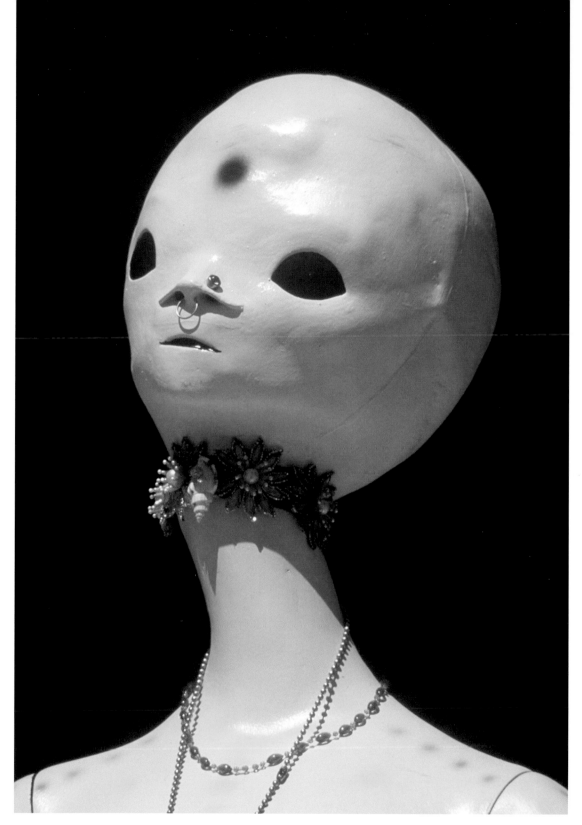

MARIPOSA
Originally a sculpture that was made for the film *ET*, this alien neon figure was decorated by Maureen Hoffmann Garrett and stationed at the entrance to *Rave Camp*.

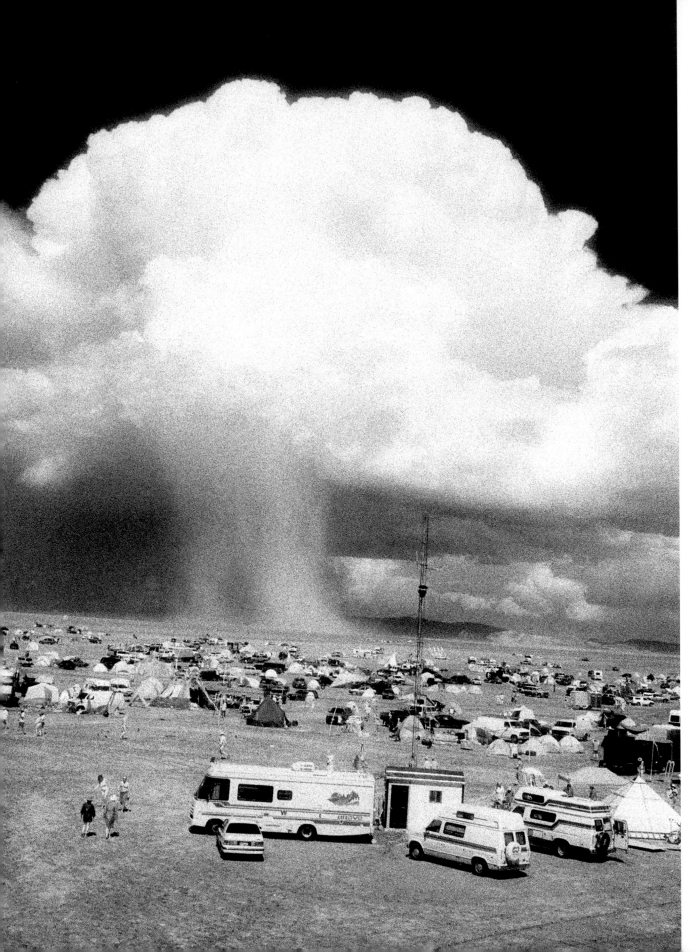

STORM CLOUD

Nature is definitely in the house.

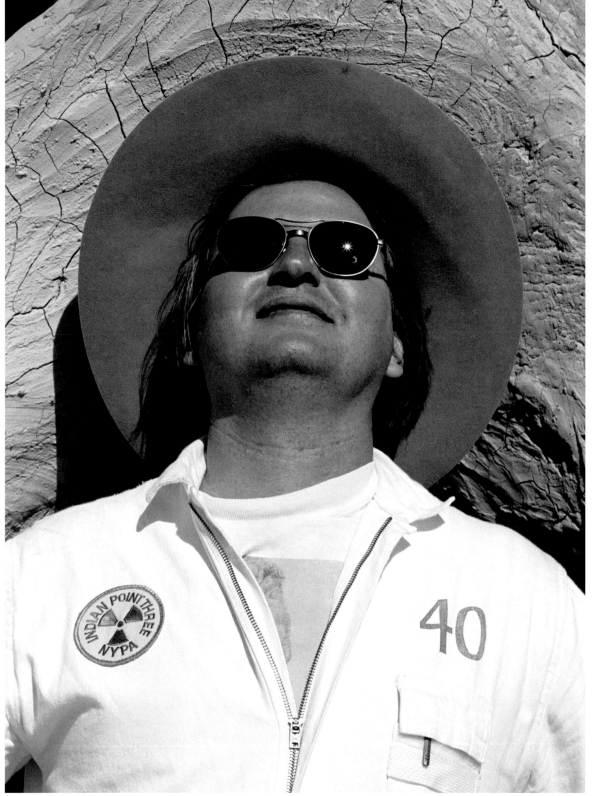

MIRRORSHADES
Bruce Sterling (see *Sagrada Familia*) revels on the playa, wearing coveralls from a nuclear power plant in upstate New York.

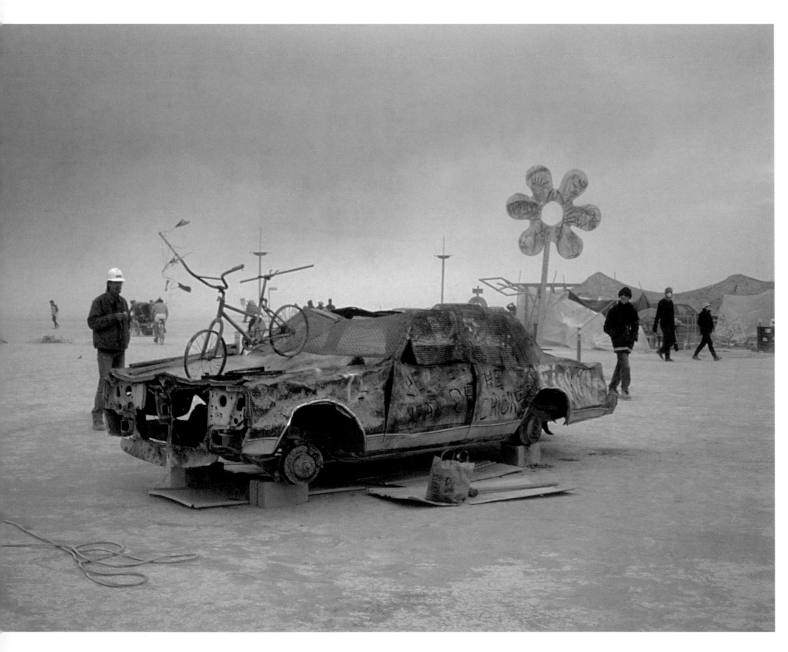

GIGSVILLE

A dust storm envelops this gutted art car, which is the centerpiece for a collection of theme camps. Burners (Burning Man participants) from around the world create communities of their own and sponsor related events all year round.

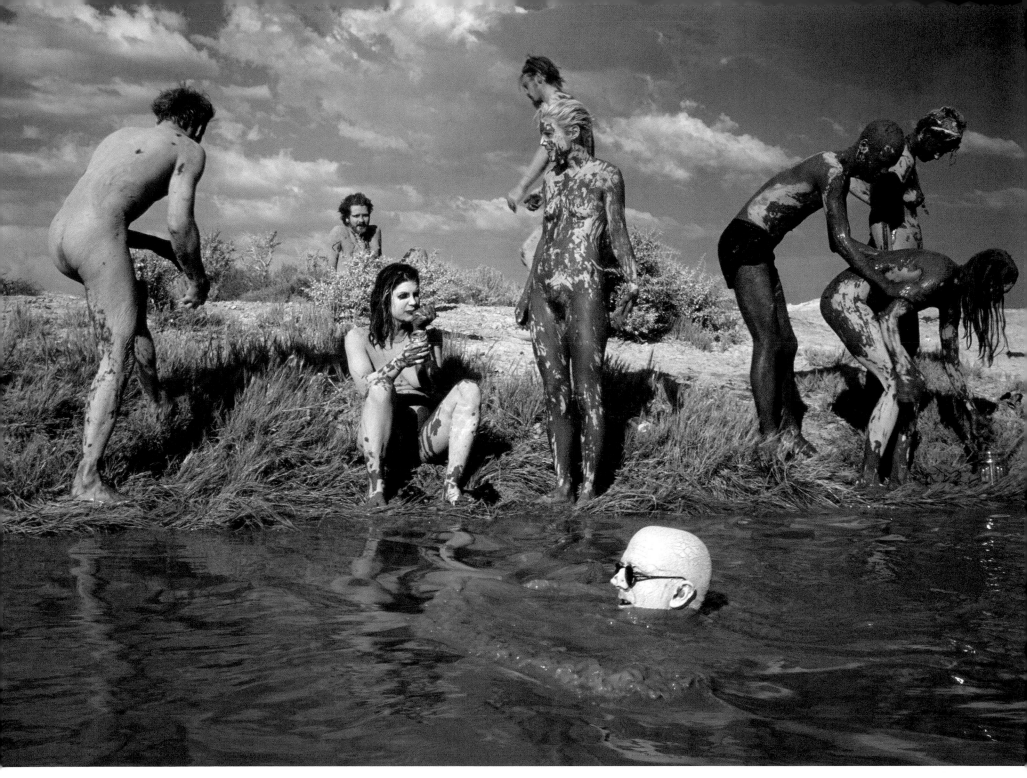

MUD CLUB
Going to the mud baths at the hot springs was an integral part of being at Burning Man. However, as attendance grew, access during the festival was restricted.

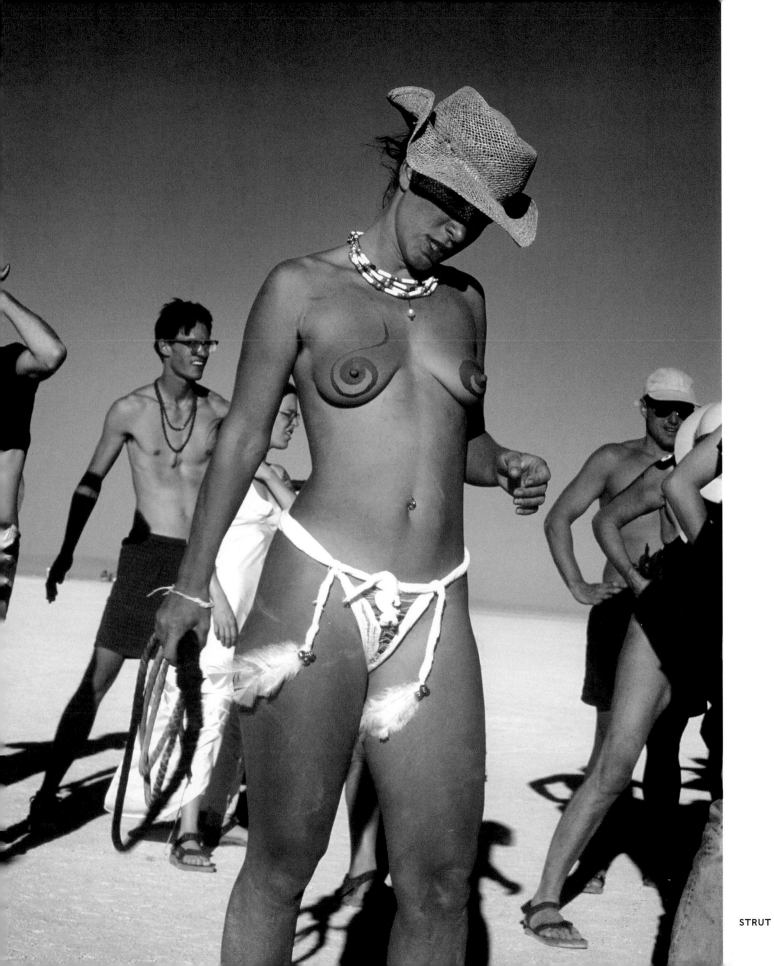

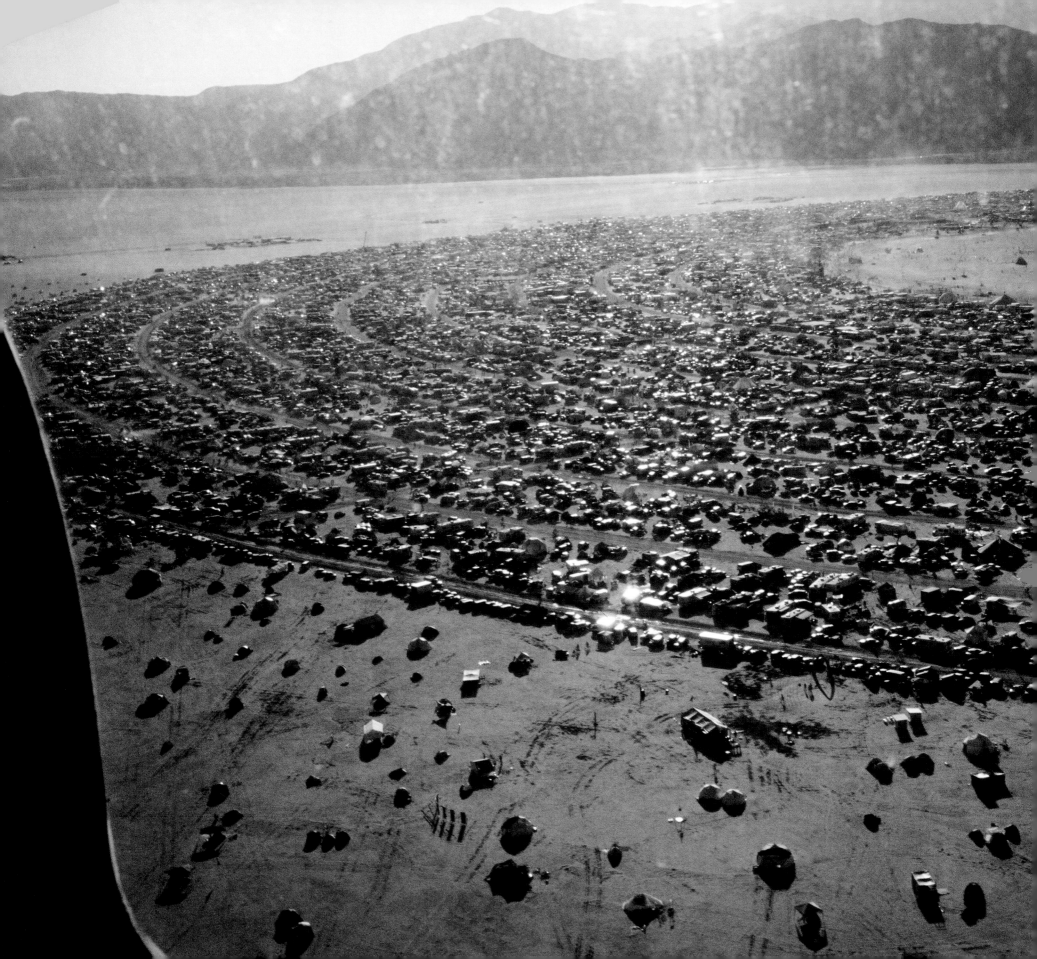

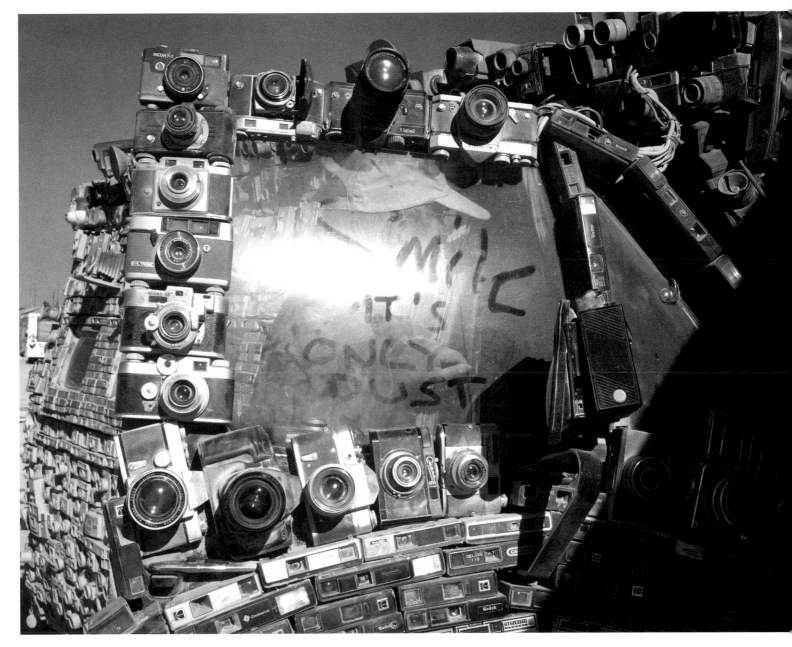

CAMERA VAN
More than 2,000 cameras cover Harrod Blank's Dodge art van and some of them function by shutter buttons wired to the dashboard.

AERIAL
View across a section of Black Rock City, a temporary town laid out in the shape of a horseshoe. Concentric roads bearing names pertaining to the theme of that year intersect with streets corresponding to the hours of the clock that extend radially from the Man. For example, in 2000, it was the Year of *The Body* and we were camped at 3:30 and Throat. For the Year of *Beyond Belief* in 2003, our address was 3:11 and Faith.

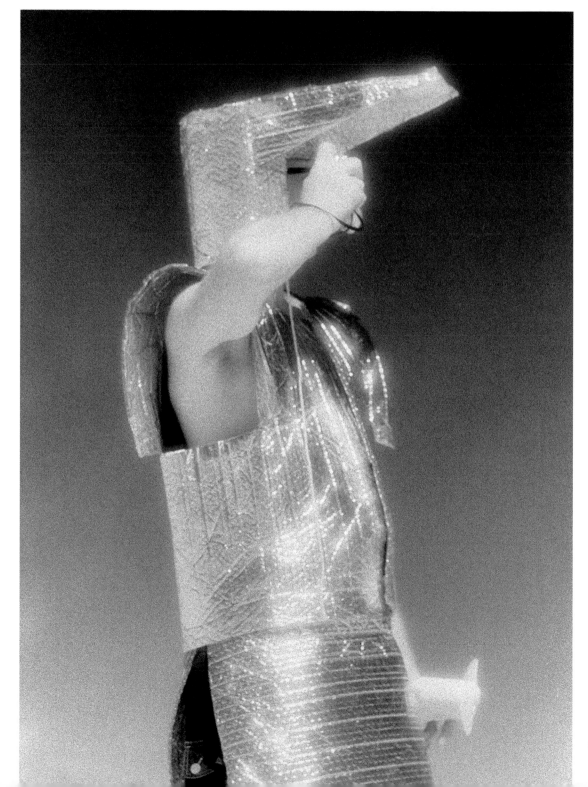

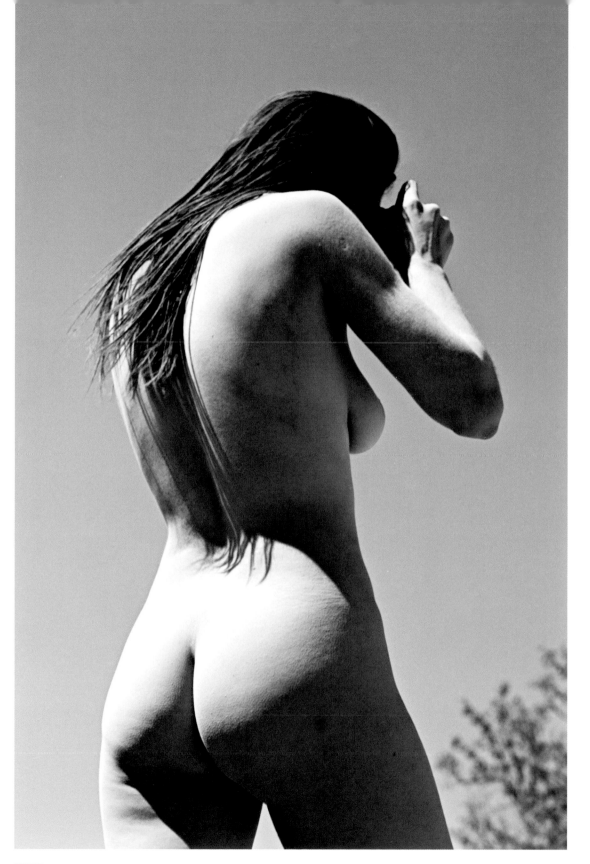

NUDE

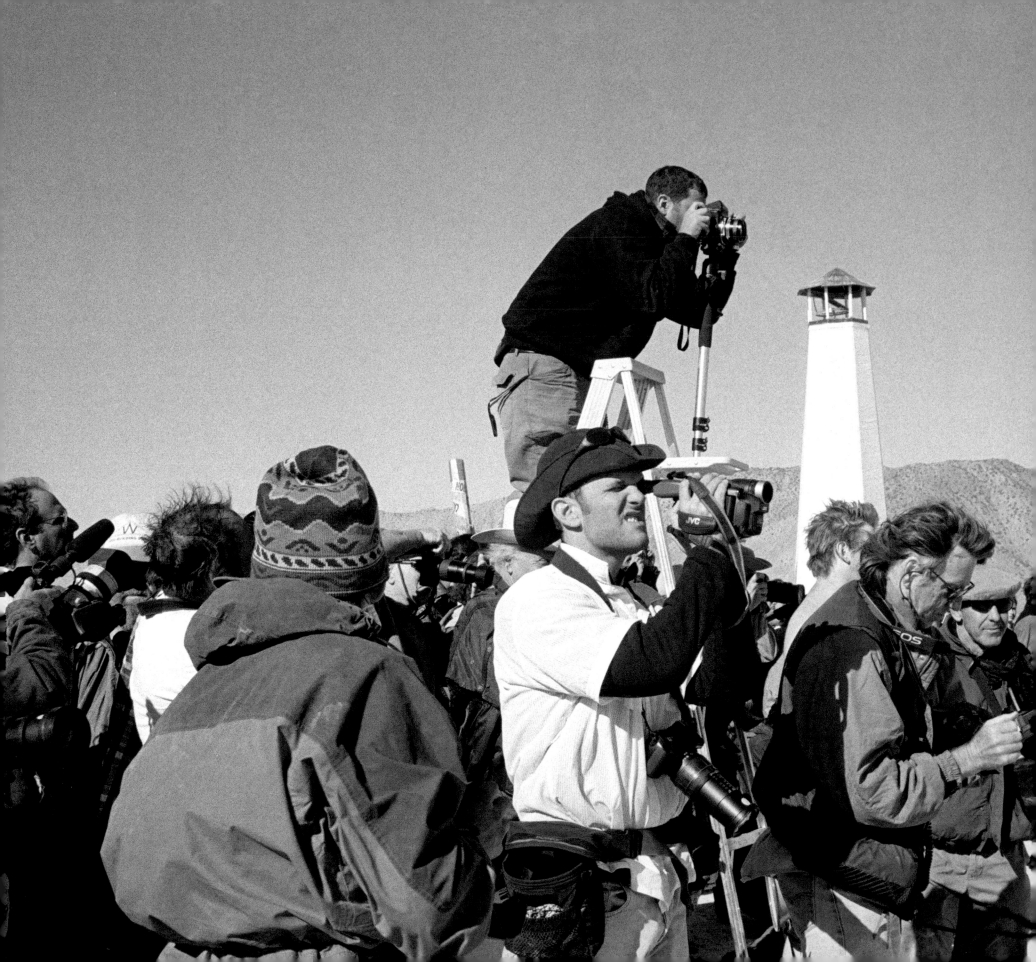

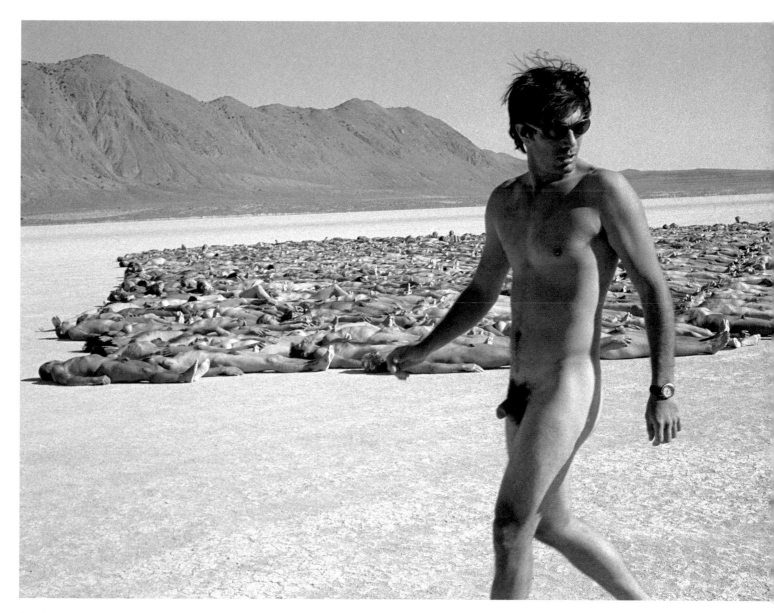

NUDISTS
The standing figure (someone working for Tunick)
prevented people from stepping into the photo.

GUIDING LIGHT
Spenser Tunick, pictured on the
ladder, directed this group nude
photo shoot seen on the facing
page. He has staged similar
photo shoots all over the world.

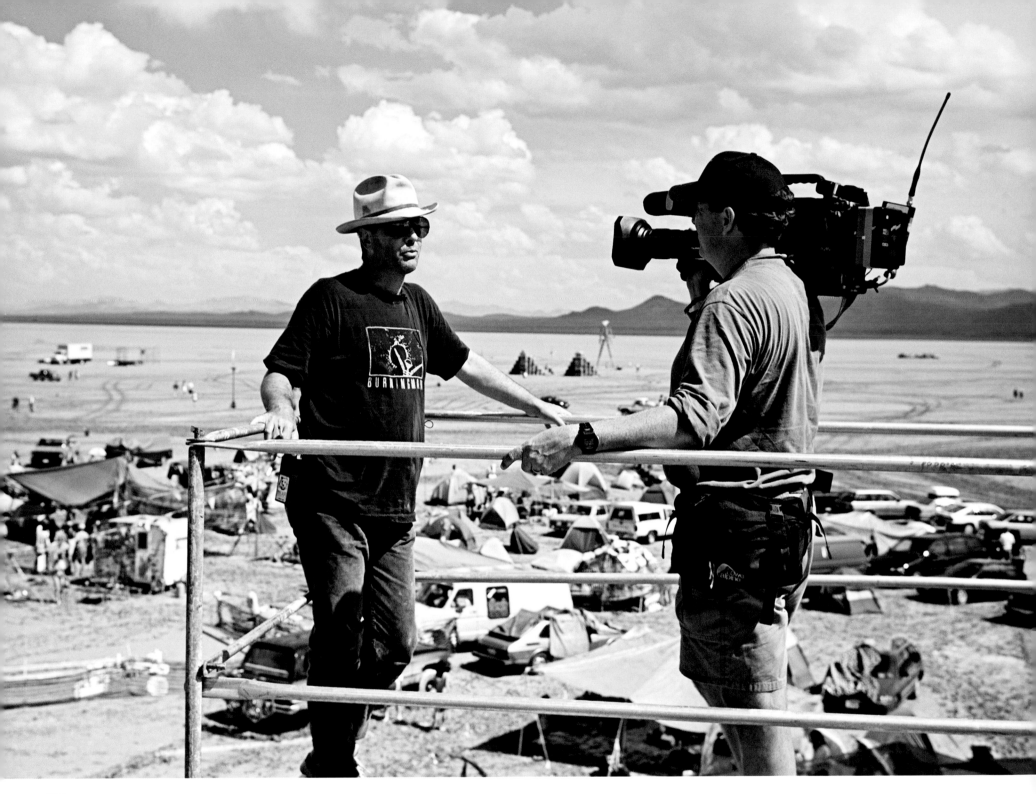

CNN
CNN interviews Larry Harvey who insisted they climb with him to
the top of this scaffolding tower (one of the World Trade Center
towers that were part of the *Algonquin Roundtable Camp* in 1995).

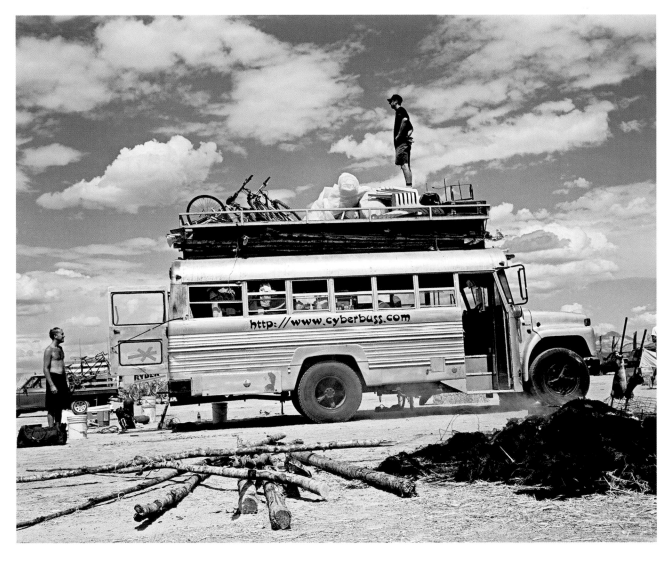

CYBERBUSS
A fhREaKy silver school bus that travels into the heart of cyber-culture and annually to Burning Man.

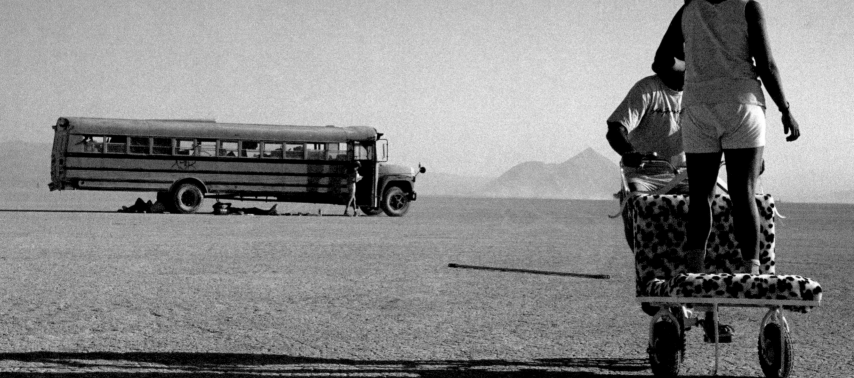

REVERSAL
Inverse of an image shot into broad daylight on black and white slide film.

ARRIVAL
Empress Zoe shared the crown of Byzantium from 1034 to 1050 and is depicted in a mosaic at the Hagia Sophia in Istanbul. She was also the subject of Pépé Ozan's *The Arrival of Empress Zoe*, a tribal opera depicting the peculiar saga of a soul's birth into death.

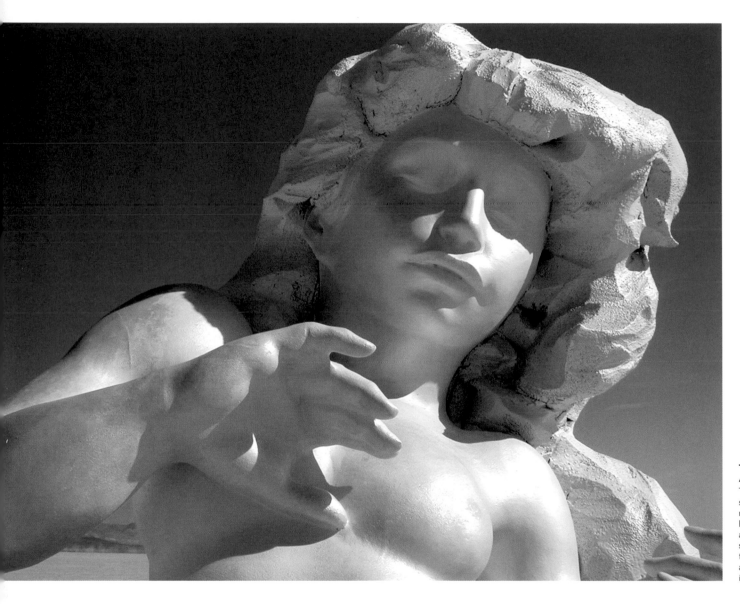

TRANSOCEANIC APHRODITE

This sensuous and serene sculpture by Thomas Morrison is like my Bonnie who lies over the Desert Ocean and Cosmic Sea. Morrison says she is a celebration of the women of Burning Man and a tribute to the pioneering spirit of playan explorers.

LA CONTESSA

La Contessa is a 40' long, 2-masted, fully-rigged mobile galleon built and crewed by Simon Cheffin, Matteo, and the Extra Action Marching Band—a group of up to 40 performers who offer a stylistic mix of traditional marching band, ecstatic turmoil, and punk flair musical extravaganzas.

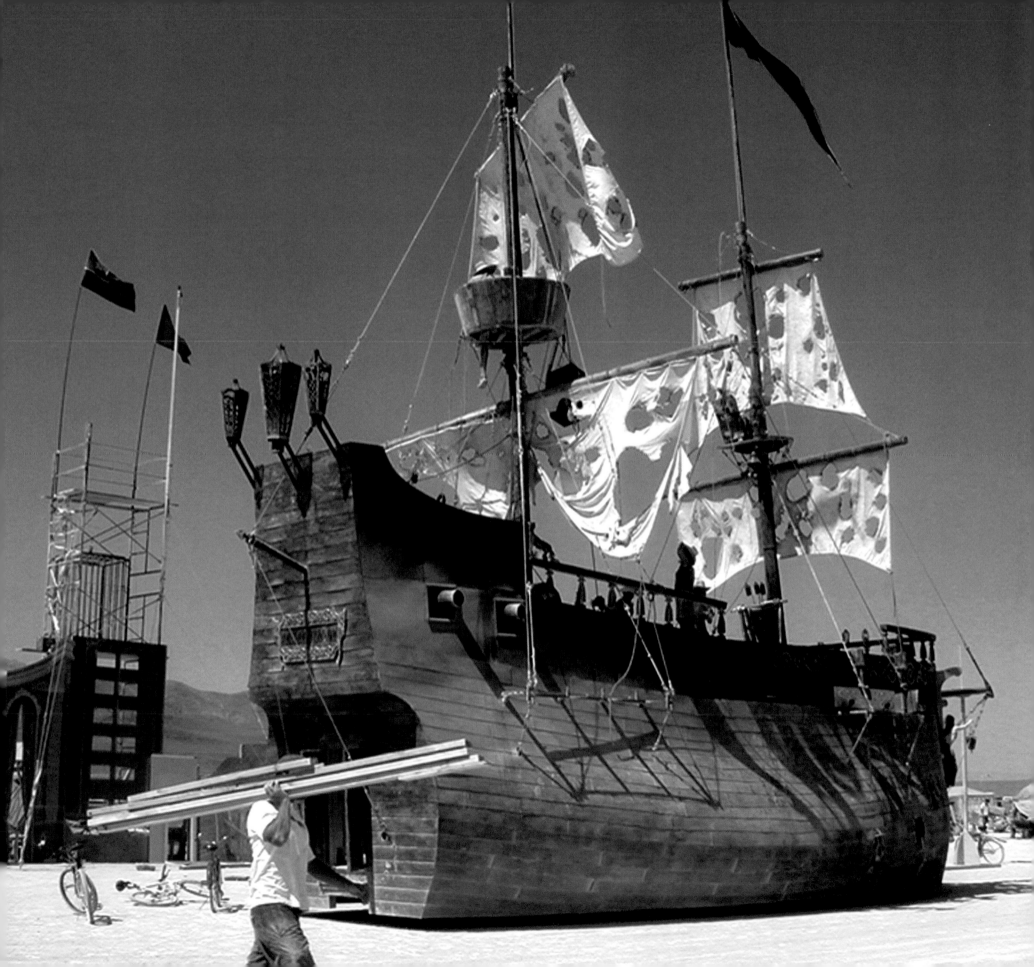

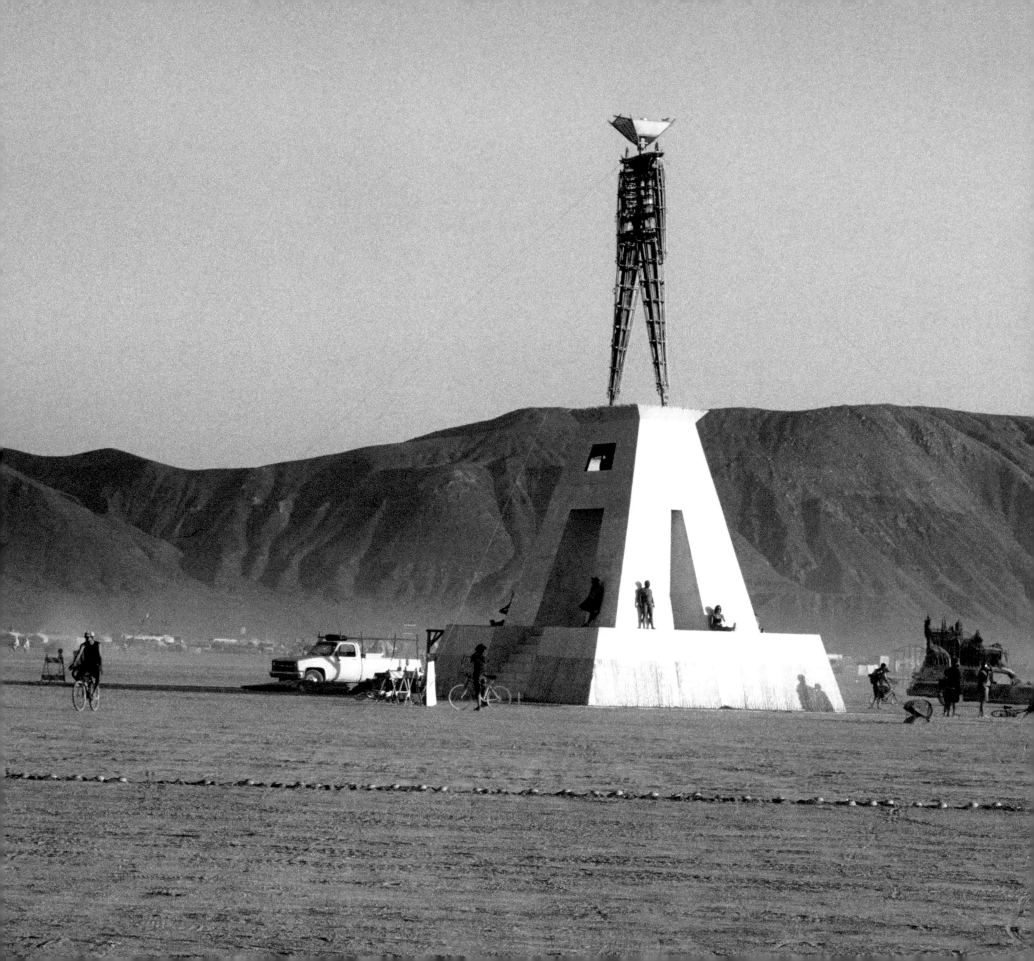

CENTER CAMP

Center Camp consists of a café, stage, installations, and seating areas all under one big tent that serves as a central meeting place for the entire city. Pictured here is Anat, the self-proclaimed queen of Burning Man.

TEMPLE OF WISDOM

The theme in 2001 was the *Seven Ages of Man*. Burning Man stood at the Fifth Age of Enlightenment atop a tower whose interior could be accessed only by those who had proven their passage through the previous Six Ages.

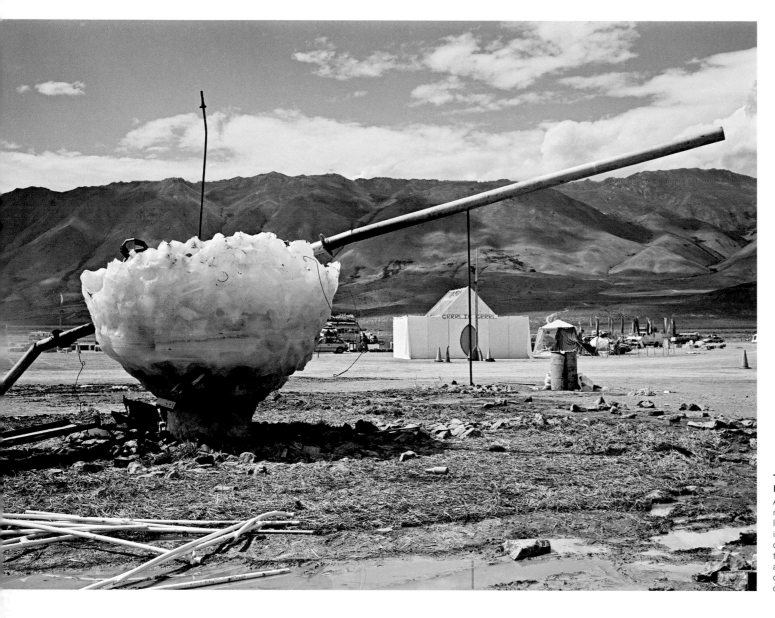

TEMPORAL DECOMPOSITION

A 57,000 pound sundial made of ice, frozen on-location, and left to melt in the sun. Conceived and designed by Jim Mason, the installation consisted of a 12' diameter solid sphere of ice that contained 200 clocks and watches.

COUCH SURFING
Motorized mobile piece of furniture heads toward *Center Camp*.

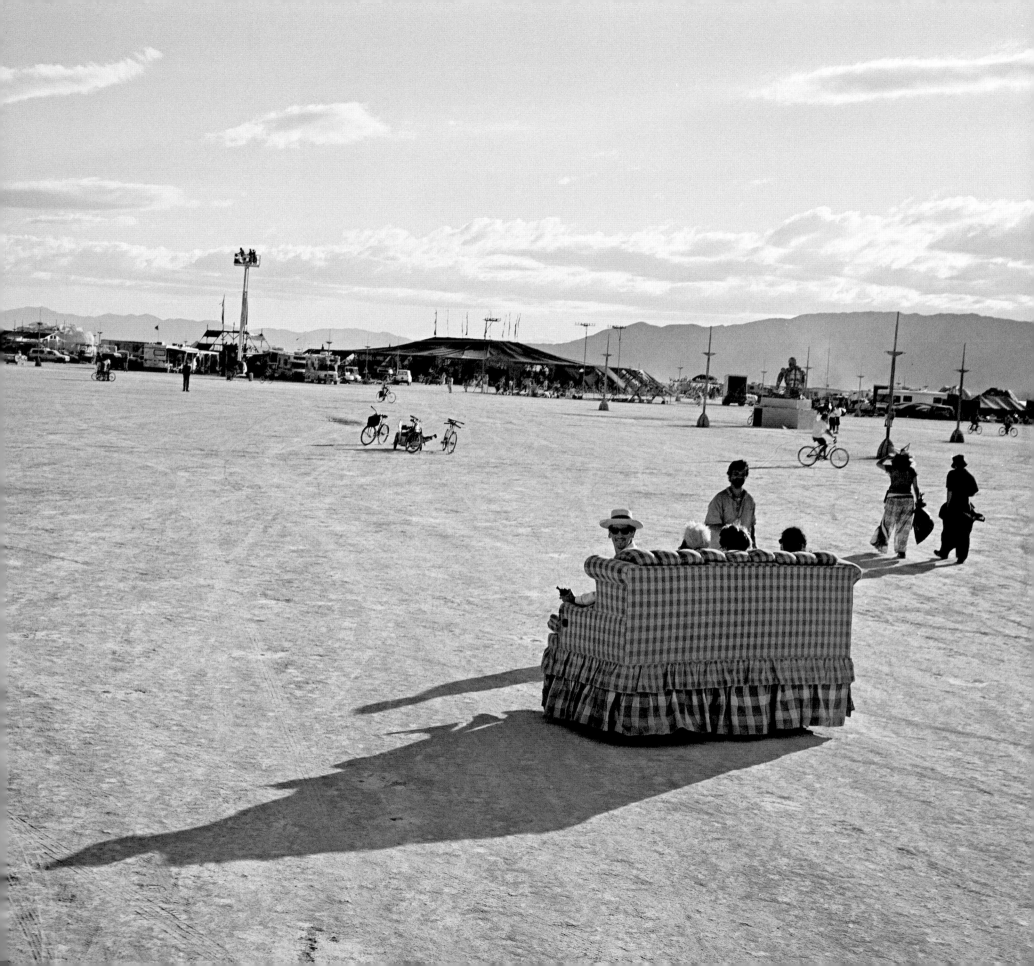

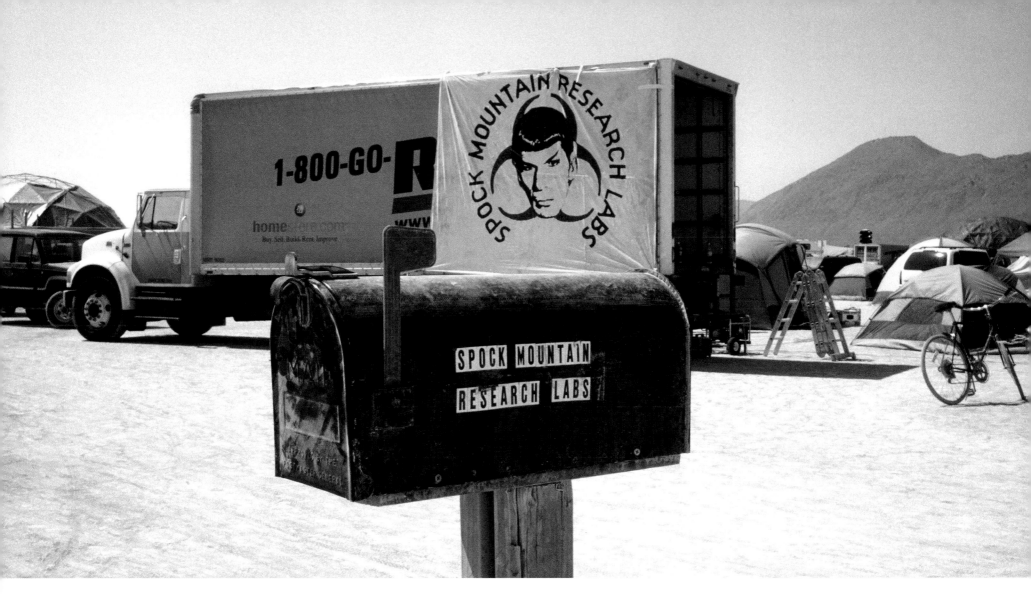

I AM NOT SPOCK

There is a suspicion that Spock has knowledge which could be very helpful to a troubled humanity. I have been contacted by metaphysical organizations. One group told me that I had been chosen for the Spock role because I was a carrier of ideas, concepts of which I myself might not be aware. That my real function in the series was to prepare mankind for the future and to relieve public tensions about phenomena which were bound to come. This particular group communed in the Nevada desert and had personal and direct contact with extraterrestrials who visited them and took members of the group on short rides on their spacecraft. They could reveal themselves to me, they said because I would be capable of accepting and understanding. However, they felt the public would be hostile and needed further education through roles like mine.

Leonard Nimoy

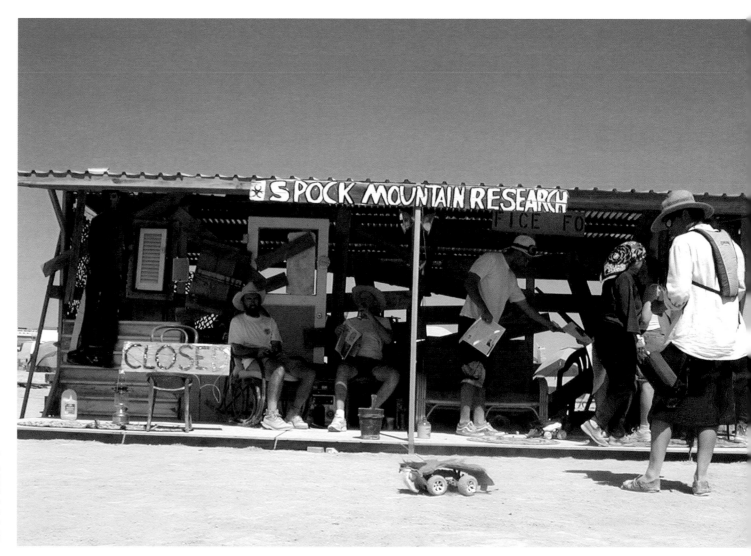

VULCAN CAMP
Coordinated by members of a San Francisco-based zine/mailing list called *Pigdog*, SMRL distributes *Spock Science Monitor*, a daily newsletter that sports the motto "Rock Out With Your Spock Out."

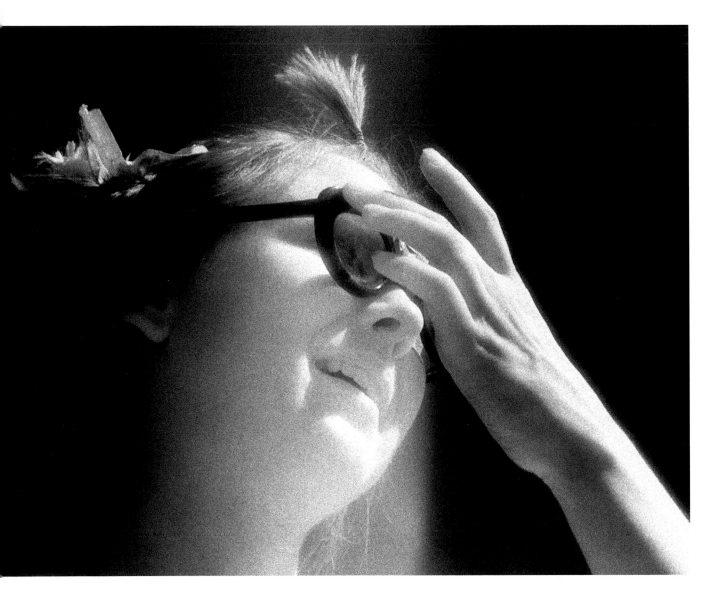

BEAMING

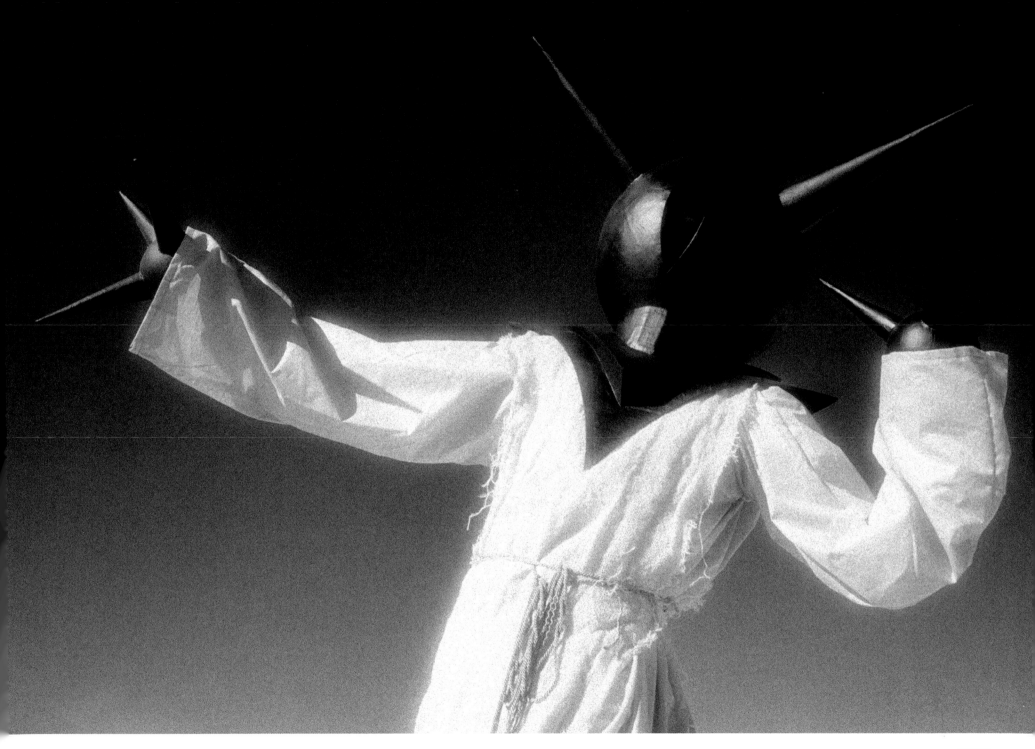

SPIKE

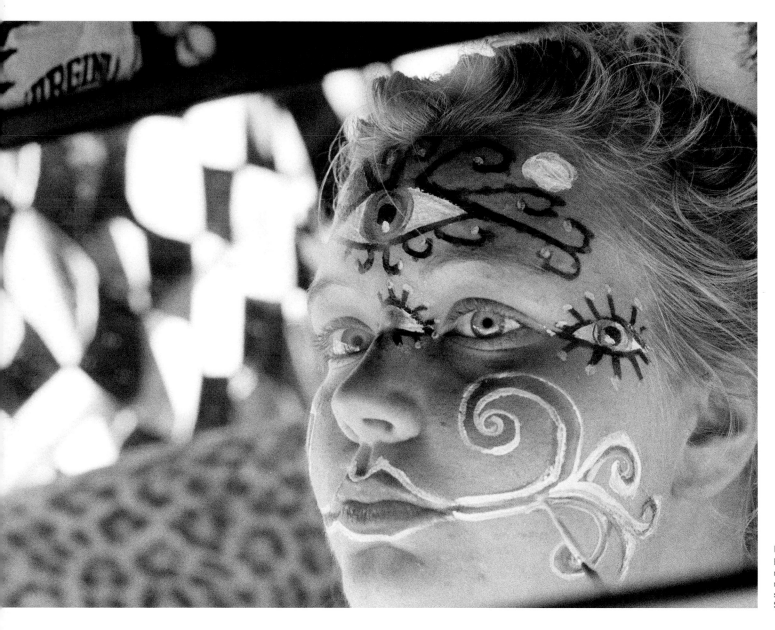

KATHMANDU
Behind the wheel and reflected in the rearview mirror of a psychedelic school bus from Santa Cruz.

THE HOST
Art van created by Michael Gump. The eye on the rear of the beetle here can also be seen in the more detailed *Eye in the Sky* photo at the beginning of this book.

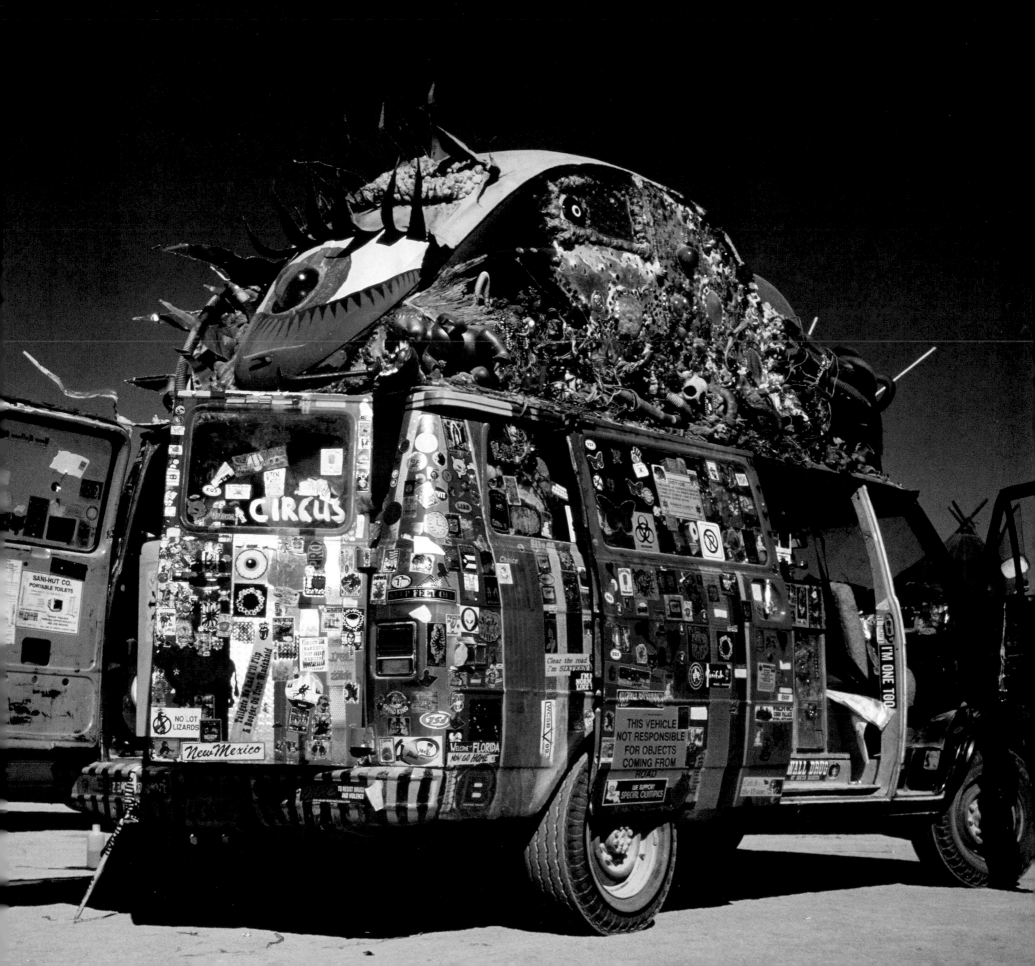

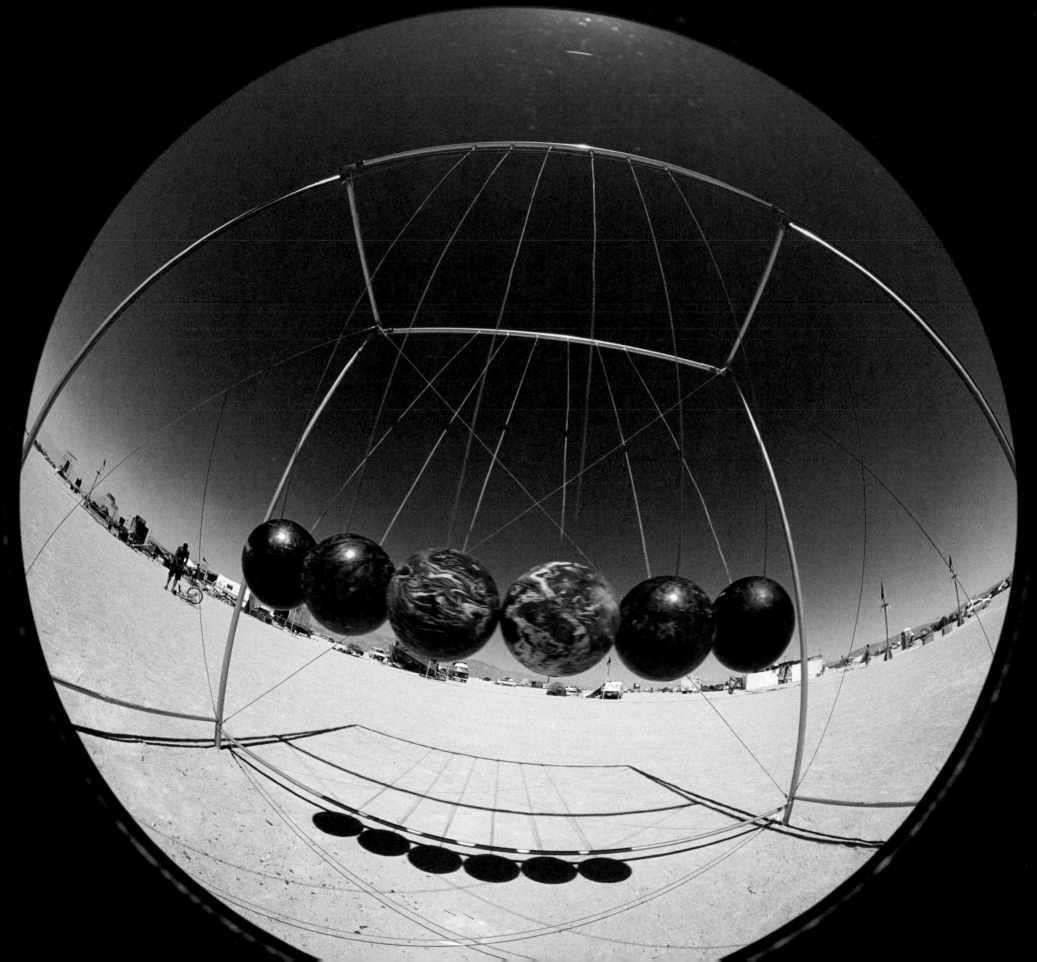

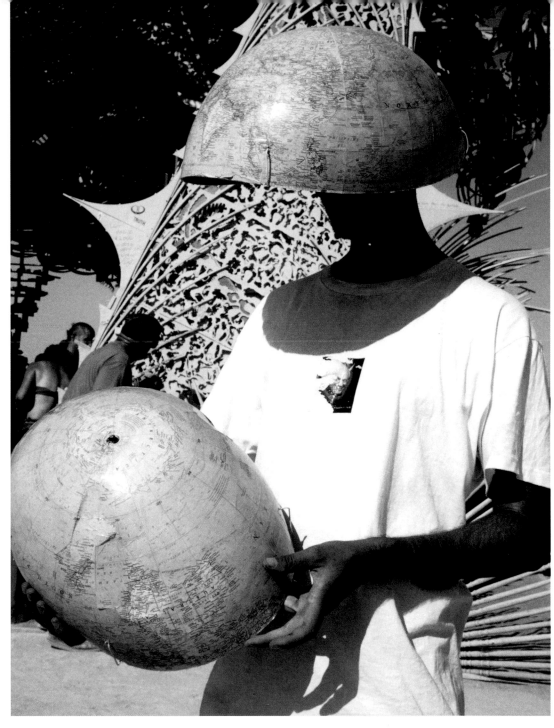

GLOBALISTA

KINETIC SCULPTURE
A giant version of the classic desktop gizmo made of steel tubes and bowling balls suspended from heavy duty string.

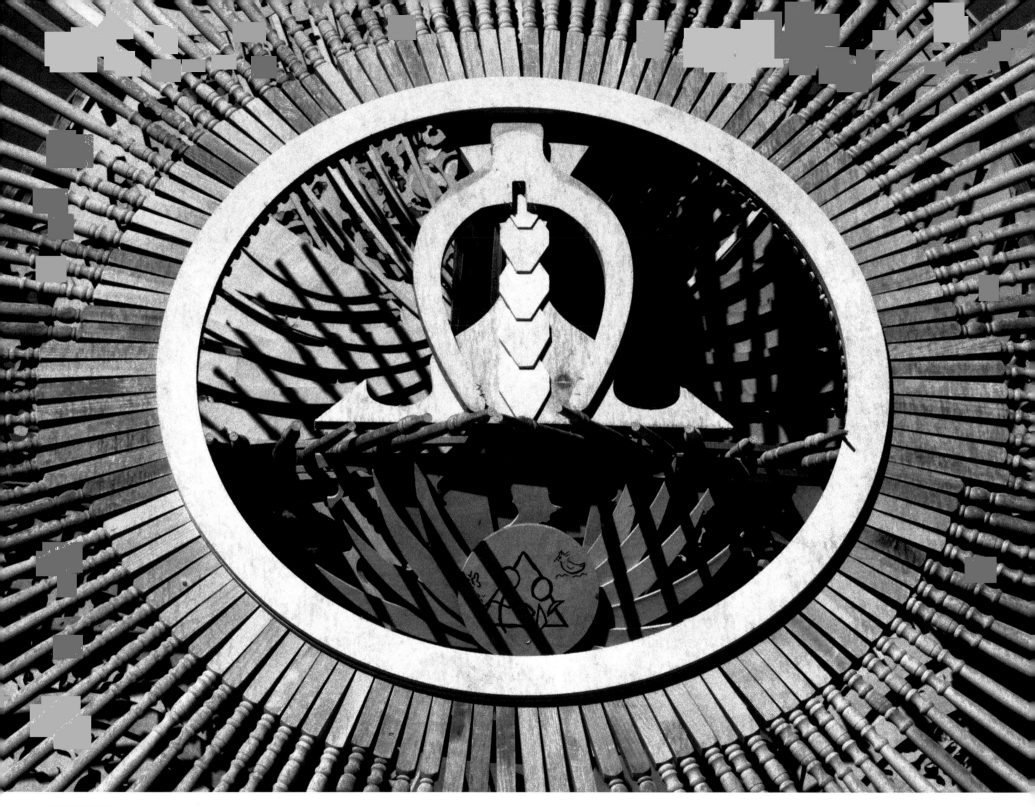

LUCKY CHARM
Detail from the *Temple of Joy*.

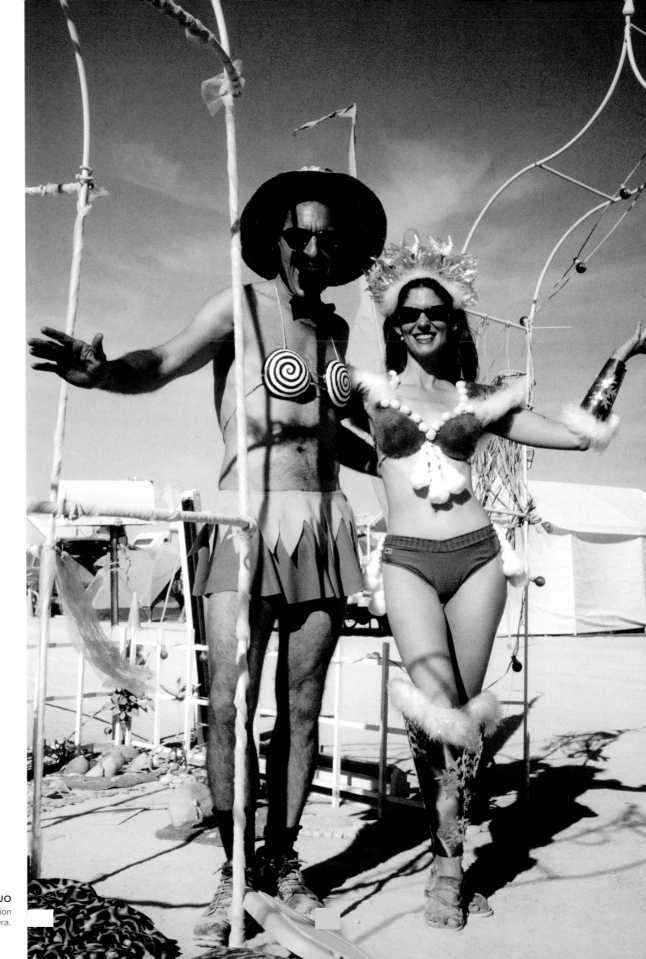

DYNAMIC DUO
Participants in the annual fashion show pose for the camera.

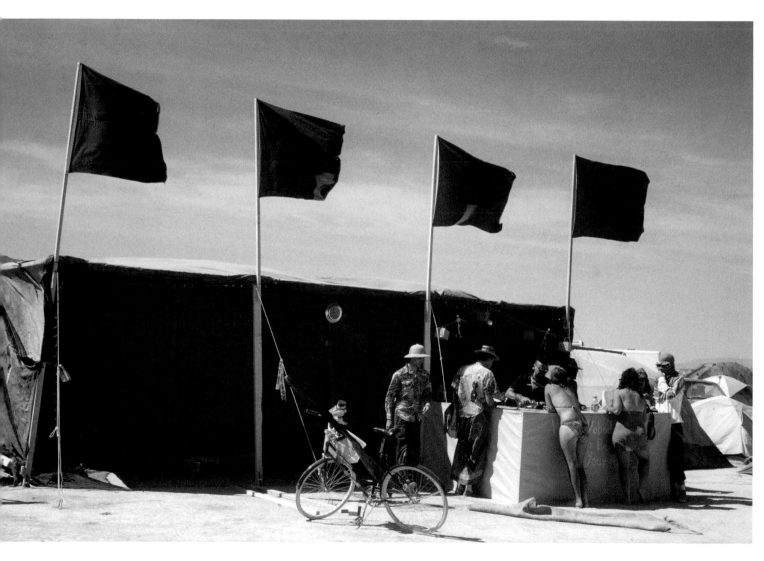

CAMP ABSTININTHE
Gathering at the bar for some mid-day cheer. Combine abstinence with absinthe and what do you have? Flavors like Anis, Apple, and Desert Breeze, which is mixed with ashes from the previous year's burn.

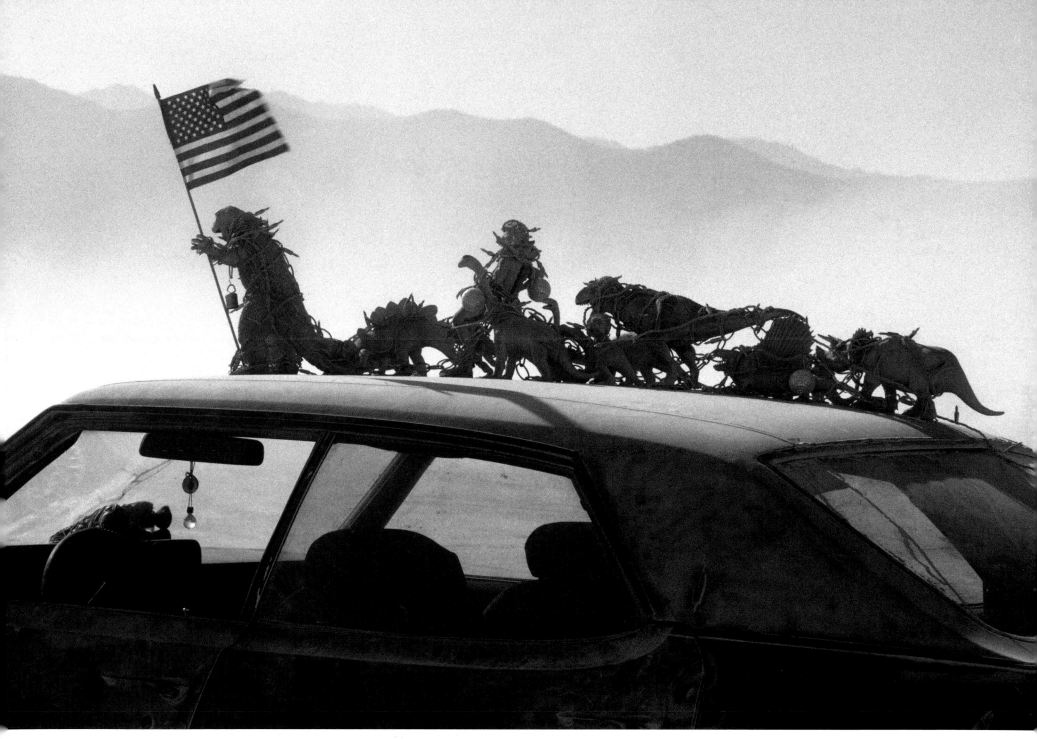

GAS GUZZLER
Cars like this Impala are relics from the last century.

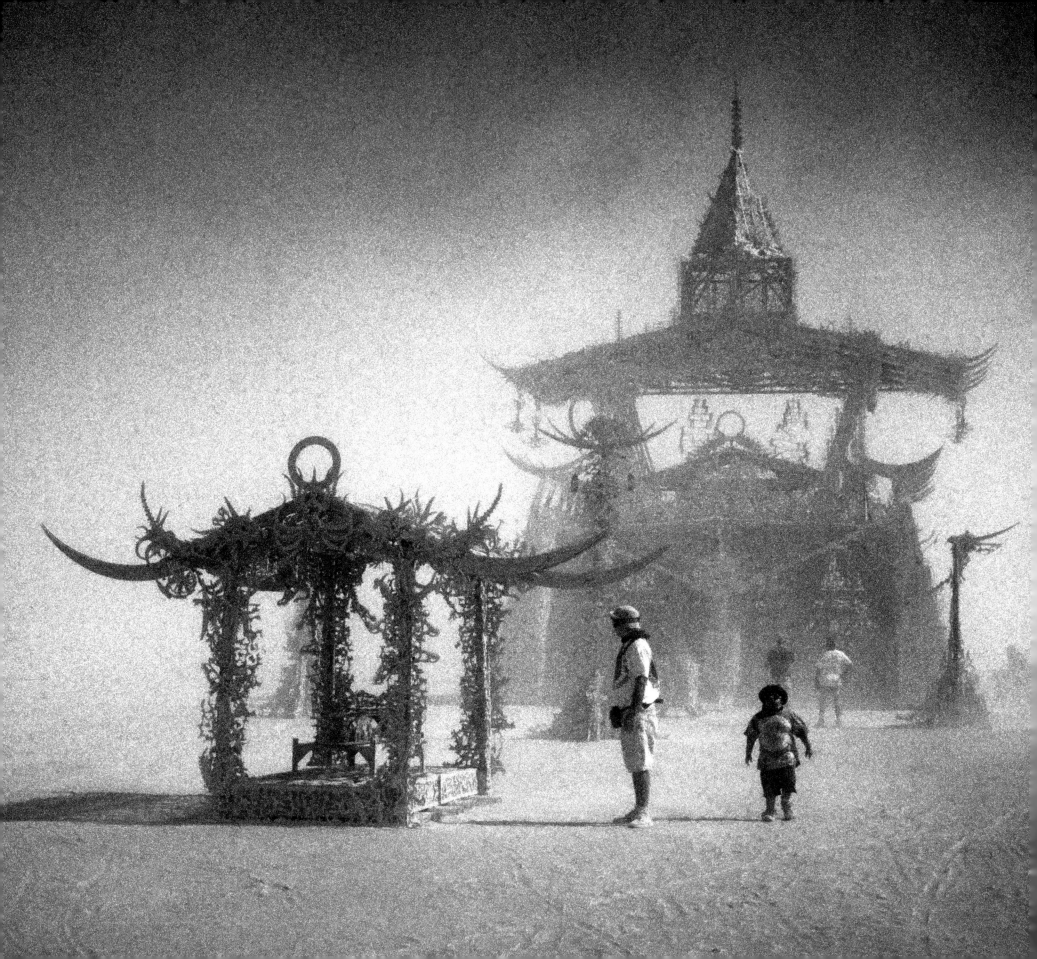

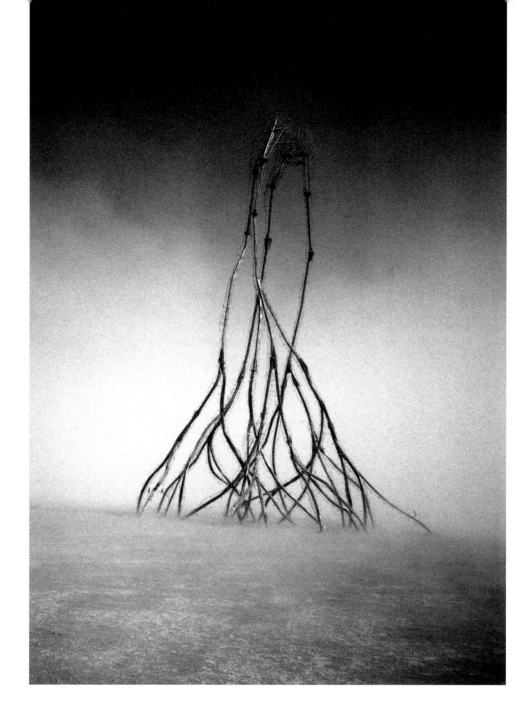

FLOCK

Michael Christian's 42' high sculpture was made of steel tubes bent into shape and welded together. Christian believes that this piece relates to the experience of being alone and lost in a large, overwhelming empty space—a place where you feel compelled to seek out and find your "flock"—though it seems to find you instead. *Flock* was subsequently on display in front of City Hall in San Francisco.

TEMPLE OF TEARS

Engulfed in a whiteout, this 2001 temple was built by David Best and crew. Burners would write messages on pieces of wood and leave them in the temple to burn on Sunday night. In 2005, with the support of the San Franicsco Arts Commission and the Black Rock Arts Foundation (the nonprofit arm of Burning Man), Best built a similar but smaller temple at Hayes Green (a small urban park) in San Francisco.

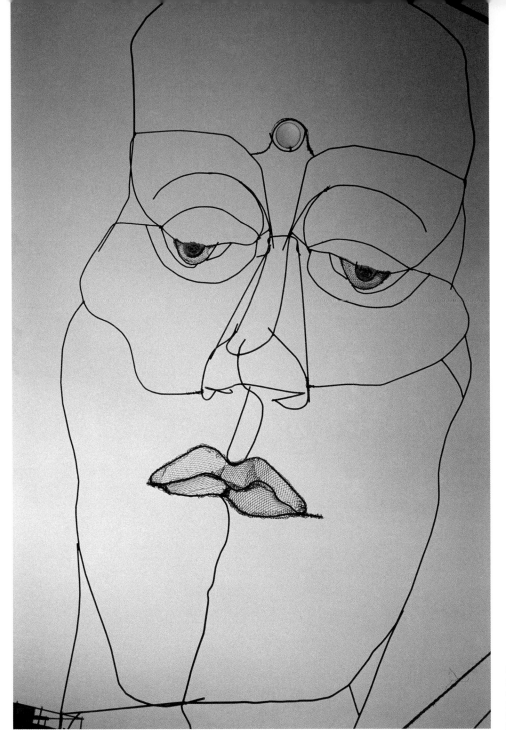

BUDDHA HEAD
Elise Fried's gigantic wire face sculpture portrays different expressions depending upon the angle of view.

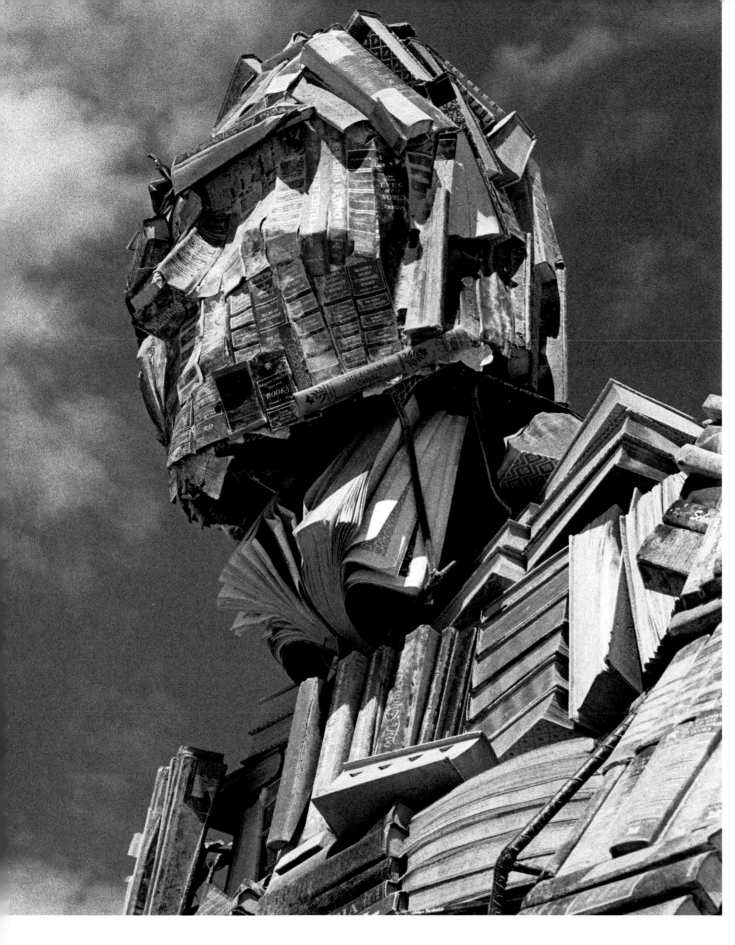

BODY OF KNOWLEDGE
Discarded books and rebar shape this enormous statue of a seated bibliophile by Dana Albany and Flash Hopkins.

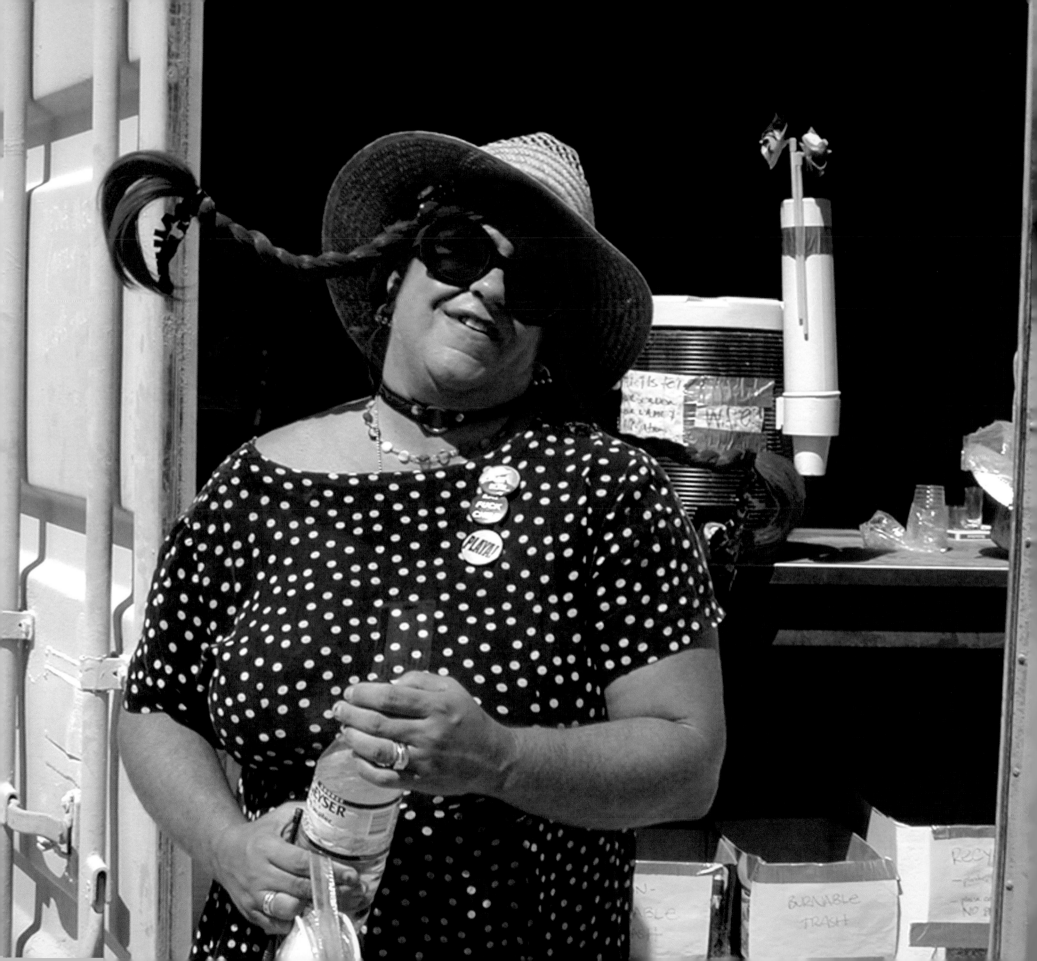

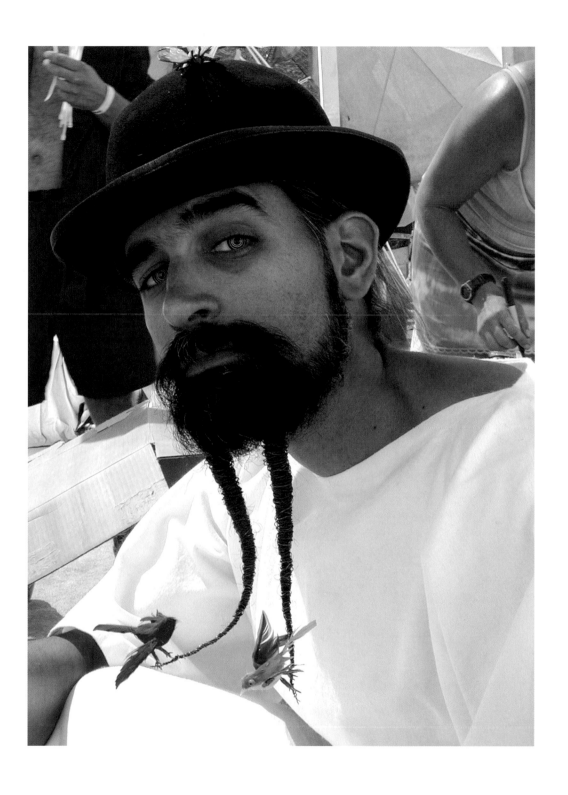

PIPPI (left), RA$PA (right)
These two burners have been
actively involved with the
Project for a long time.

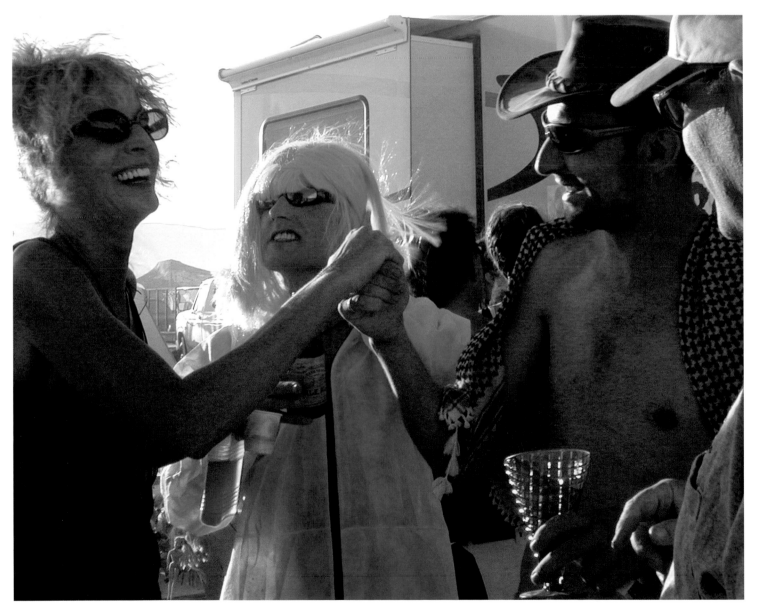

HAPPY HOUR

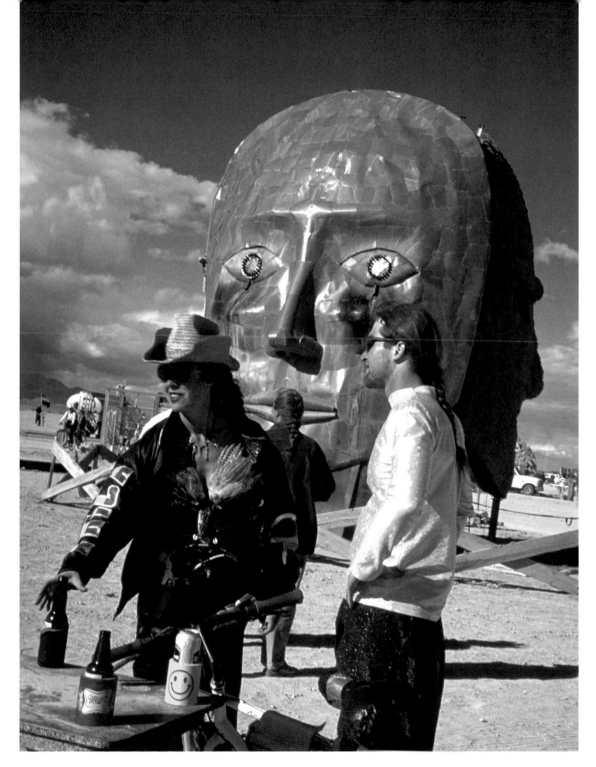

FACES OF MAN
Three heads made of copper, driftwood, and grass cry fire, water, and sand to music. Burn stains on the copper face were caused by gasoline that would pour out of the eyes and catch fire. This piece is one in a series of monumental art installations created by Dan Das Mann (and later on with Karen Cusolito) for Burning Man.

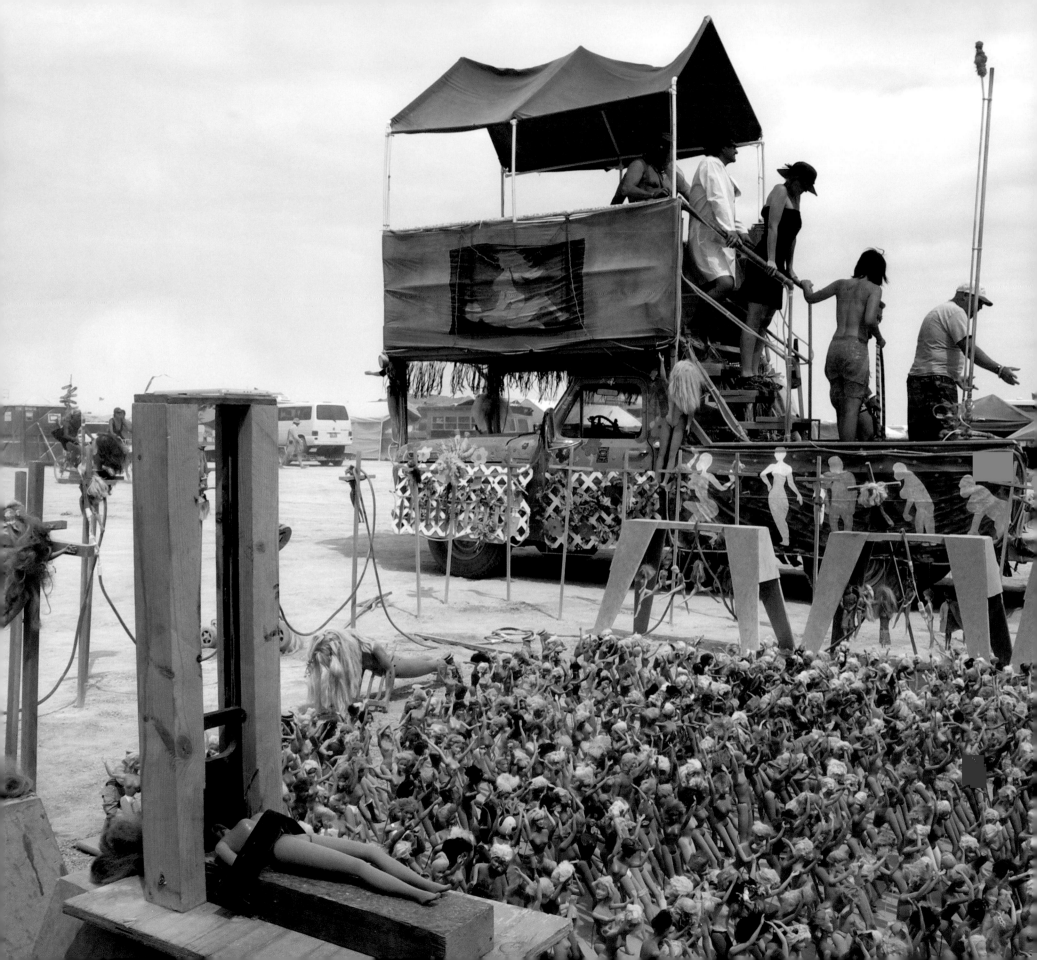

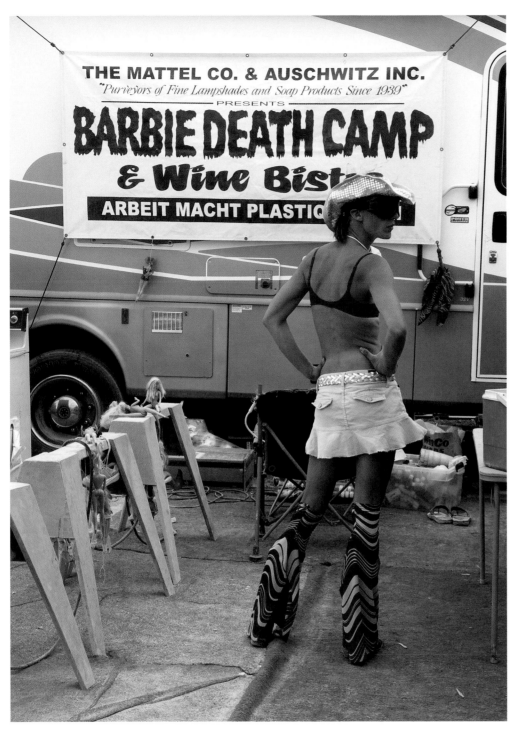

PRETTY IN PINK

THEME CAMP
Burners can sip fine wine in
Dixie cups while checking out
a display of more than one thousand
Barbies in various states of action
and expiration.

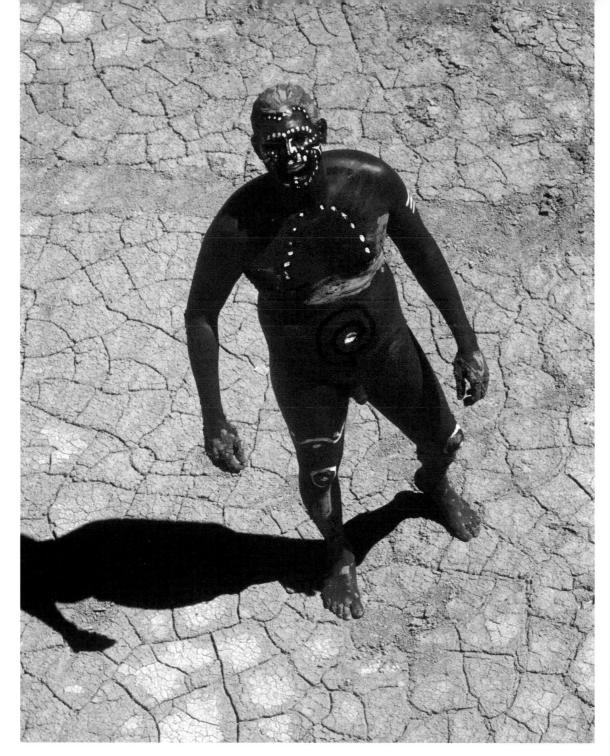

RED MAN
His body is painted in a way that suggests the style of Australian Aboriginal dreamtime art. In Aboriginal mythology, dreamtime is when the earth and patterns of life on earth take shape.

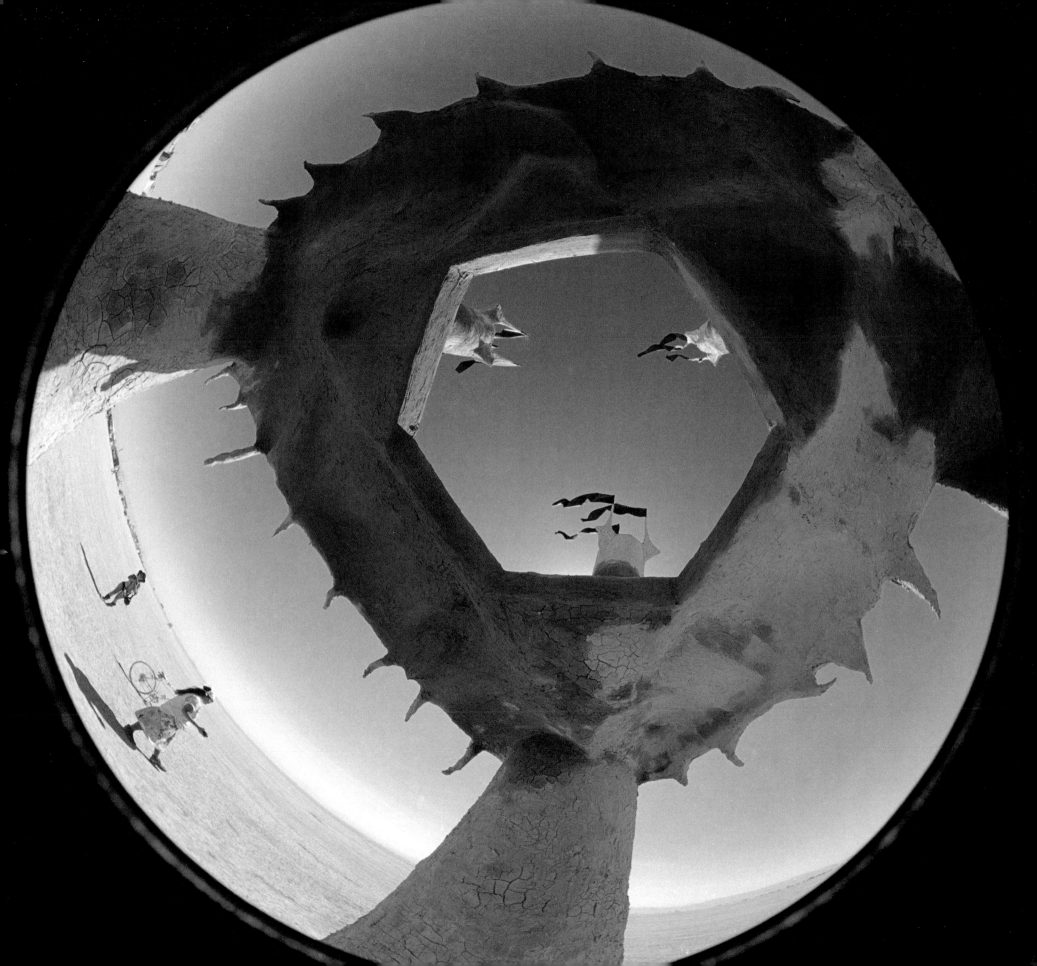

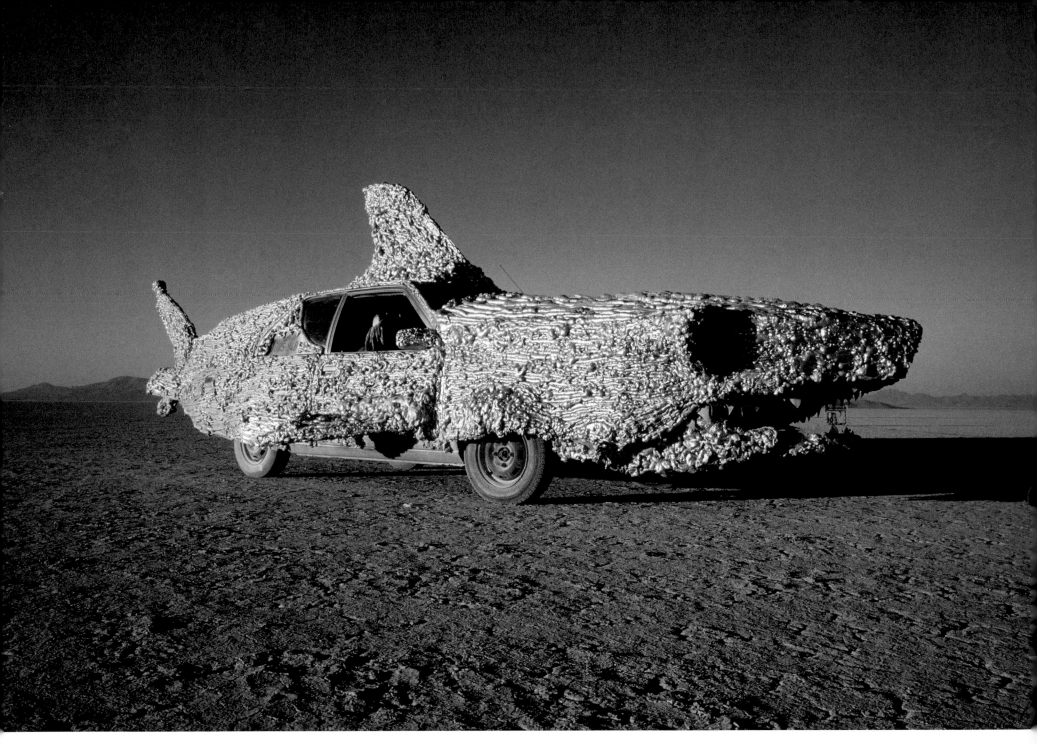

RIPPER

Ripper the Friendly Shark car by Tom Kennedy reveals very little of the
original Nissan Sentra as the custom-built frame and foam insulation create
a new look-and-feel. Inside the car, blue fluorescent light illuminates the
shark's belly and little rubber fish that dangle from the ceiling.

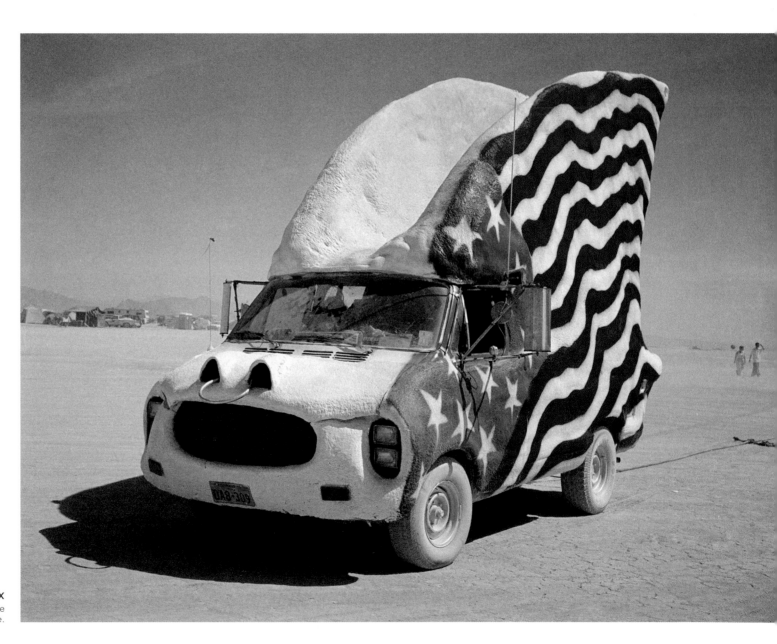

MAX
Tom Kennedy also created the
Daredevil Fin Mobile.

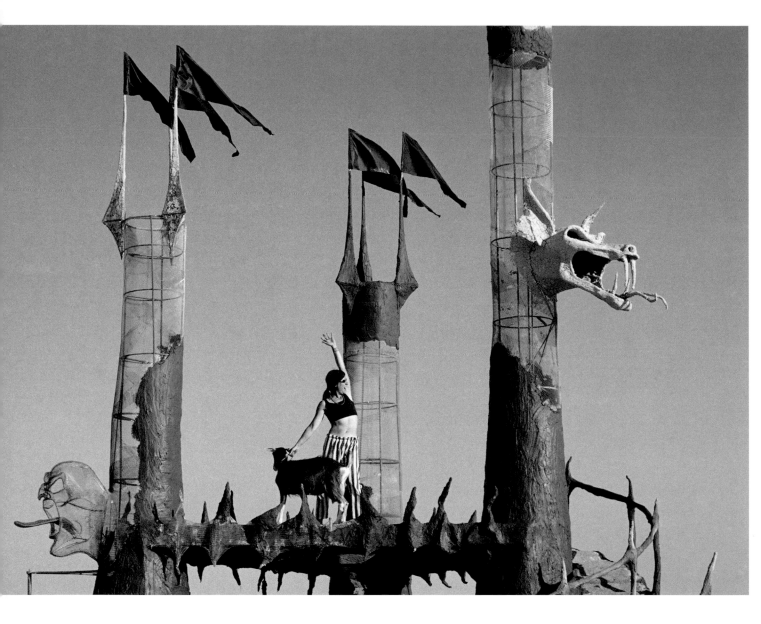

WARRIOR GIRL
WarriorGirl and Mephistopheles, the goat, salute Black Rock City from the *Towers of Dis*.

REHEARSAL
Dancers warm up for the evening's opera.

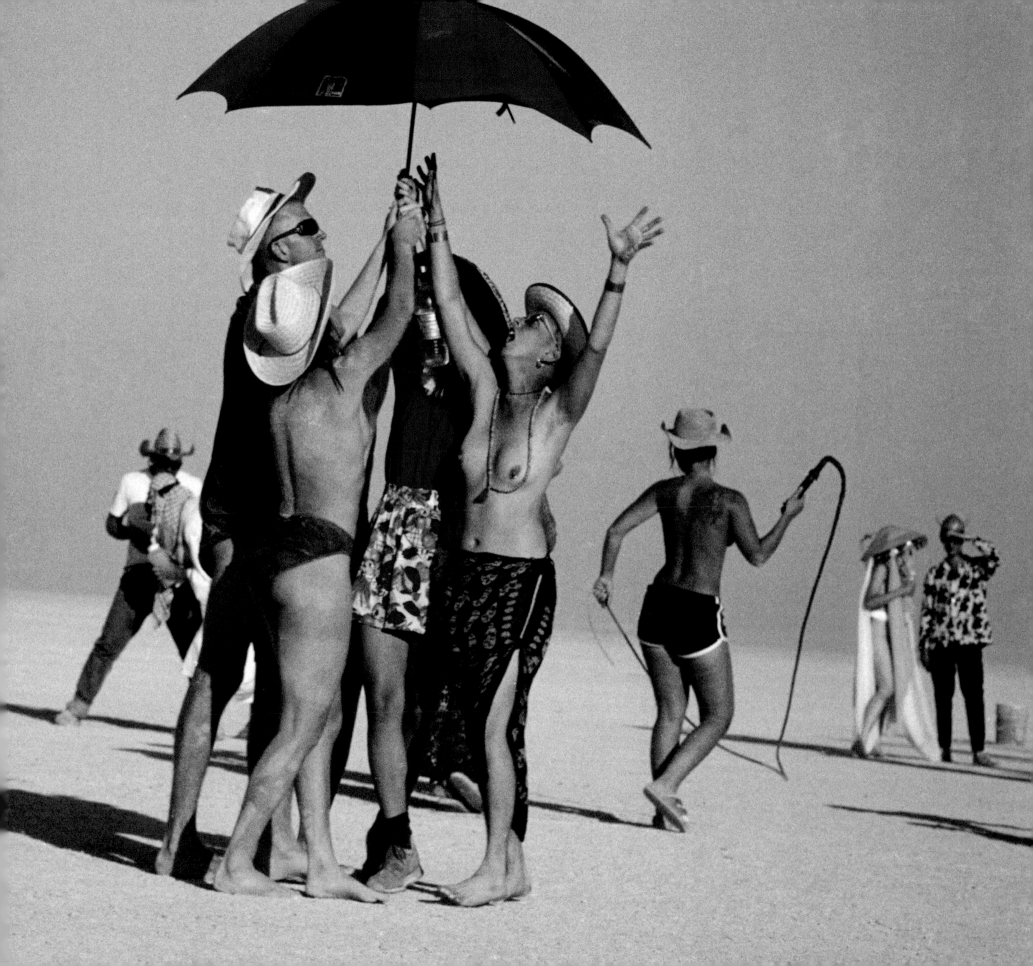

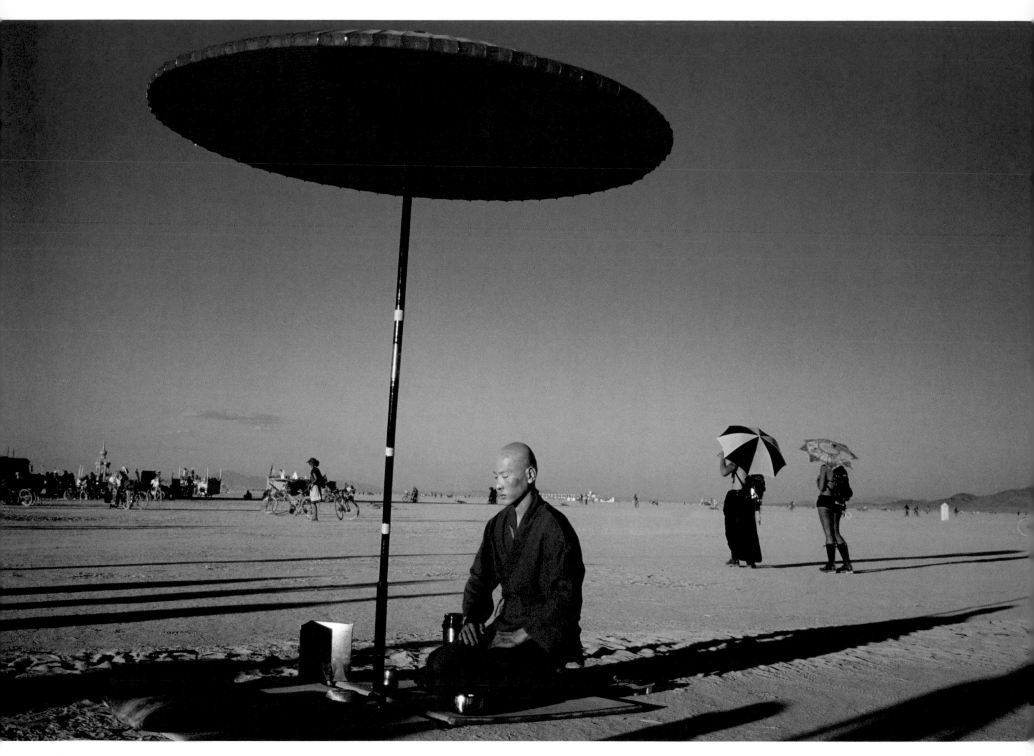

TEA TIME
Anyone can stop by for a cup of tea and some Zen with Ken.

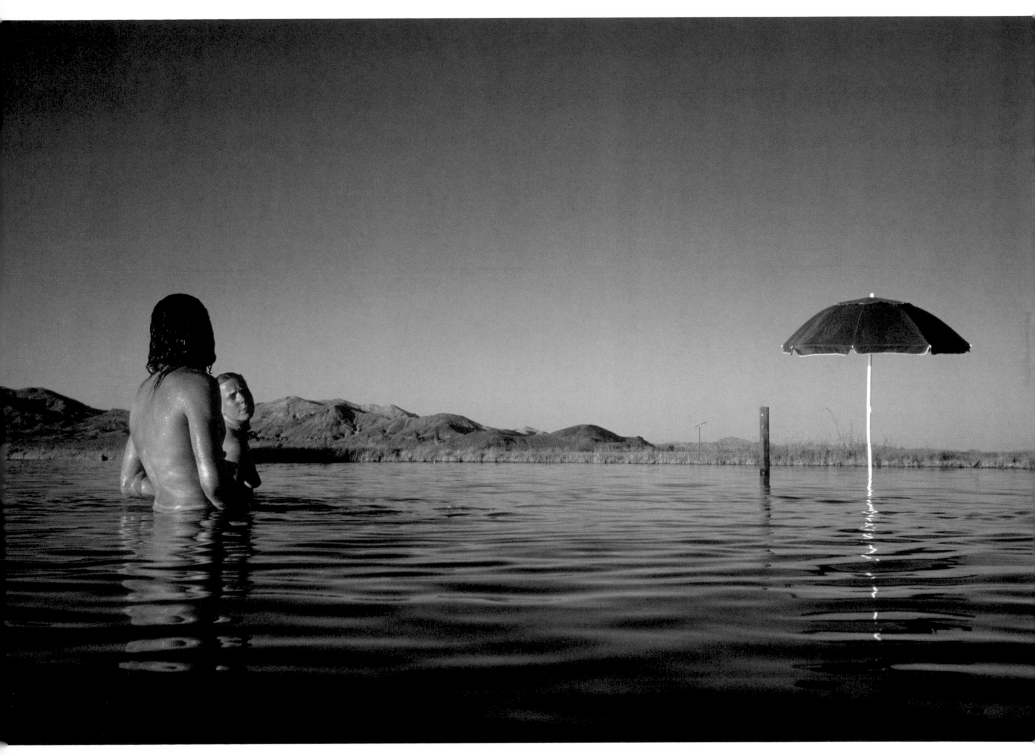

HOT SPRINGS
Due to the volcanic nature of Black Rock Desert, there are natural hot spring formations like this mineral water pool, which is great for a soak and some sun or shade.

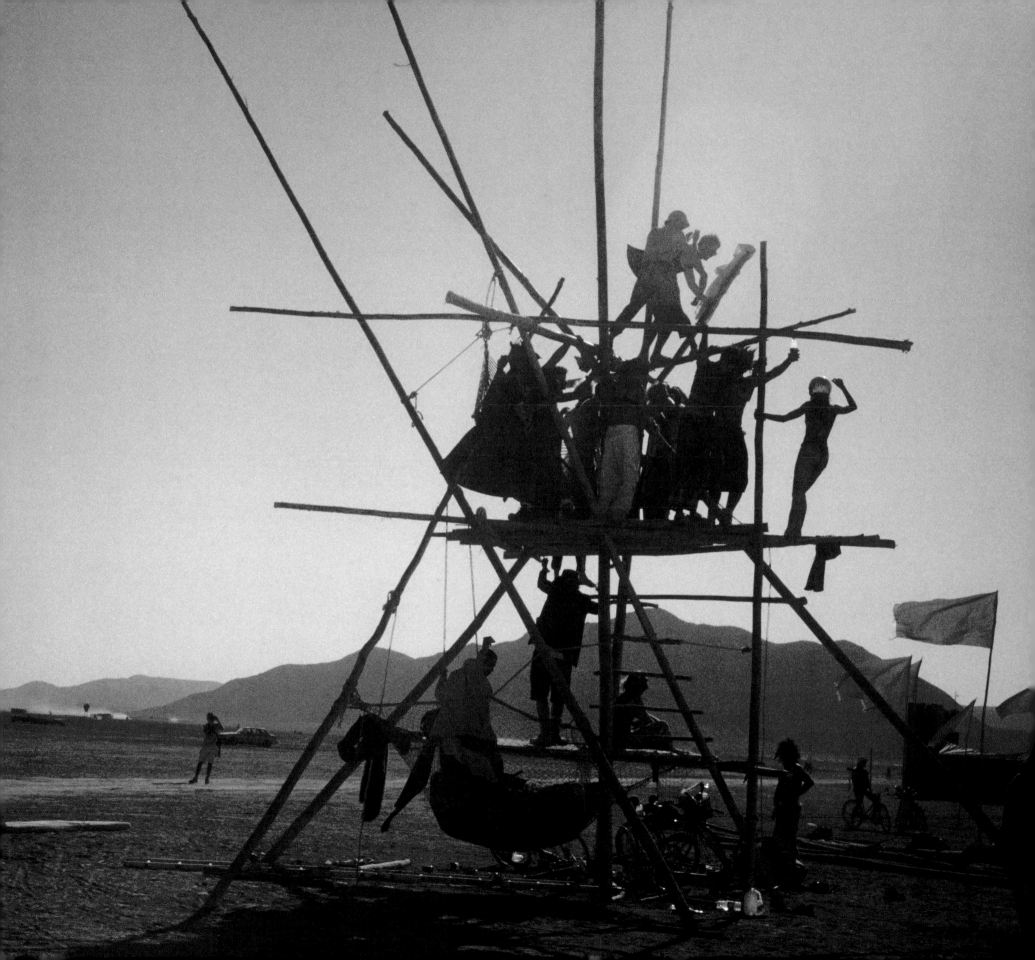

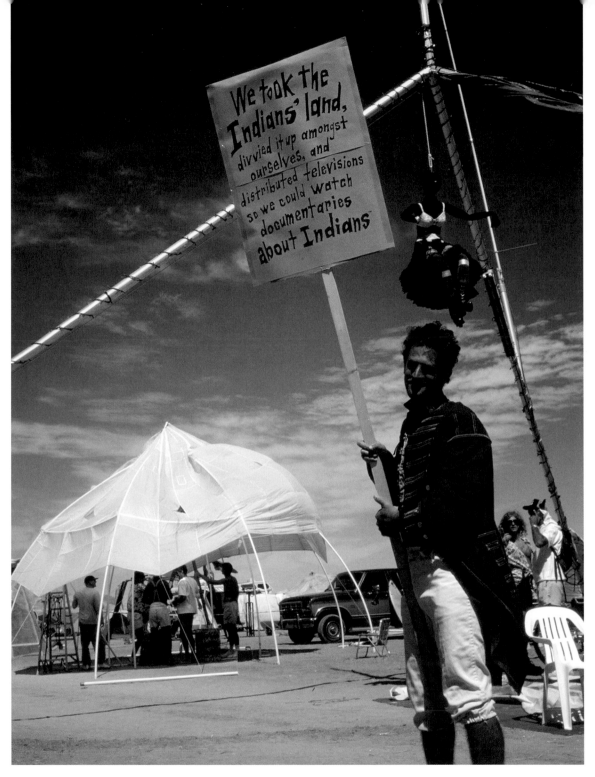

PROTEST

RAVE
Burners at *Camp Oz* are
still at it the next morning.

101

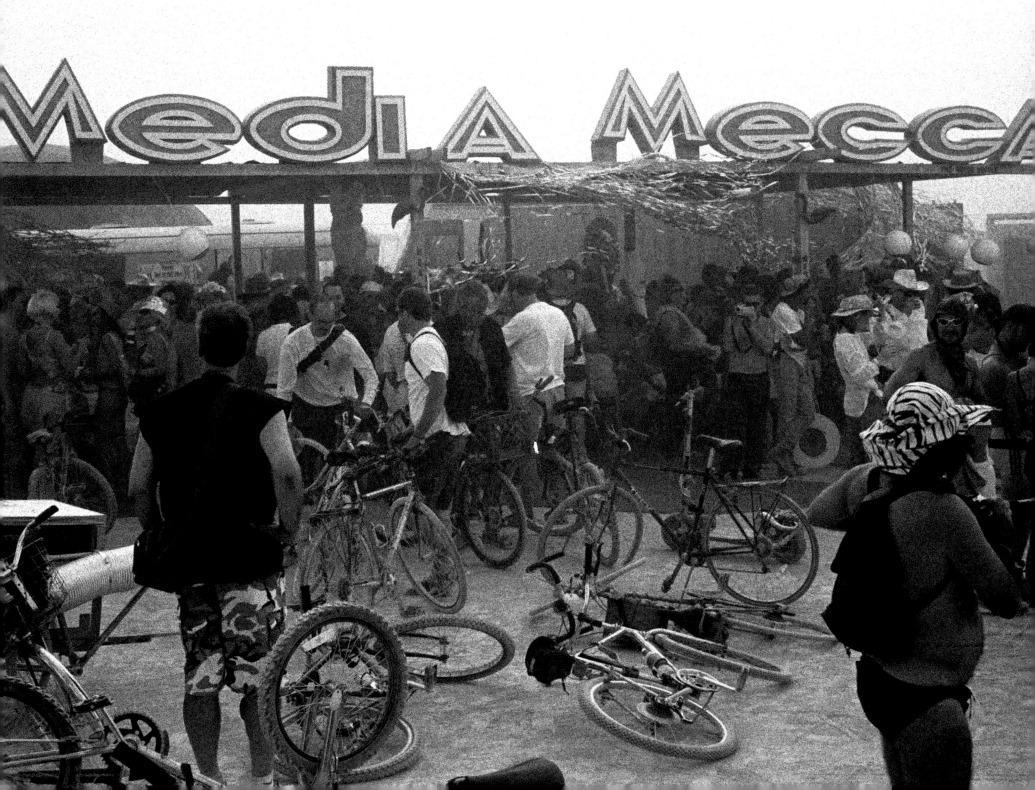

DANGER RANGER

Danger joined the Project in 1990 and two years later founded the Black Rock Rangers who oversee the safety and survival of the Burning Man community. As a member of the the board, he represents BMorg in the virtual world of Burn2... and is also known as M2, guiding light of SF Cacophony Society, a randomly gathered network of individuals united in pursuit of experience beyond the mainstream.

PRESS ROOM

Home base of Black Rock City's press team run by "Maid" Marian Goodell and staff. Reporters from around the world gather here to meet, greet, drink, cheer, and chat.

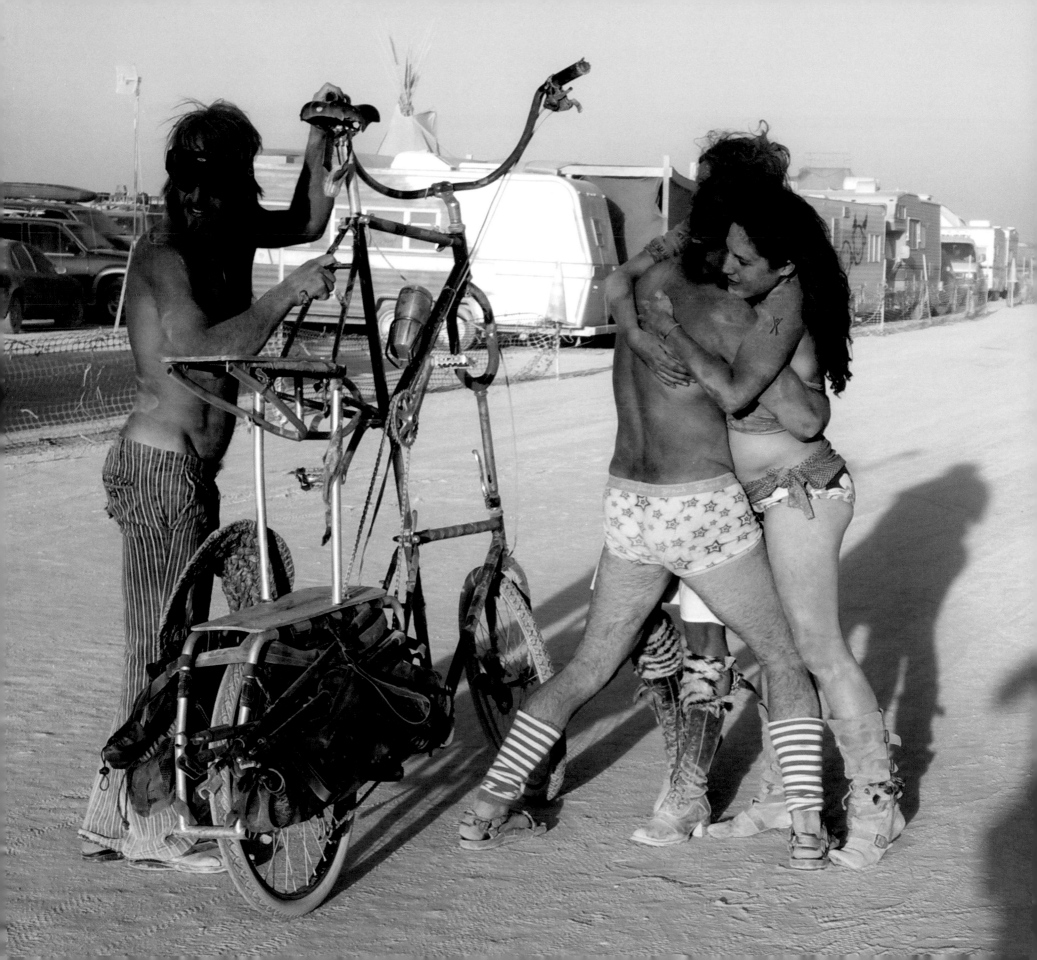

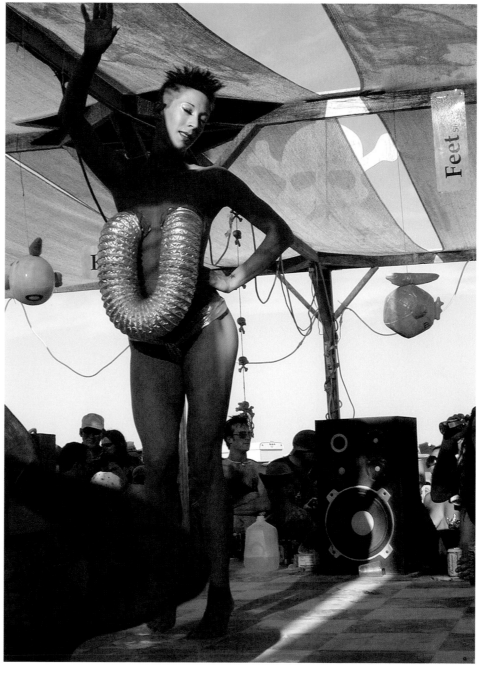

PASSION FASHION

MAGIC HOUR
The time of day when the light turns golden and the sun casts long shadows. The tall bike was constructed by welding together parts of one bike on top of another.

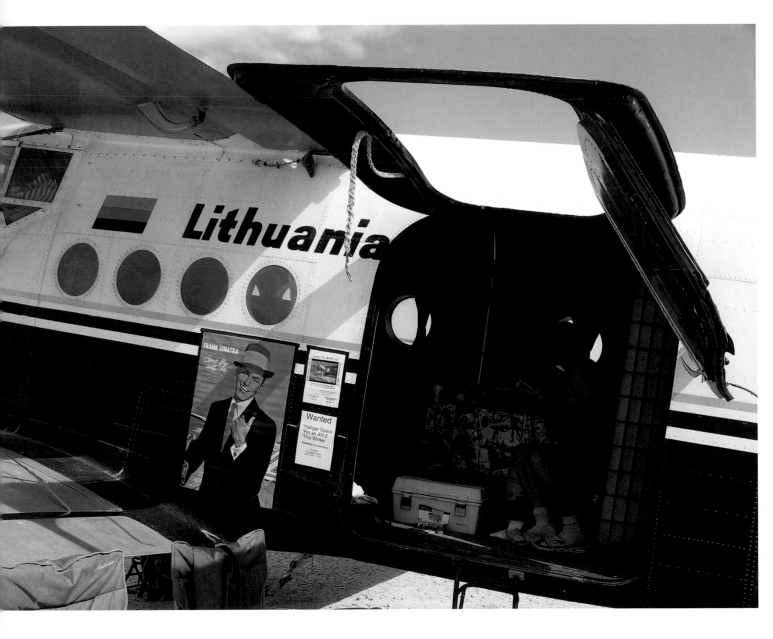

BIPLANE
Burners who fly
into Black Rock City
camp out at the airport.

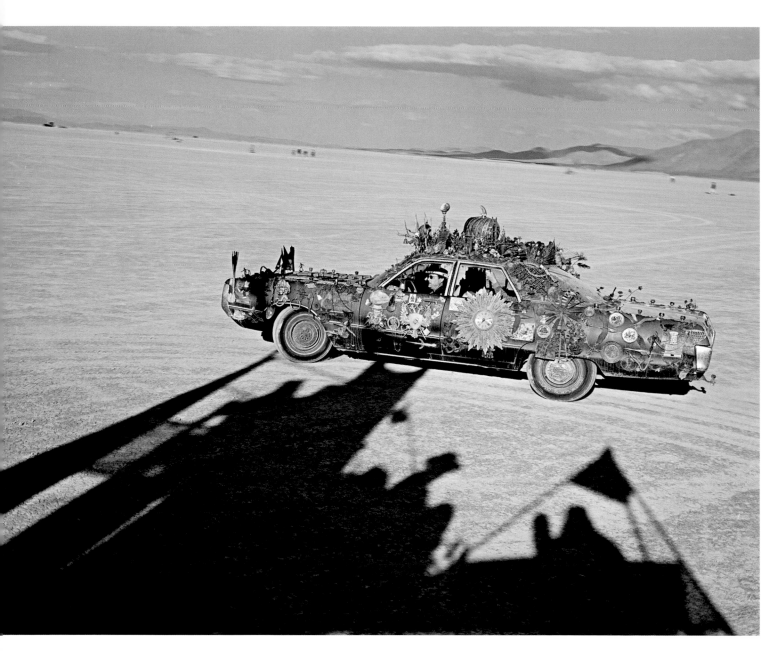

JESUS CHRYSLER
Reverend Linville's art car was photographed from inside the pyramid of another art car seen here in shadow on the playa.

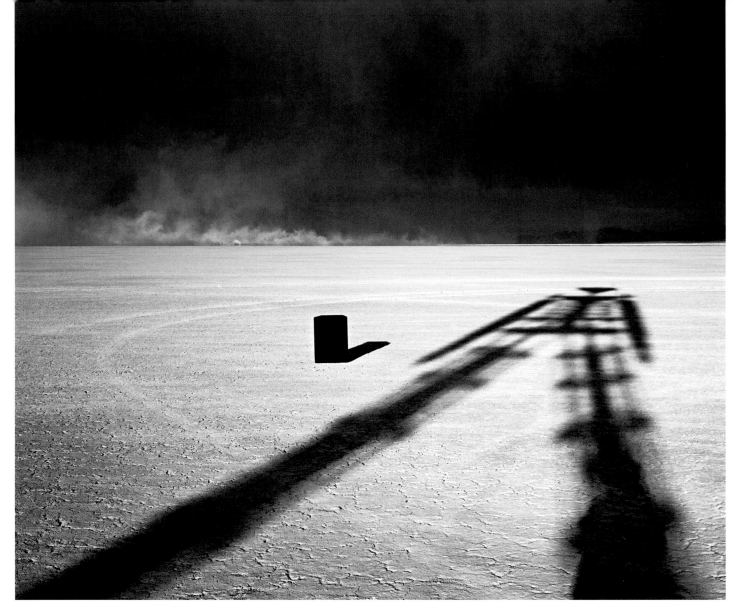

RIDDLE OF THE SANDS
Late in the afternoon under a storm-filled sky, the shadow of the Man stretches out on the playa next to a speaker box. In the distance, a car kicks up a trail of dust. This photo was taken around the same time as the color version on the cover.

109

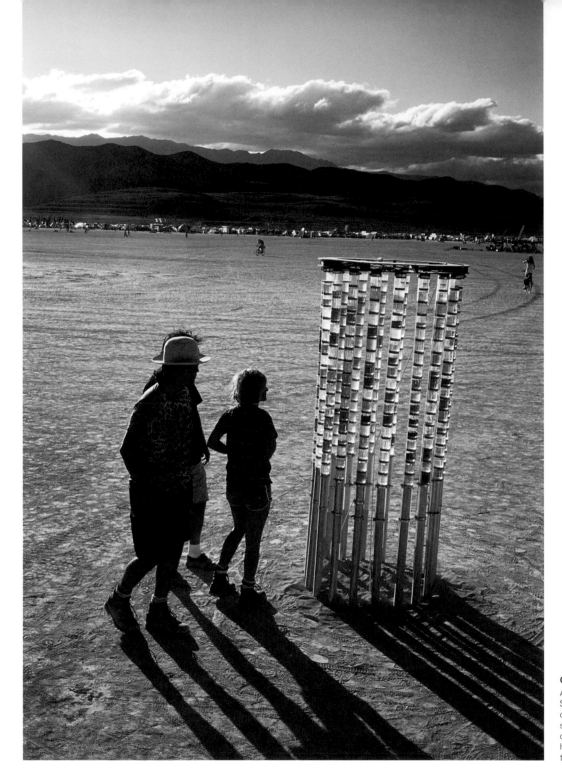

GOLDEN TOWER
A sculpture created by Susan Robb featured jars containing urine of different shades that were lighter or darker depending on how hydrated or dehydrated the person was.

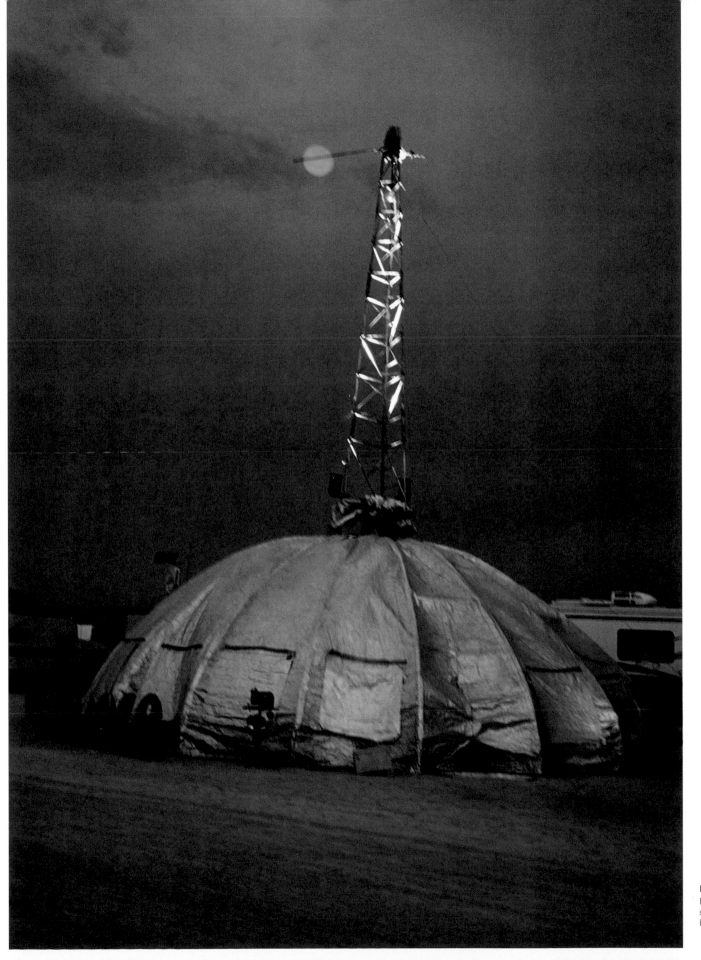

DOME
Inside the dome is one of
several radio stations that
broadcast at Burning Man.

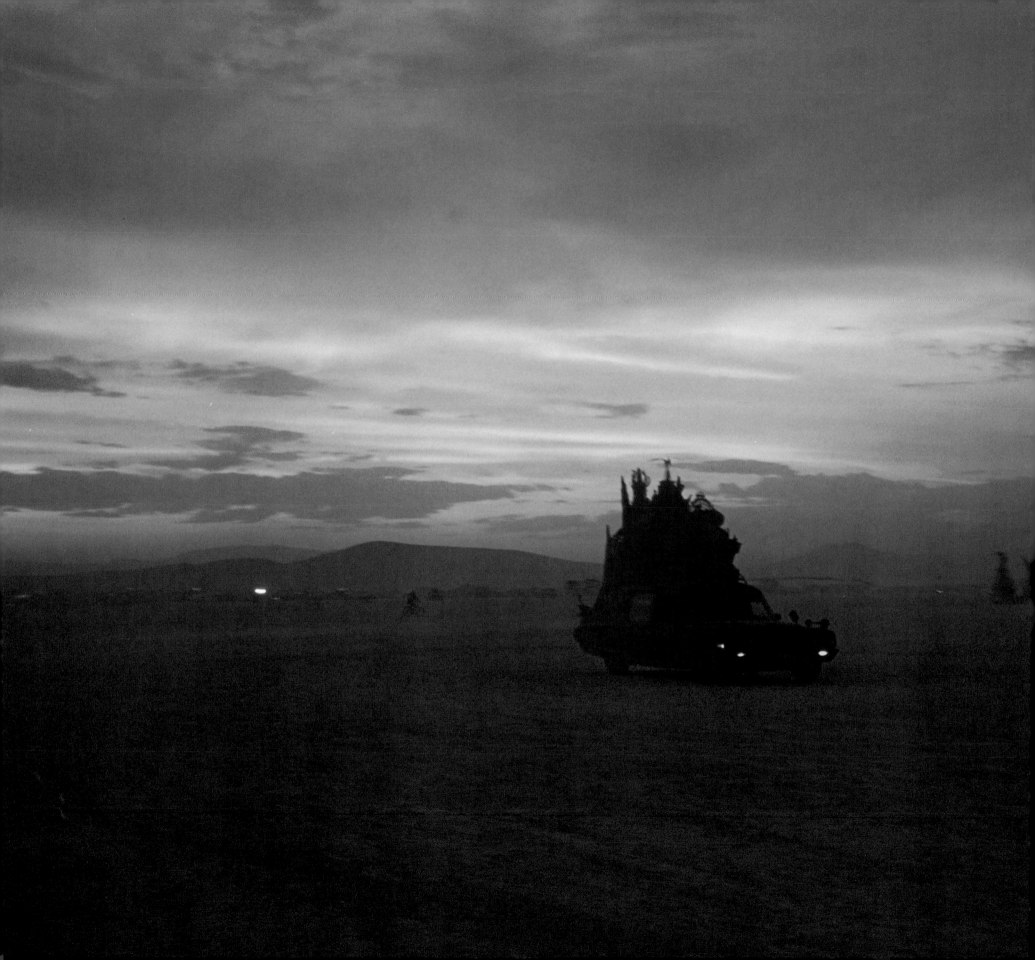

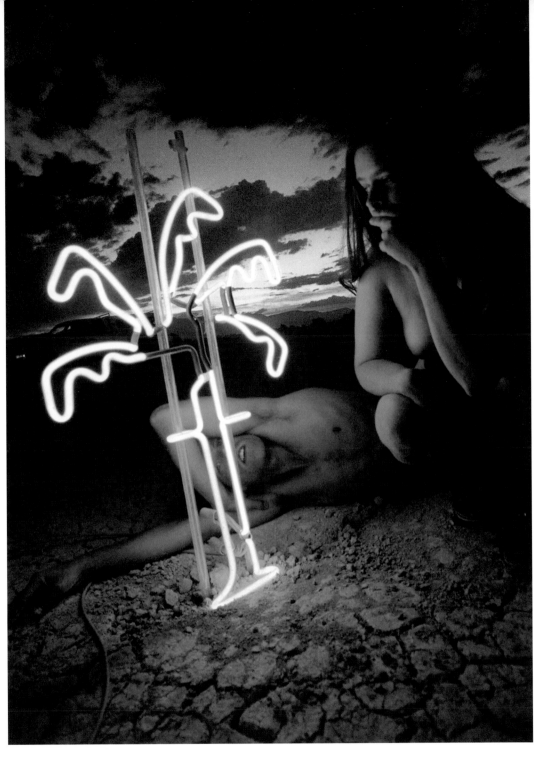

PARADISE

CARTHEDRAL

What began simply as a coffin on top of a Cadillac hearse evolved into a gothic cathedral. Rebecca Caldwell placed a VW bug on top of the hearse and adorned it with stained glass windows, spires, flying buttresses, and gargoyles.

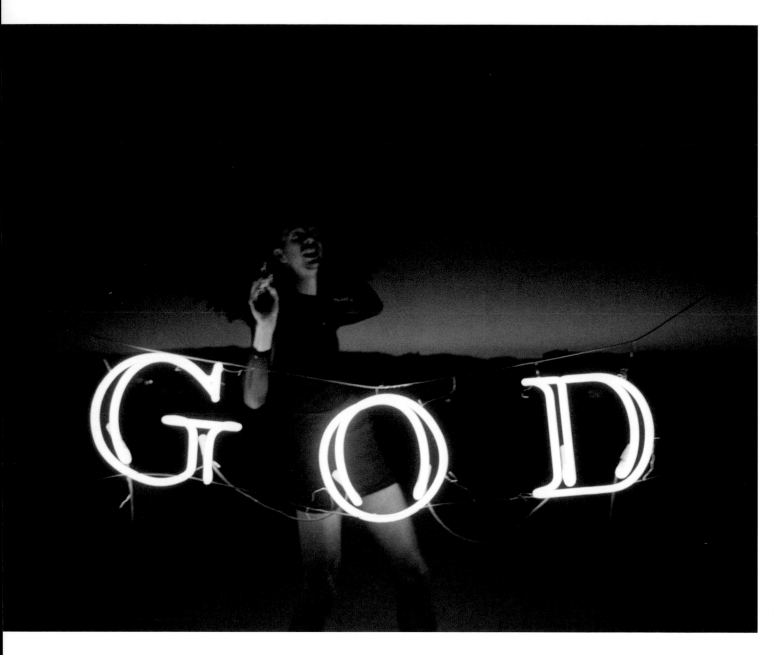

DEITY
This person dressed in black with a big hat stepped suddenly into the frame an instant before the shutter clicked.

TWILIGHT
Three burners gaze at the sunset from beneath the Burning Man, a statue that towers like a beacon over Black Rock City.

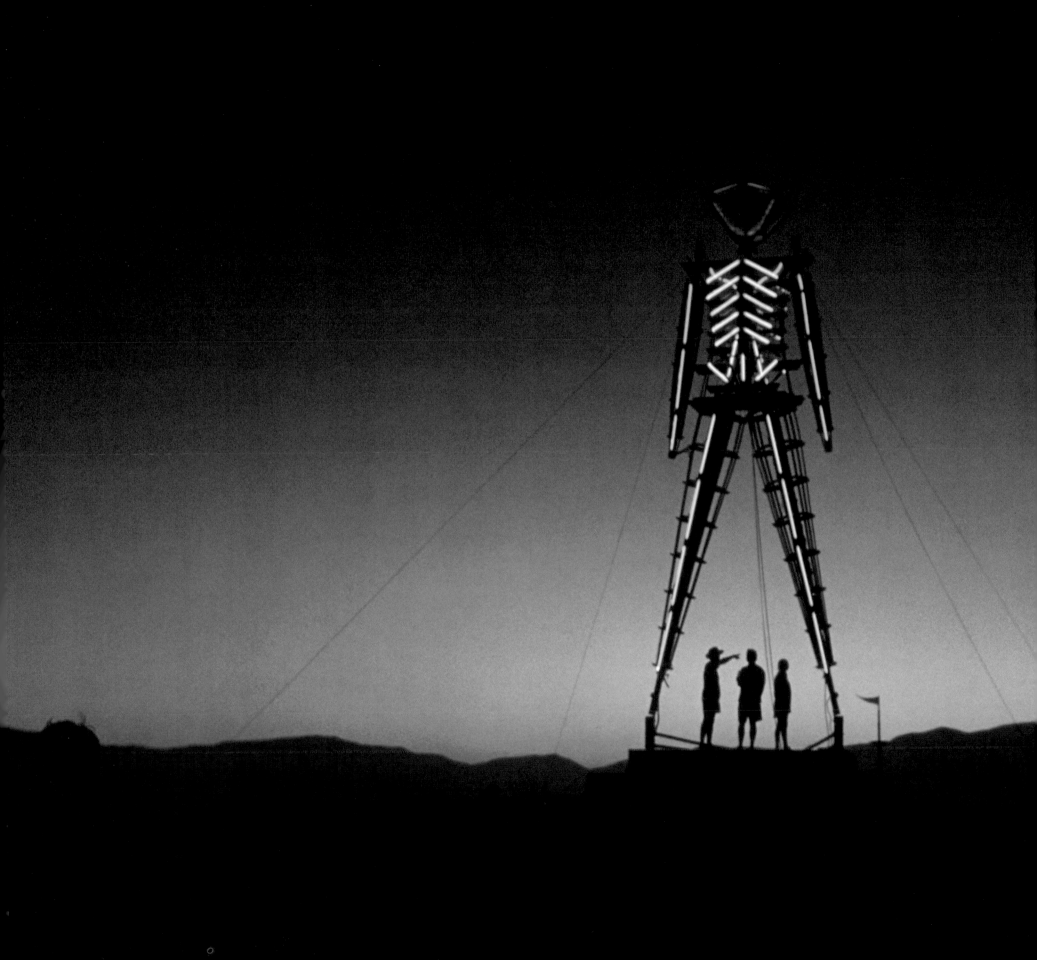

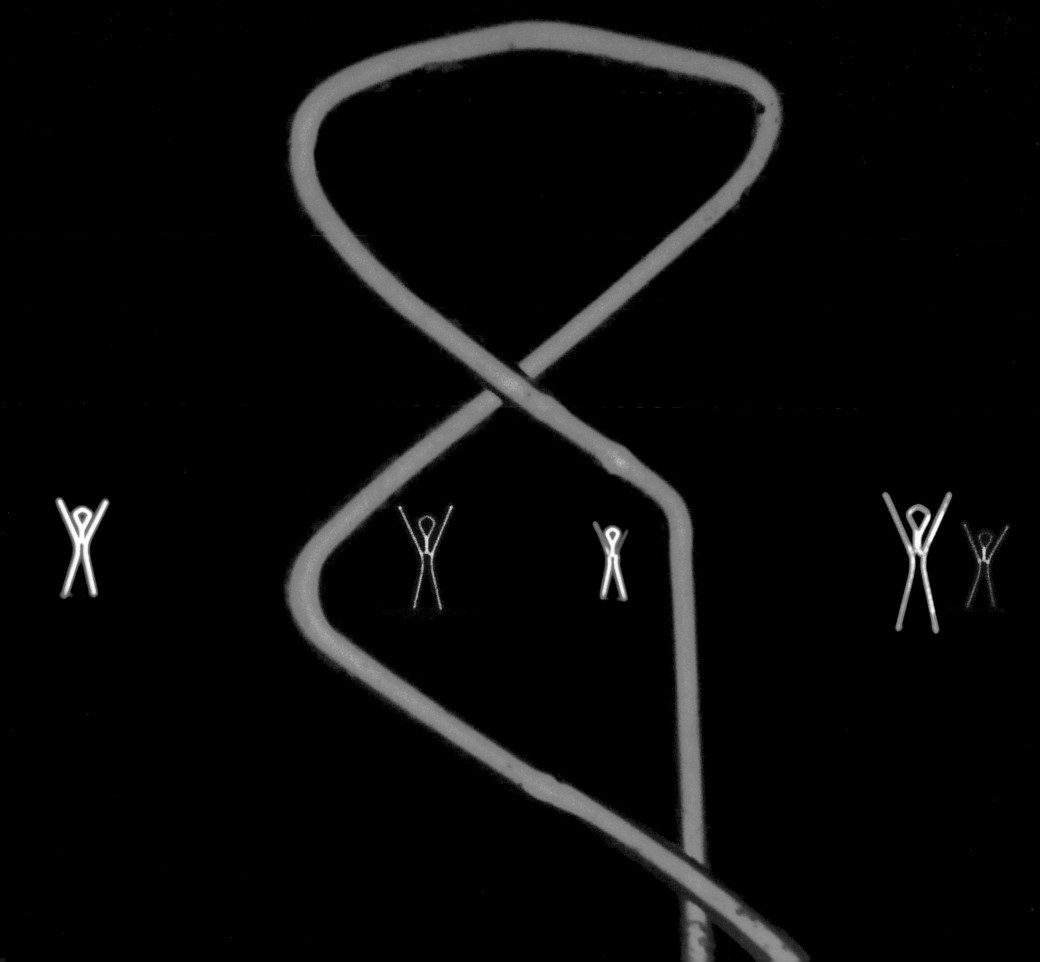

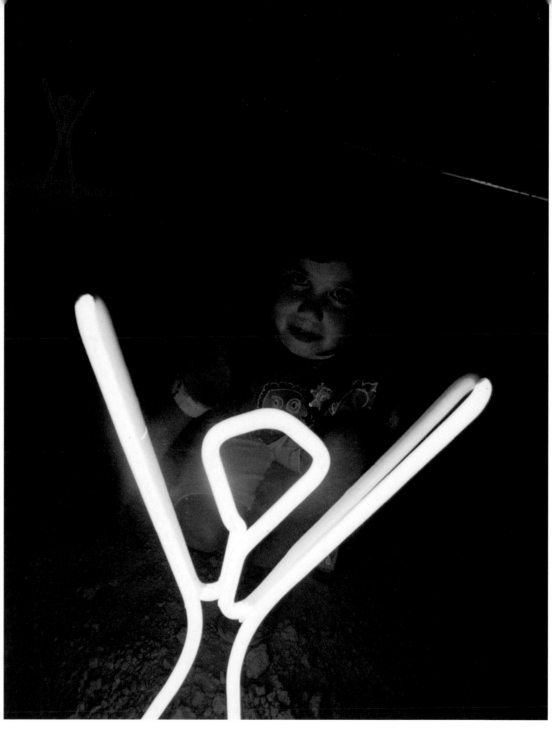

CHILDREN OF LIGHT

INFINITY
Neon statuettes pictured here
were part of an installation by
Steve Yonkman.

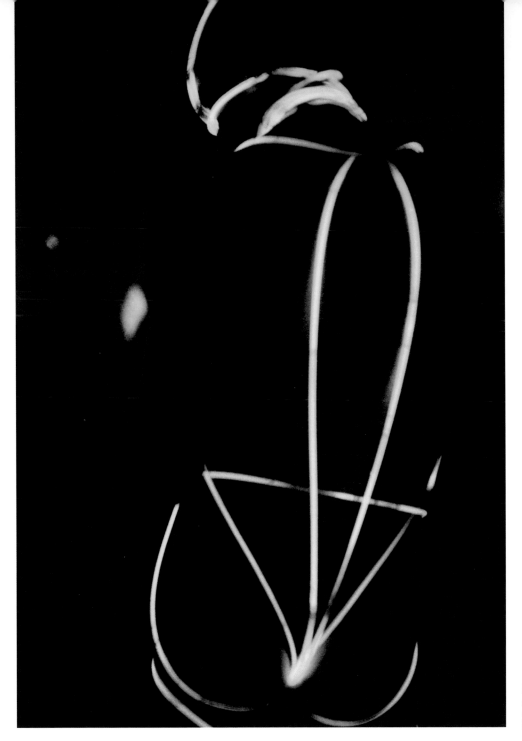

BODY ELECTRIC
A figure fashioned in a costume inspired by Burning Man appears in silhouette.

STREAK
Nudes bathed in light from neon tubes placed on the playa appear submerged underwater beneath the dusk from above.

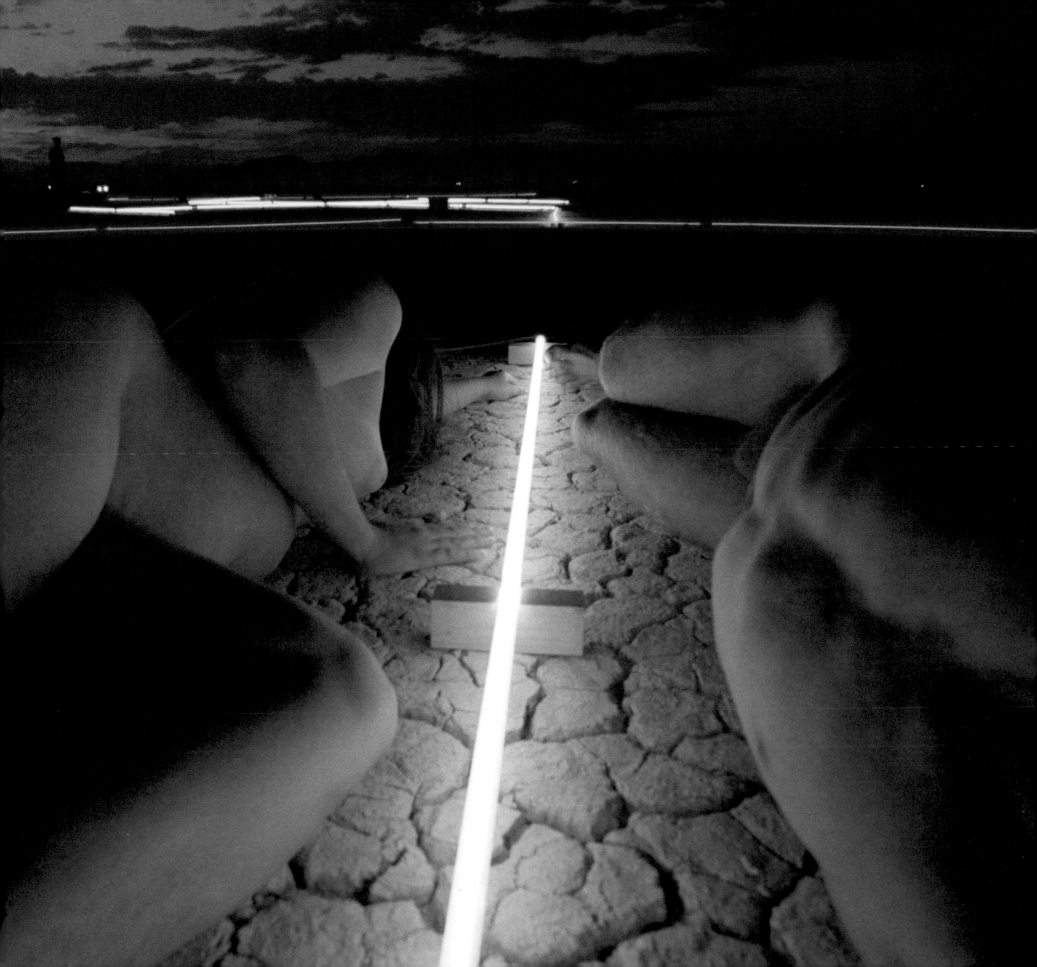

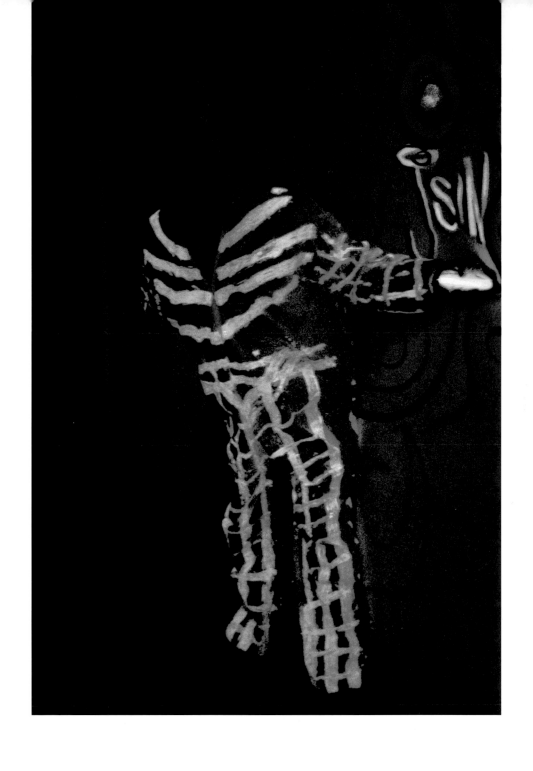

COWGIRL (left), FANTOM (right)

Black light is a form of invisible light
that causes fluorescent paint and certain
whites to glow in the dark.

STUD
Body suit made entirely
of glow sticks.

FLAPPER
An EL (electroluminescent) wire sculpture on wheels was attached to the rear of a bicycle. As the cyclist rode around the playa, the penguin appeared to waddle behind.

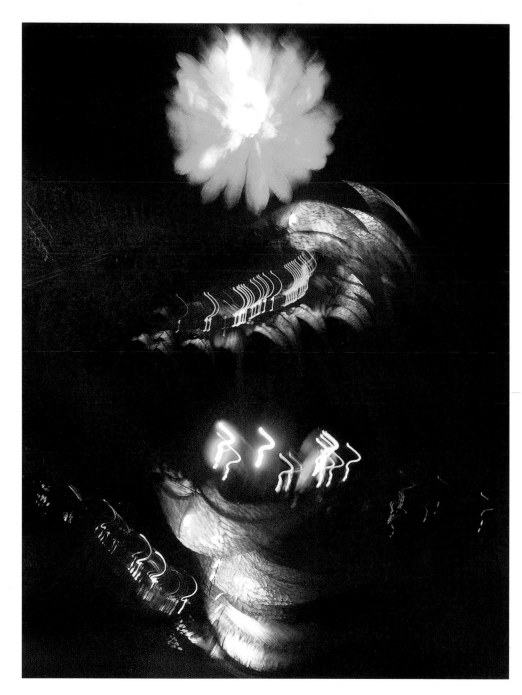

SYNERGY
Hope Flower and *Fear Trap*, built over cherry pickers, roam the playa together. These 100-foot-tall mobile sculptures were created by Patrick Shearn, Abundant Sugar, and the DoLab.

DRAGNONFLY
Detail from *Love and Dragons* mobile installation of illuminated sculptures by Sean Sobczak.

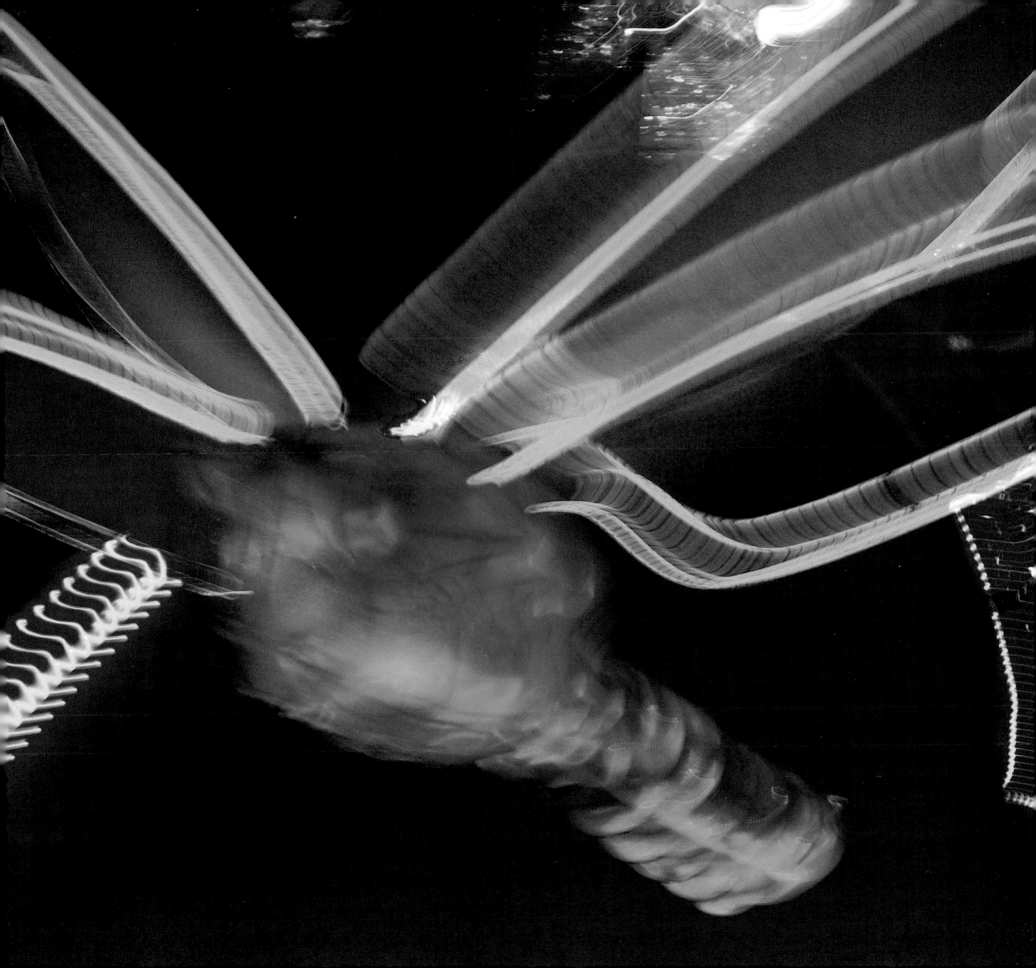

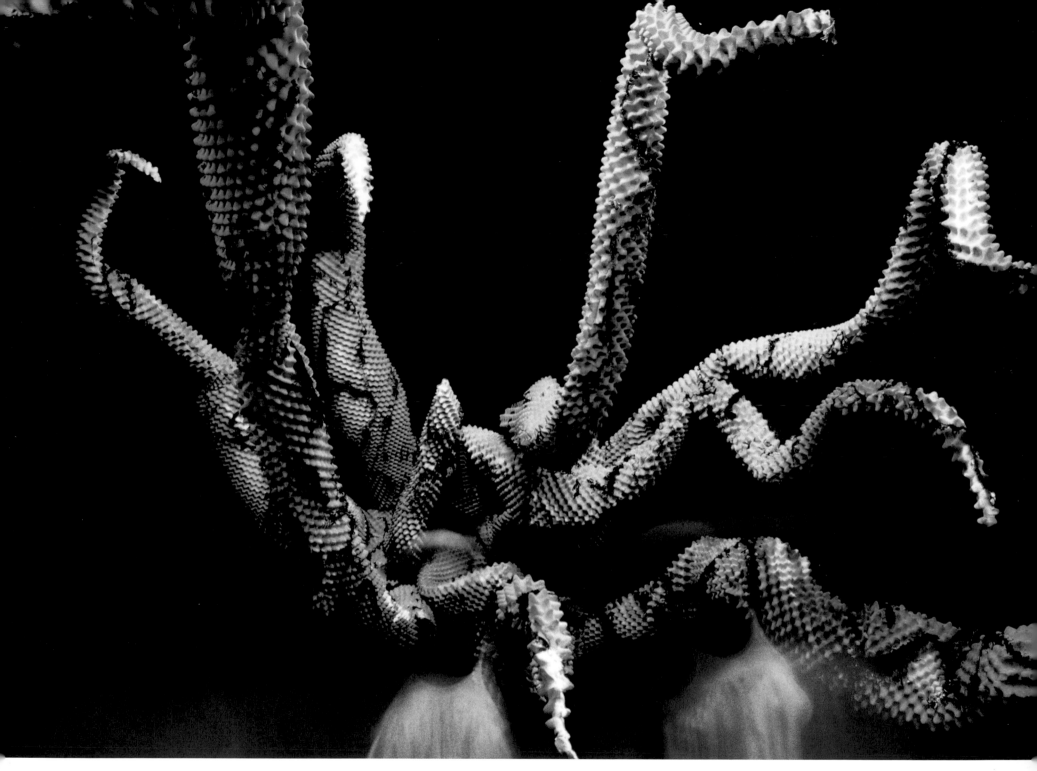

NEBULOUS ENTITY

Dana Albany created this black lit, suspended installation specifically
for Burning Man in 1998. Earlier that summer, it was also displayed as
part of the Burning Man exhibit at the San Francisco Arts Commission.
The figures in the photo are me twirling around during a long exposure.
The tentacles are timed to undulate at automated intervals.

RIPPLE EFFECT
Before the sculpture of Burning Man was hauled out to the desert one year, it was on display overlooking a pool at SomArts Gallery in San Francisco. This reflection was created by stirring the water in the pool.

BLUE RIBBON
Long camera exposure
of the Man taken while
panning the camera
from right to left. There
are gaps in the neon
because it flickers.

STARFISH
EL wire sculpture made for
the 2002 *Floating World*
theme. In prehistoric times,
Black Rock Desert was the
bottom of a great inland sea.

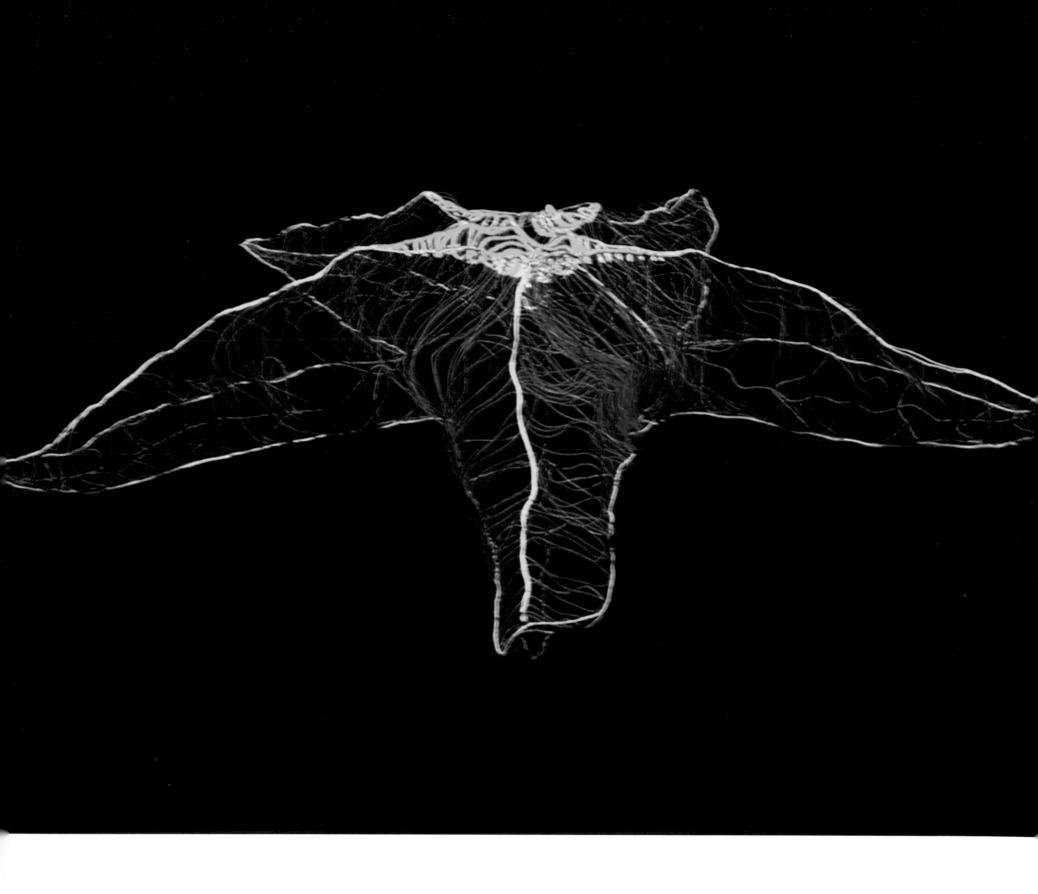

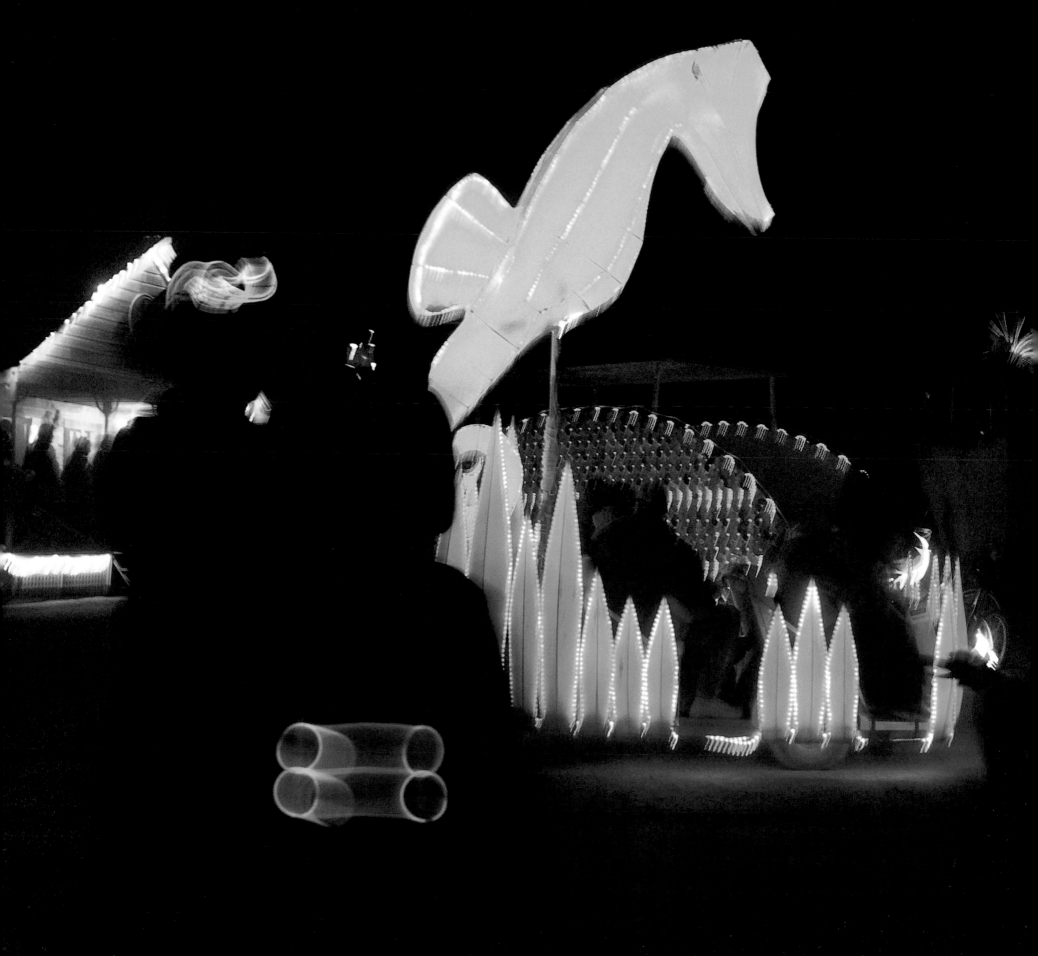

ART CAR

ARThur Carr by Crash and Forno Reason is a *Back to the Future* DeLorean time machine, complete with flux capacitor, which makes time travel possible, according to its inventor Doc Brown.

MUTANT VEHICLE

On the night of the man and temple burns, art cars and mutant vehicles form an outermost ring around the crowd to watch the conflagrations. An art car is street legal whereas a mutant vehicle is not.

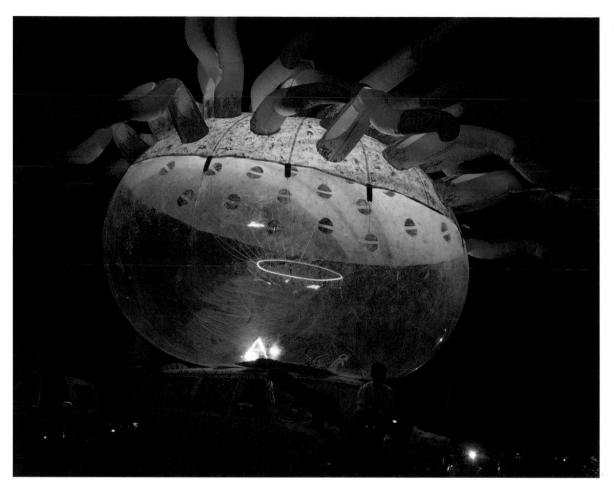

SEA ANEMONE
Vinyl ball with tentacles
on top of a van by Pali-X-Mano.

ESPLANANDE
The innermost concentric road,
where big theme camps and
art installations are, face
the open playa with the
man in the middle.

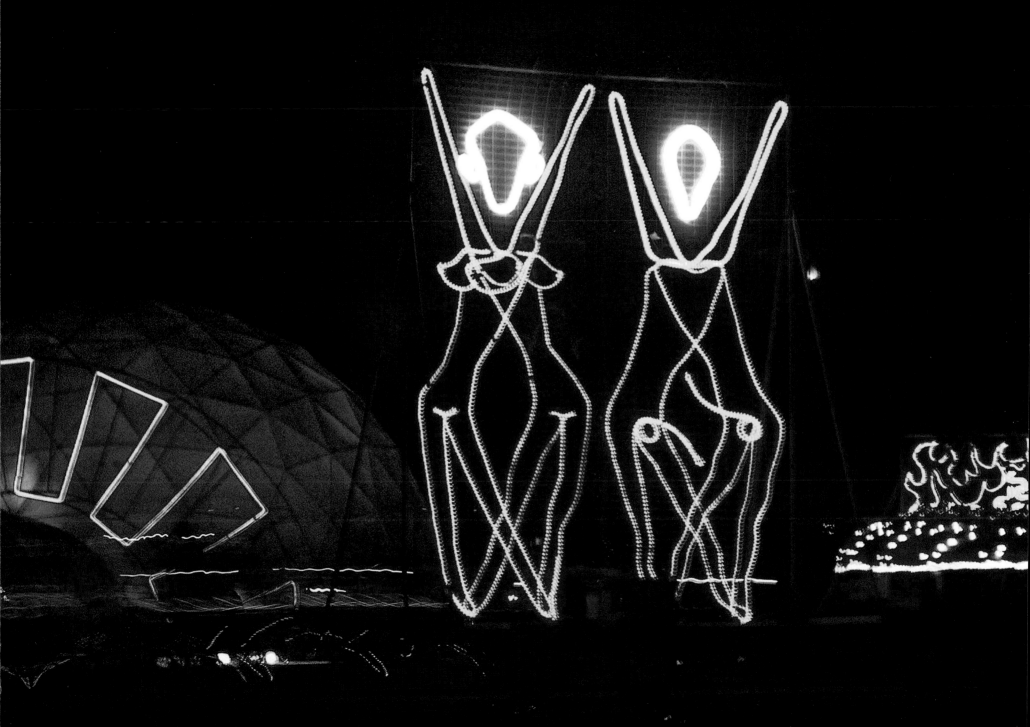

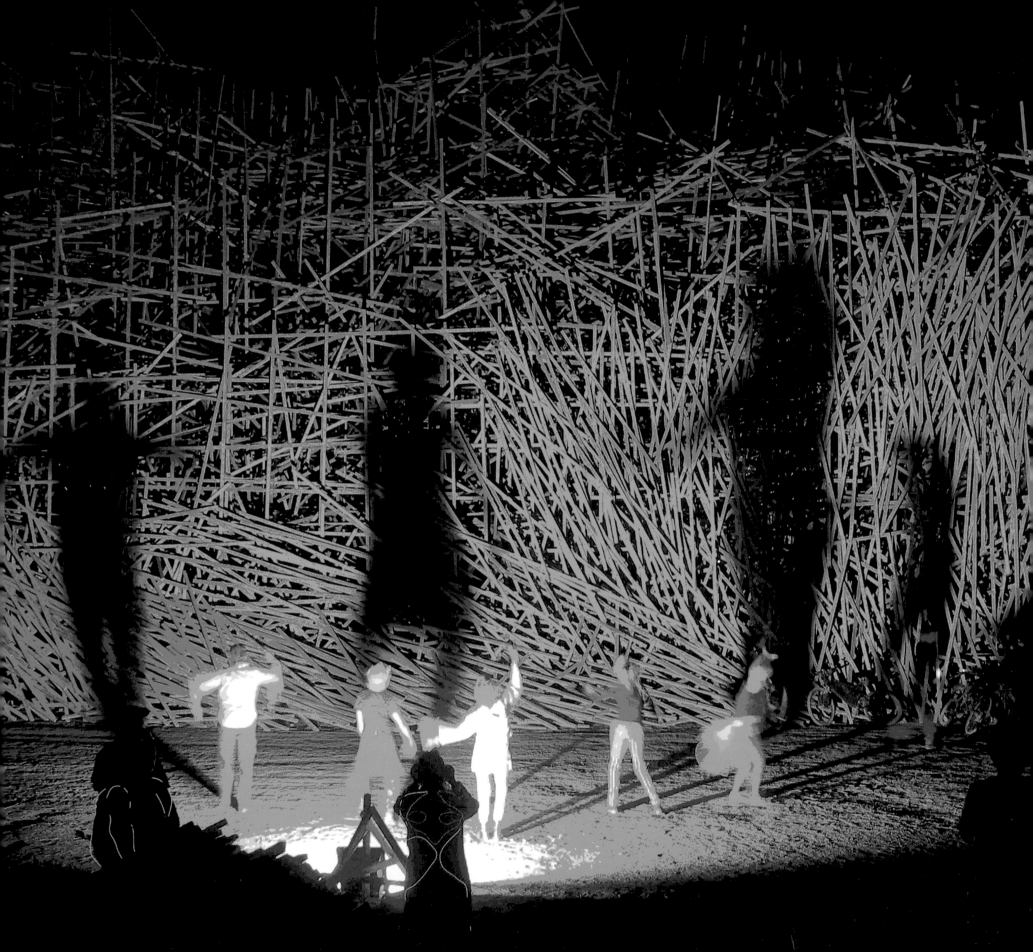

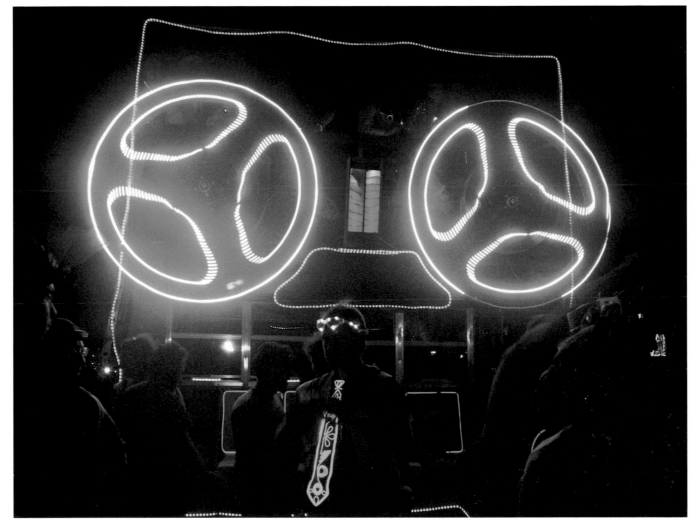

REEL MOBILE
Giant sound system that cruises the playa.
Music, which is everywhere at Burning Man, inspires my work.

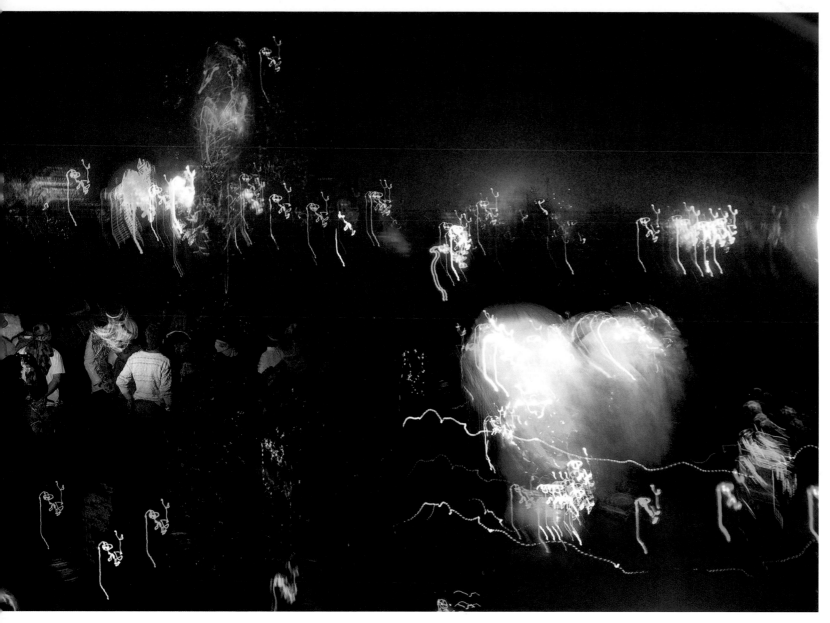

ROCKETSHIP LAUNCH
Burners, gathered in a circle around the
Raygun Gothic Rocketship, watch
the simulation of a liftoff. The flash
from another photographer's camera
illuminates some people in the
lower left part of the photo.

CHARIOT OF BLACK LIGHT
Ferries burners around the playa.

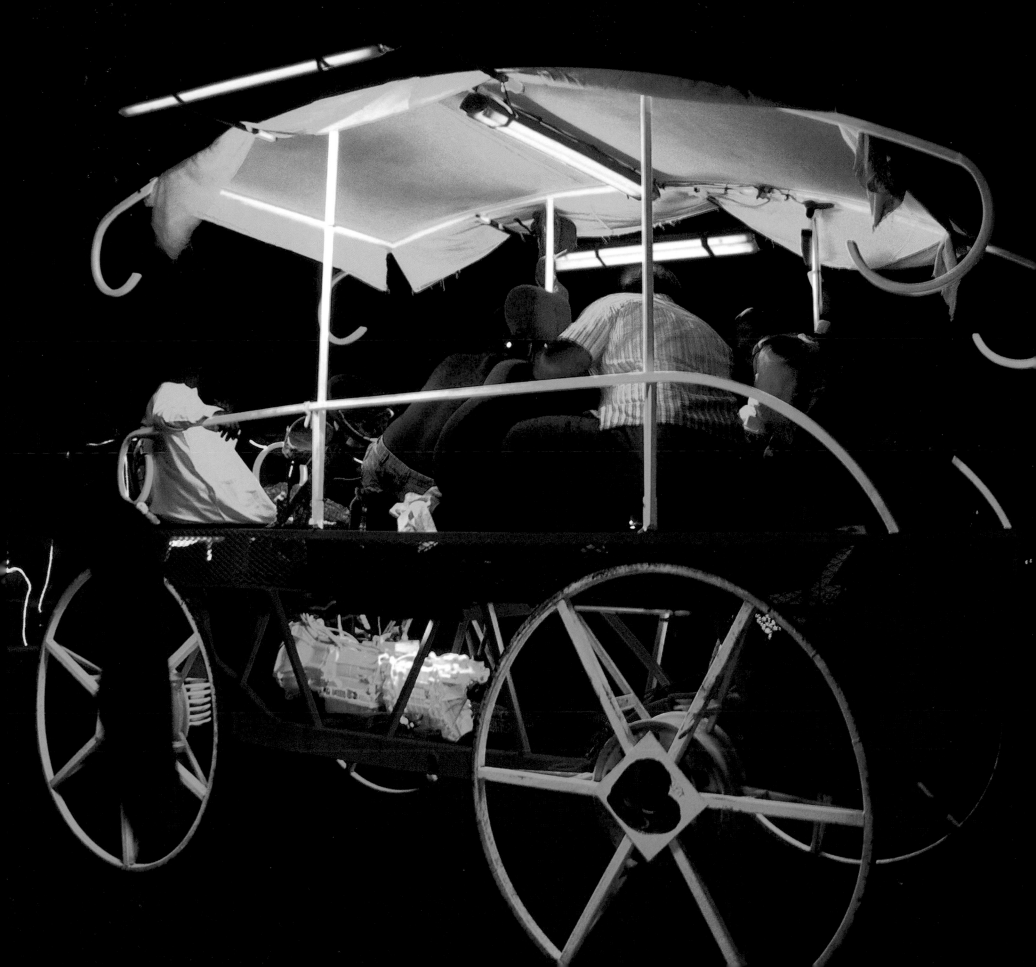

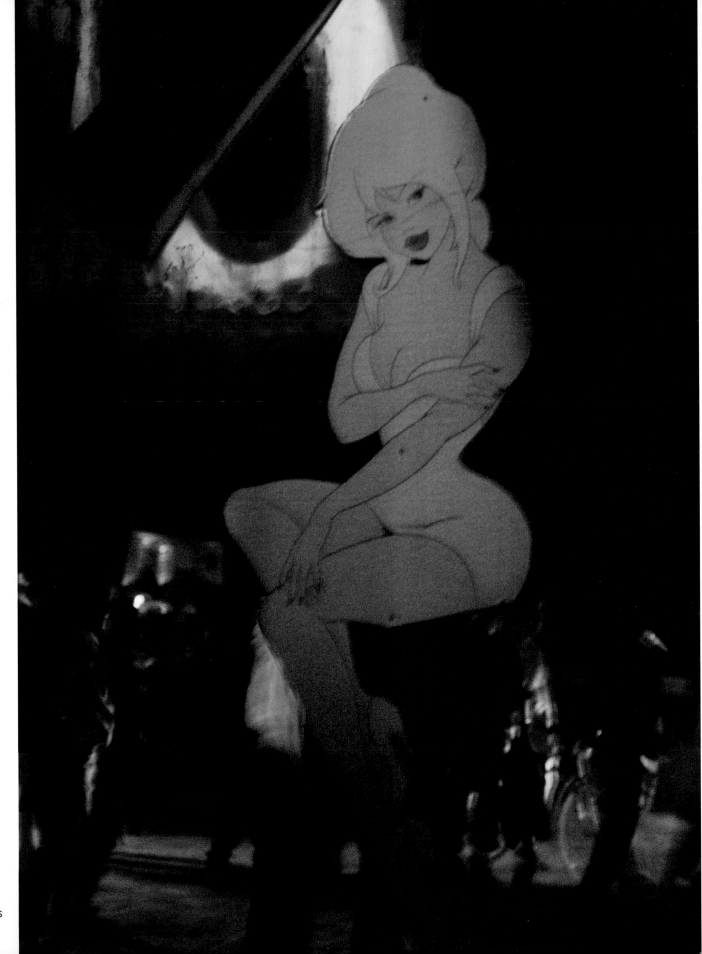

LOST VEGAS

BELLY OF THE BEAST
View inside *Ripper the Friendly Shark*.

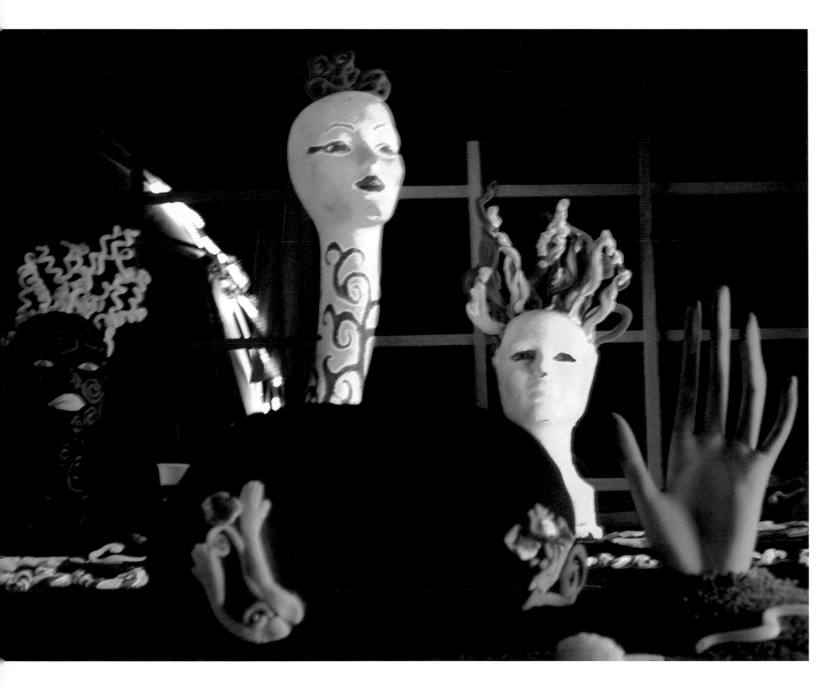

GARDEN OF ENLIGHTENMENT
Black light installations with techno-trance acoustics bring evenings at Burning Man to life.

GREENHOUSE EFFECT
Scene at night on the hood of art car *Omygawd*. Fred Flintstone has since been replaced by Tiki Giant.

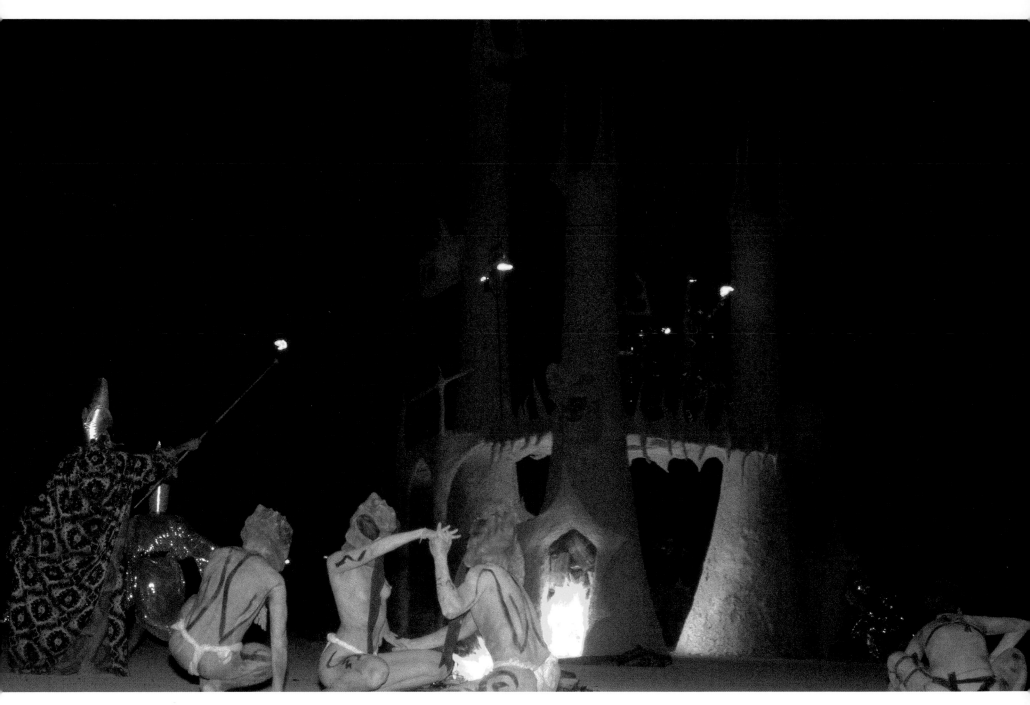

INCANTATION

Wood piles inside the *Towers of Dis* were ignited for the *Arrival of Empress Zoe*, while an entourage danced to loudspeakers blasting hellish bass tones and tormented screams.

FIREFLY

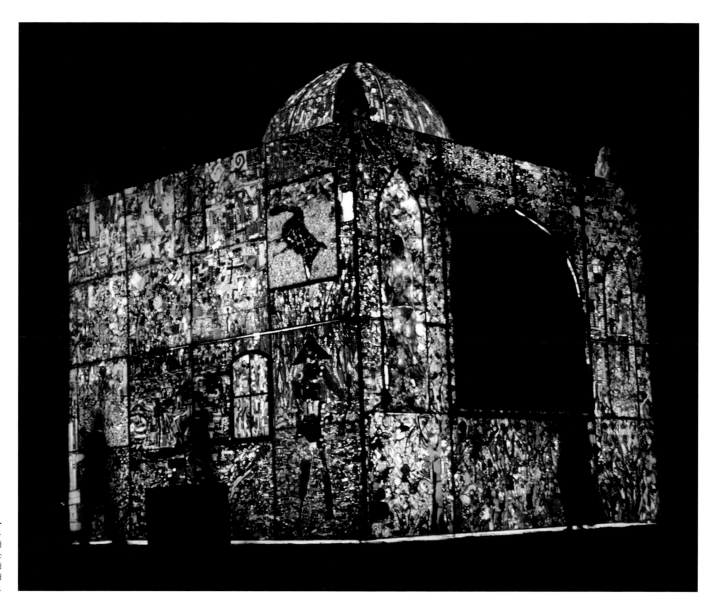

PLASTIC CHAPEL
An architectural marvel constructed primarily of recycled plastic, Finley Fryer's *Plastic Chapel* is lit from within and glows like a giant domed cube of stained glass.

BLACK JACQUES
Detail from a panel on the *Plastic Chapel*.

ARABIC (left), ROMAN (right)
Streaks created by a dancer spinning fire
were captured with a long camera exposure.

FIRE CONCLAVE (left), PLAYA DEL FUEGO (right)
Every year Crimson Rose directs fire dancers, spinners,
eaters, and gymnasts who perform in a circle around the
Man before he goes up in flames.

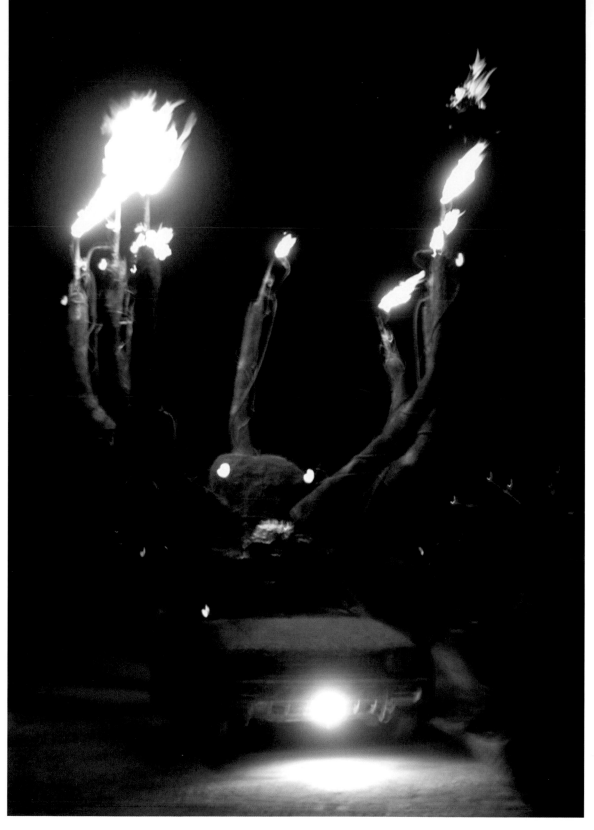

CANDLE CAR

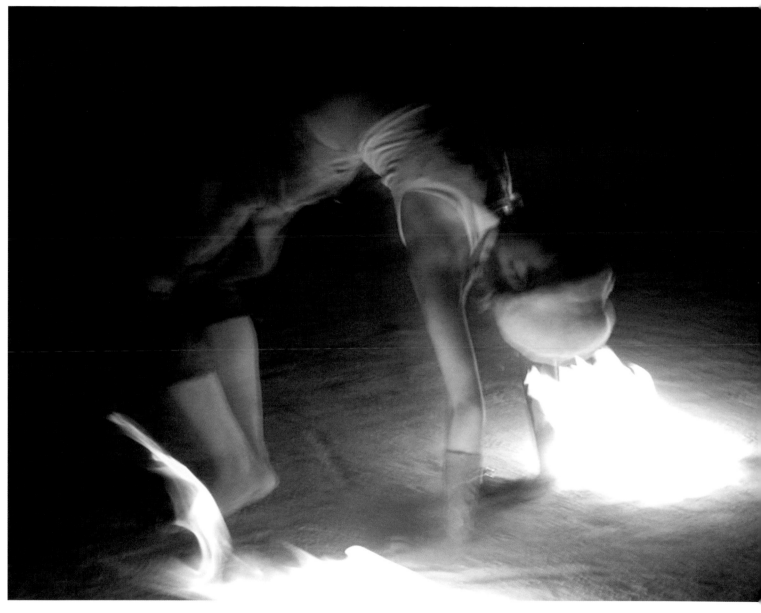

ACROBAT

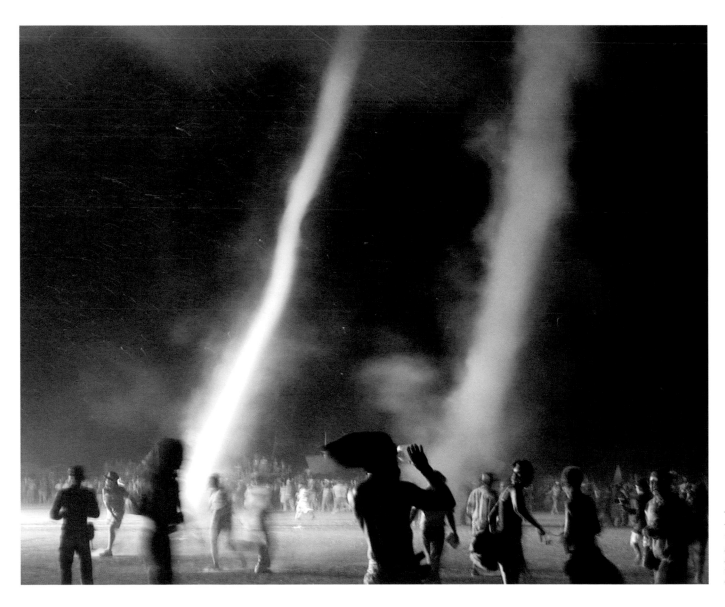

TWISTERS
Twisting columns of 'dust devils', containing a high density of dust and hot air, spin off from the intense heat of Burning Man.

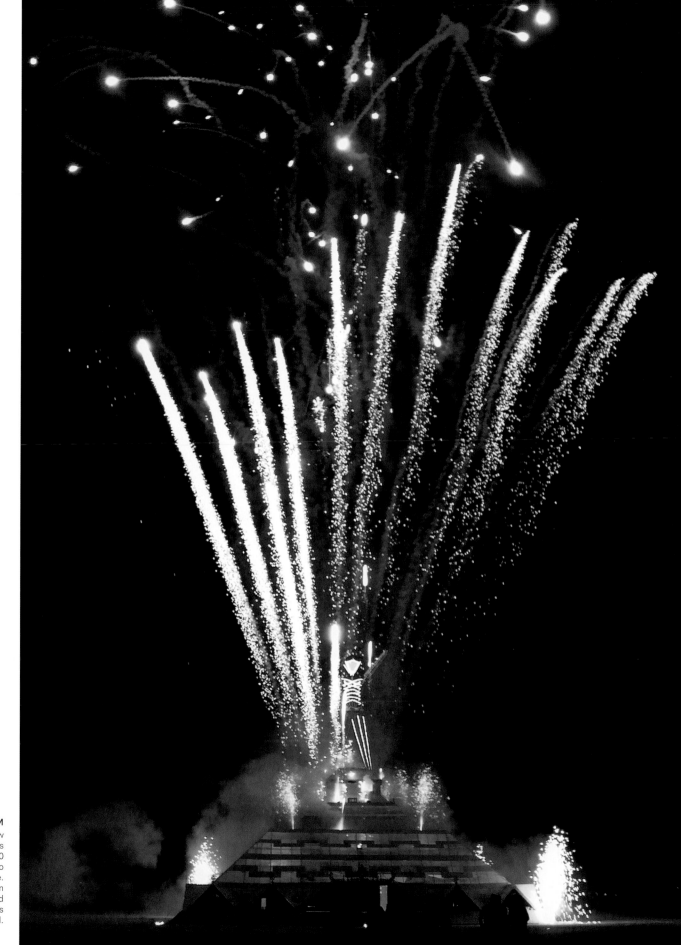

KABOOM
As Black Rock City grew bigger (from 1,500 participants in 1994 to more than 50,000 in 2010), the Man needed to be taller for everyone to see. Instead of being increased in size, the statue was elevated on top of different structures like this pyramid.

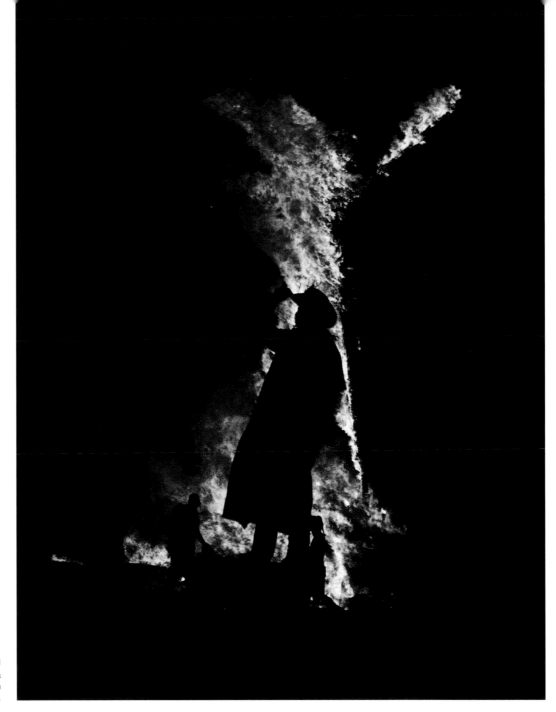

BURNING MAN
Every year, the festival culminates with the burning of this wooden and neon statue.

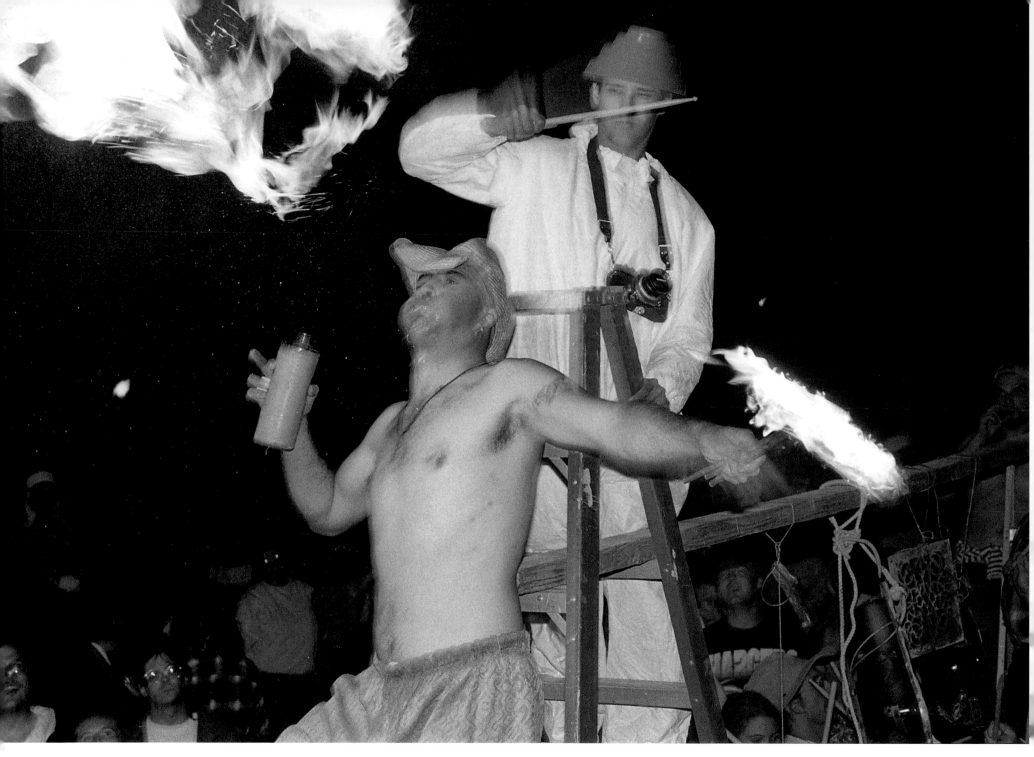

FIRE BREATH

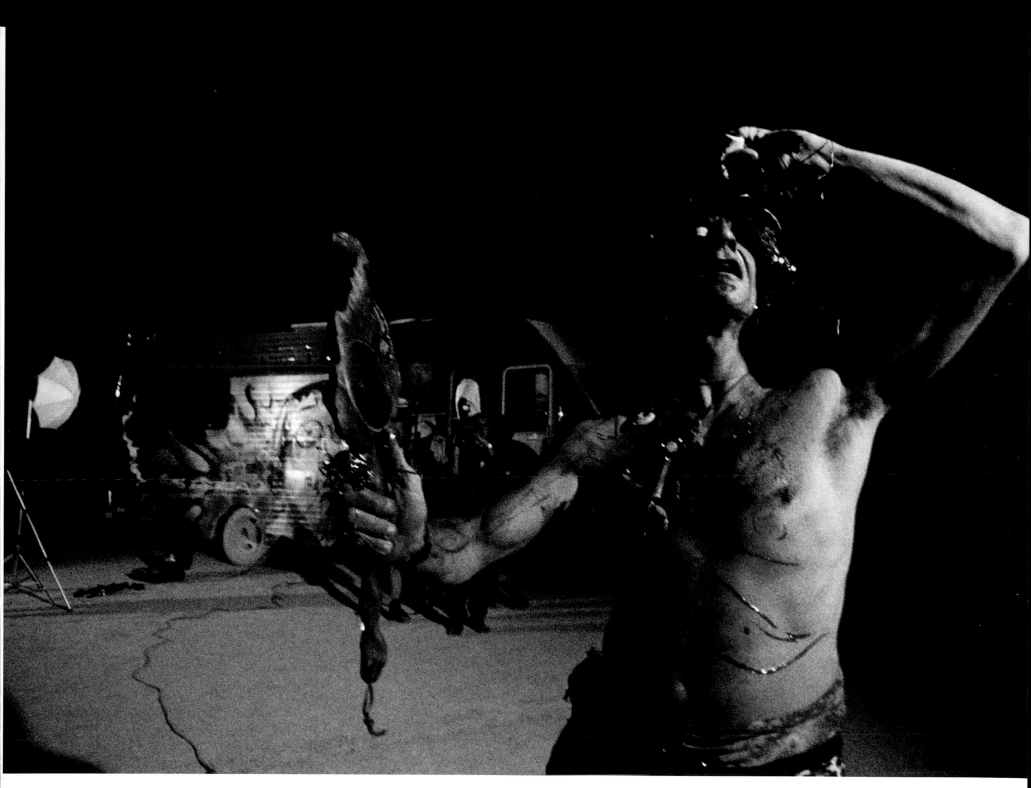

SHAMAN

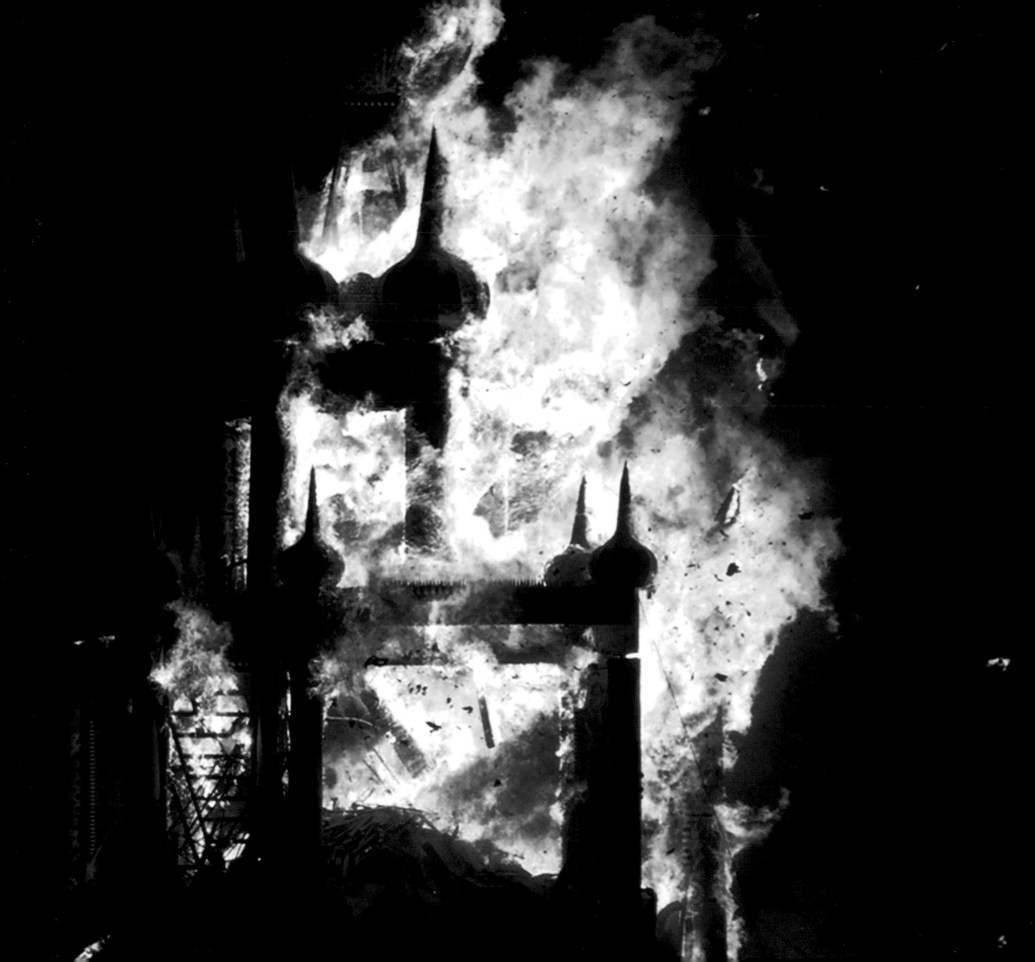

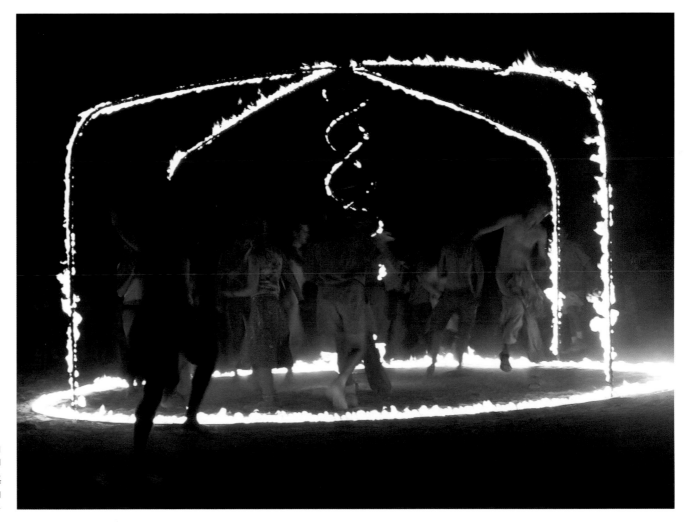

CHAMBER OF CREATION
Sculpture by Susan Glover and
John Wilson made for the *Cradle*,
the first Age in the *Seven Ages of
Man* theme. At night it was pumped
with propane and lit on fire.

TEMPLE OF HONOR
Built by David Best and crew
in 2003, the *Temple of Honor*
stood 80' high with onion
domes before going up in
flames on Sunday night to
mark the close of the event.

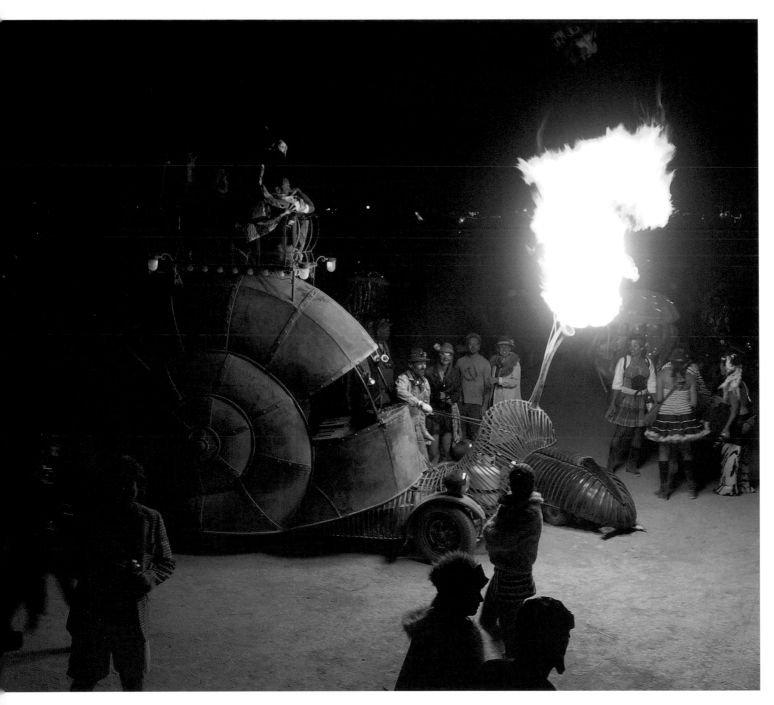

GOLDEN MEAN
Jon Sarriugarte and Kyrsten Mate converted this VW bug into a snail whose spiral invokes the golden ratio, a mathematical proportion said to produce aesthetically pleasing art and architecture.

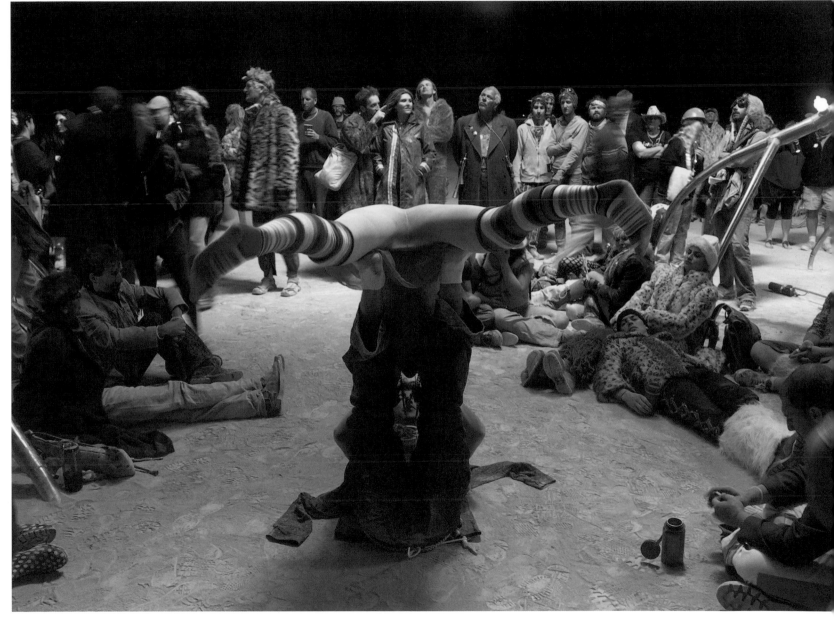

PARTNER YOGA

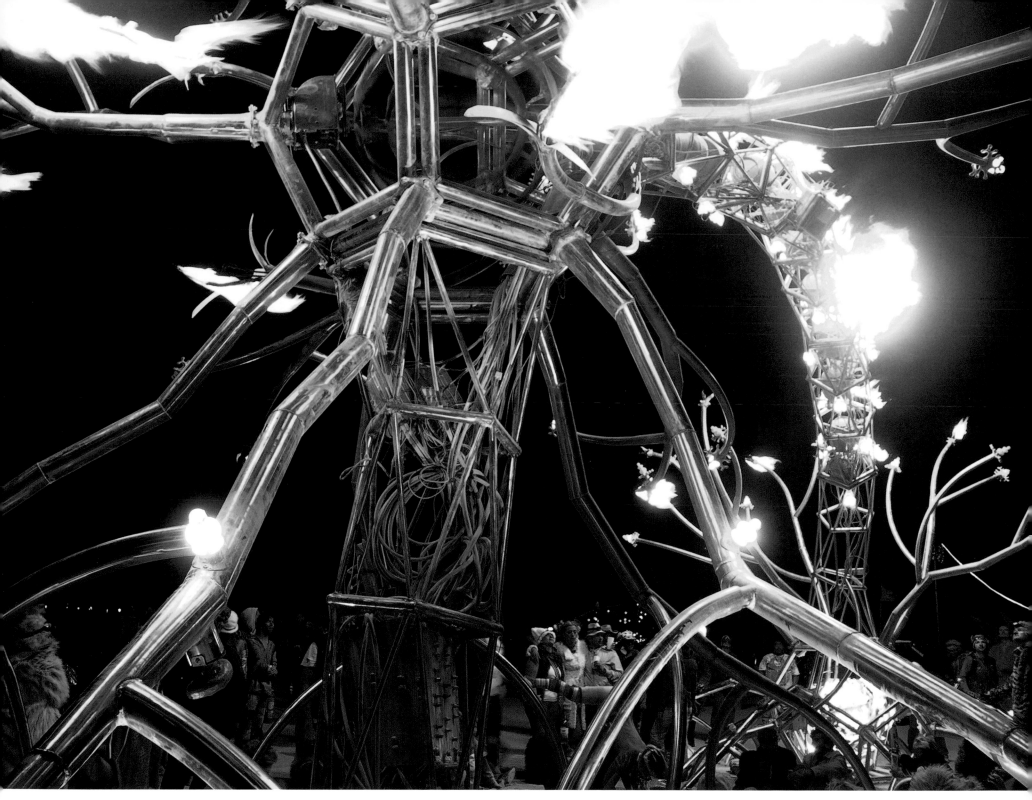

SOMA

Created by the Flaming Lotus Girls, who have made large-scale incendiary art for Burning Man since 2000, Soma translates the anatomy of neurons by magnifying the microscopic world to epic scale. Fiery special effects and LED lights are participant controlled, allowing burners to communicate with the sculpture itself.

WHEEL

BURNERS

UCHRONIA

Massive installation and nightclub made of wooden beams, connected in triangles to create a chaotic interior truss and warped exterior grid. Built by a team from Belgium and hence dubbed "The Belgian Waffle", it went up in flames on a Sunday night after the temple burn.

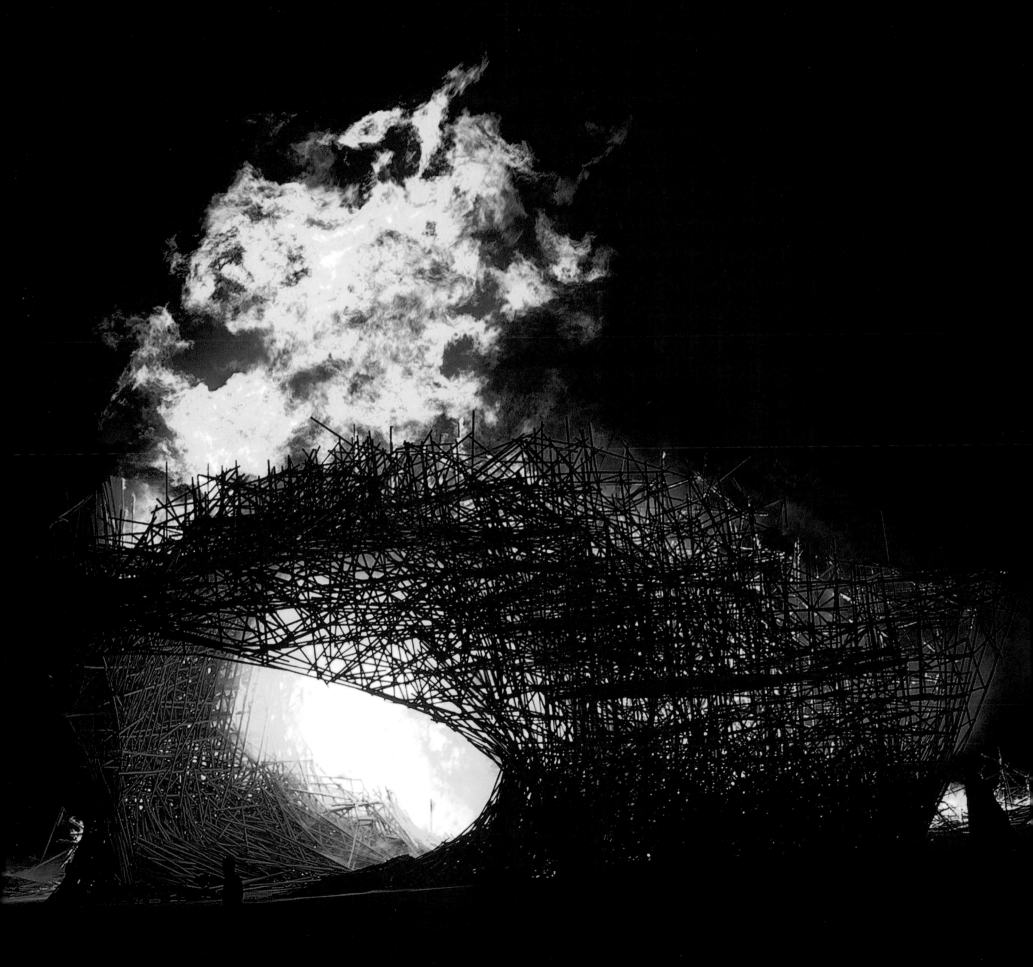

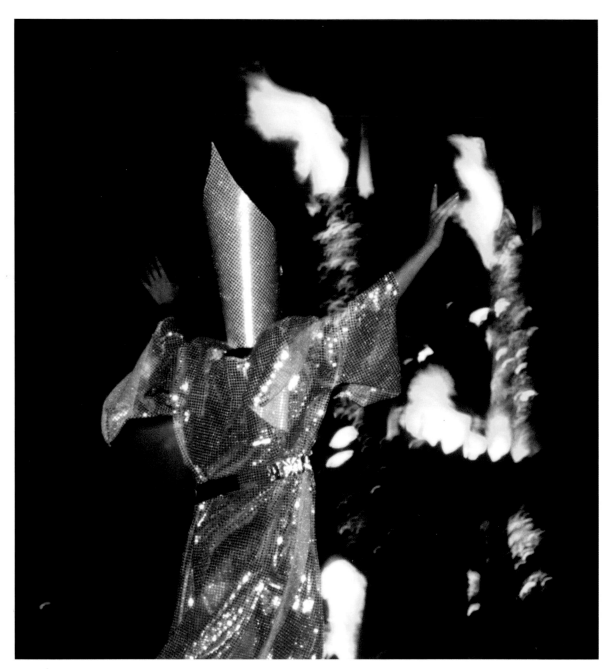

HIEROPHANT
This person who
reveals sacred things
embraces the hot air
of the burning towers.

AFTERGLOW
A design carved out of the side
of *Center Camp*'s fire drum
stays lit continuously for the
duration of the festival.

166

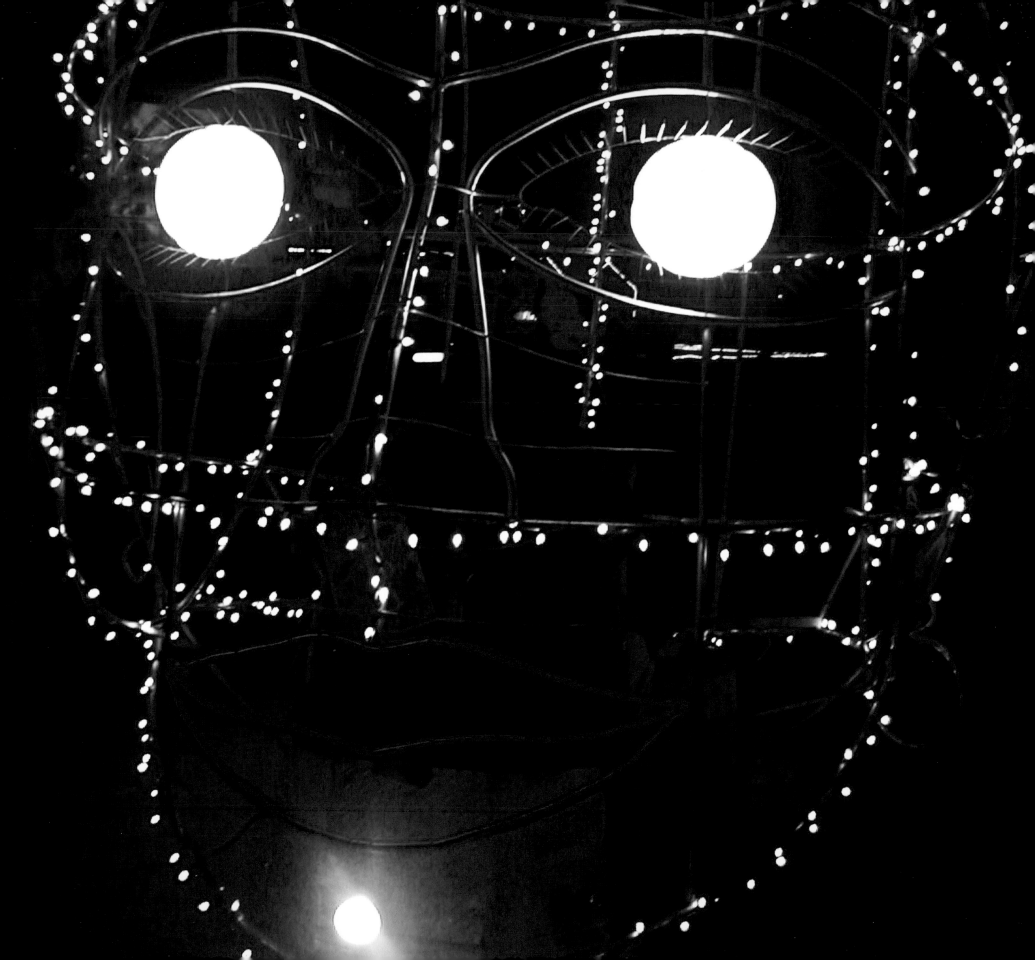

EPILOGUE
#97 FROM *A FAR ROCKAWAY OF THE HEART*

But what is that laughter under the hill

It's the laughter of the Marvelous
 of the Invisible
 of the Absurd
Since there isn't any longer any Away
 (on the island furthest out
 there's a Club Med)
 we seek the island inside us
 an island in the sun
 a wild calypso place
 an isle of last escape
 the land that is unconquerable
 that cannot be consumed
There is a passionate yearning
 a longing for wildness
 a love of wildness
 at the heart of every history
From Caliban to Gaugin
 from Rousseau's noble savage
 to Rimbaud's Drunken Boat
 and Whitman's first barbaric yawp
From the Roanoke colonists
 (who disappeared into the wilderness
 leaving a note behind:
 'Gone to Croatoan')
 to London's Call of the Wild
 to Kerouac's Cassady
 whose hotrod was his horse
 and Ken Kesey in his bus
 with sign reading "Further"
 on the last frontier
It is land of heretics and witches
 runaway slaves and mountainmen
 Burning Men and *poètes maudits*
We hear their high laughter
 We hear their high keening
 here at the end of the world

Lawrence Ferlinghetti

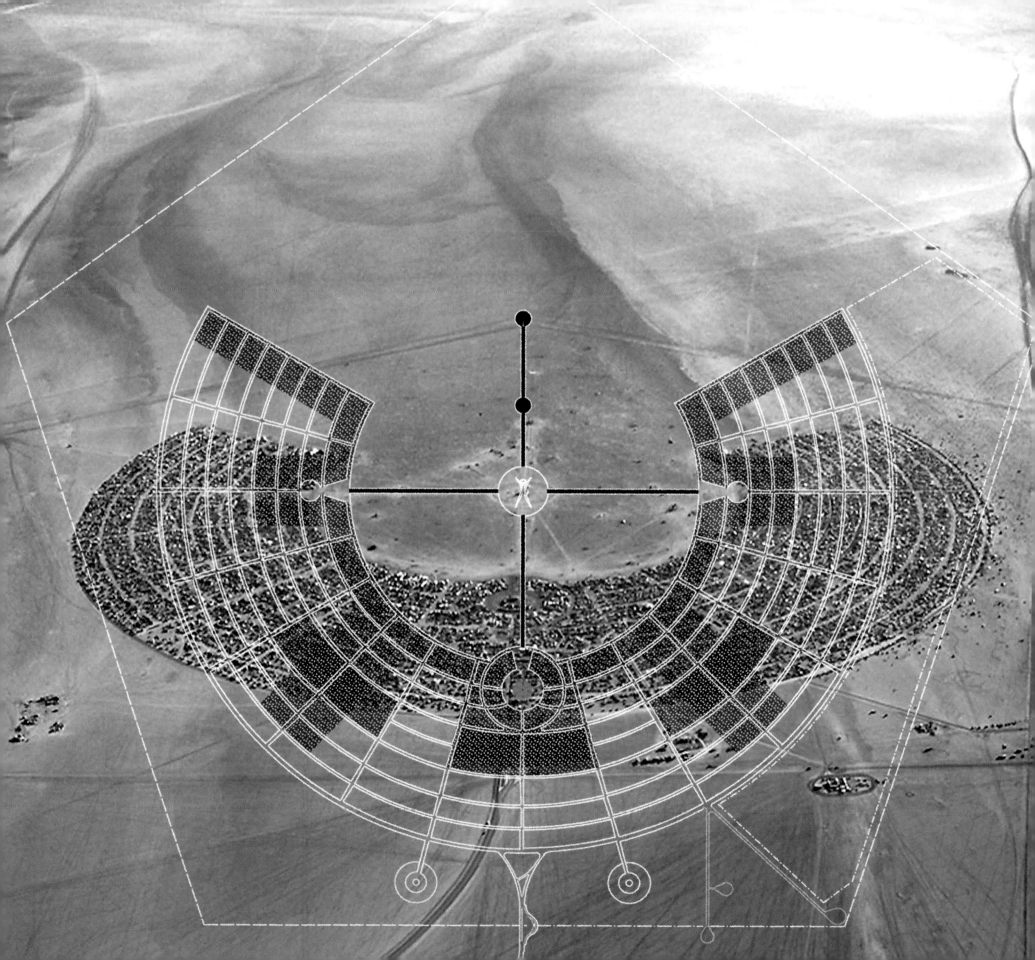

AFTERWORD

Very little can be said to be new amid the postmodern marketplace for style. The qualities that make the art of Burning Man remarkable, however, derive from its communal and economic origins. This is not art that can be viewed independently of the social process that fosters its creation. It is the fruit of self-expression elevated to a civic duty, a medium of gift exchange within a relentlessly interactive environment. This work is not designed to reify critical theory, nor has it been subsumed as a commodity within the marketplace. Burning Man is a revival of art's culture-bearing and connective function. It is art that is designed to be touched, handled, played with and moved through in a public arena. It solicits a collaborative response from its audience, even as it encourages collaboration between artists. It deliberately blurs the distinction between audience and art form, professional and amateur, spectator and participant. Burning Man is art that's generated by a way of life, and it seeks, in its broadest aims, to reclaim the realms of politics, nature, history, ritual and myth for the practice of art. This is art with a utopian agenda.

Unless such ground can be secured in our contemporary world, some context for the production of art that is independent of the organized marketplace and freed from the dictates of a misapplied scholarship, it seems doubtful that any avant-garde challenge to the status quo can succeed. Indeed, if avant-garde movements originate upon the fringes of society, what better fringe could be secured than an experimental city located in the heart of a desert? If avant-garde movements extend themselves independently of established institutions, what better medium could be employed than the Worldwide Web? Finally, if avant-gardes challenge the rule of entrenched social interest and material gain, what better vehicle than a movement devoted to the essential calling of an artist's life: the bestowal of spiritual gifts? Outsiders, it would appear, are coming in from the cold, and Burning Man is a phenomenon whose time has come.

Larry Harvey

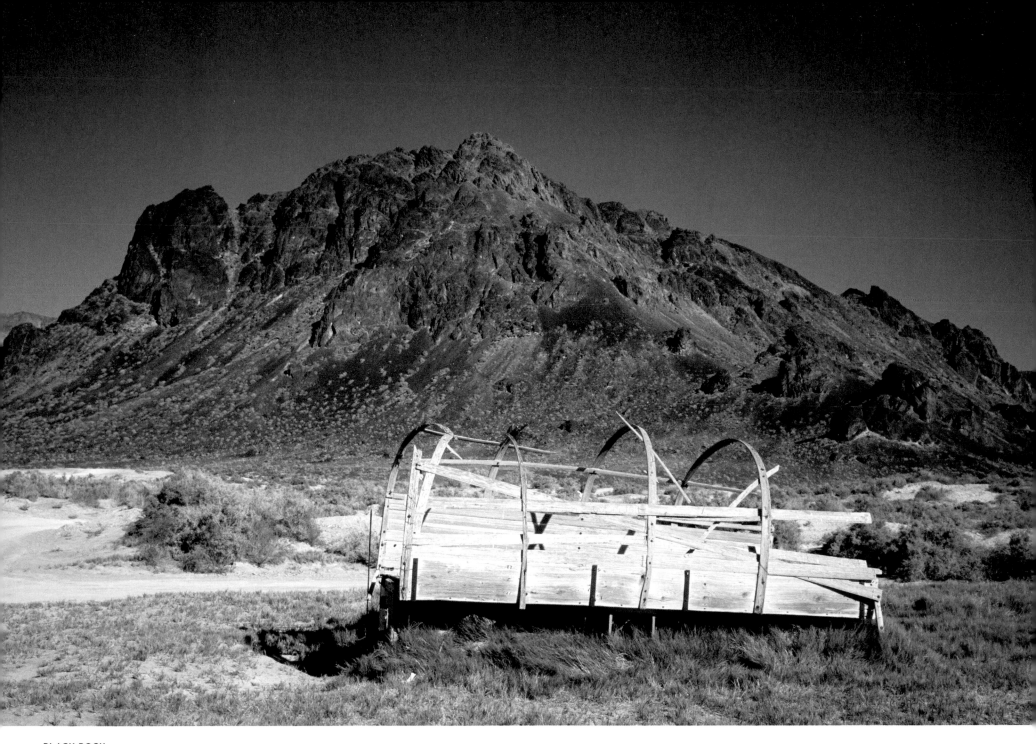

BLACK ROCK
The desert, which was once part of the Lassen-Applegate emigrant trail that led into Oregon and California, is named after this Black Rock peak located at the northeastern edge of the playa.

CONTRIBUTOR BIOGRAPHIES

LES BLANK is a documentary filmmaker whose work offers intimate glimpses into the lives and music of passionate people who live at the periphery of American society—a series that includes rural Louisiana French musicians and cooks, Mexican and Polish-Americans, New Orleans music and Mardi Gras, chef Alice Waters, filmmaker Werner Herzog in *Burden of Dreams*, cowboy Gerald Gaxiola, blues singer Lightnin' Hopkins, *Gap-Toothed Women*, and a tea expert. Major retrospectives of his work have been held at venues such as MoMA in New York, FILMEX in LA, Cinémathèque Français in Paris, and Cineteca Nacional in Mexico City. In 1990, Blank received the American Film Institute's Maya Deren Award for outstanding lifetime achievement as an independent filmmaker.

LAWRENCE FERLINGHETTI is a writer, poet and painter, who co-founded City Lights, the first all-paperbound bookshop in the country. His publication of Allen Ginsberg's *Howl* in 1956 and the trial that followed drew national attention to the San Francisco Renaissance and Beat movement. Ferlinghetti's *A Coney Island of the Mind* continues to be the most popular poetry book in the U.S. and in 1998 he was named San Francisco's Poet Laureate. He has a dozen books currently in print in the U.S., numerous translations of his work abroad, and his paintings have been shown in galleries worldwide. Elected to the American Academy of Arts and Letters, he has received the BABRA Award for Lifetime Achievement and the Author's Guild Lifetime Achievement Award.

LARRY HARVEY is the co-founder and executive director of Burning Man. He serves as chairman of senior staff and Black Rock City LLC. He co-chairs the organization's Art Department, scripts and co-curates the annual art theme, collaborates with artists in creating aspects of the art and design of Black Rock City, produces the annual newsletter, and supervises the organization's political lobbying efforts. Harvey has lectured at Harvard's International Conference on Internet and Society in Boston, Walker Art Center in Minneapolis, Cooper Union in Manhattan, South By Southwest Interactive Conference in Austin, Portland Art Museum, Grace Cathedral and Main Library in San Francisco. In his role as spokesperson for the Project, he is known for his Stetson hat.

LEONARD NIMOY earned three Emmy nominations for playing Mr. Spock in the original *Star Trek* TV series from 1966-1969. He reprised that role in many *Star Trek* films and also directed *Star Trek III: The Search for Spock*, *Star Trek IV: The Voyage Home*, and *Three Men and a Baby*. He released several albums of vocal recordings on Dot Records, acted in various made for TV films and such plays as *Oliver!*, *The King And I*, and *Sherlock Holmes*. Nimoy is also a poet and photographer with books published such as *A Lifetime of Love: Poems on the Passages of Life* and *Shekhina*, a photographic study of women that visualizes the feminine aspect of God's presence, inspired by Kabbalah. He has written two autobiographies: *I Am Not Spock* in 1977 and *I Am Spock* in 1995.

Photo © Harrod Blank

ABOUT THE AUTHOR

Following her father's footsteps, Barbara launched her photographic career in 1987 with a solo show at the Hubble Space Telescope Science Institute and won first place in the *Baltimore Sun Magazine*'s annual photo contest. Since then her photography has been featured in dozens of exhibitions and publications worldwide.

1994 was Traub's first time at Burning Man. Soon she worked on assignment for *Wired* and wired.com and was the chief photographer for *HardWired*'s 1997 book *Burning Man*. In 2004 she curated the "Art of Burning Man" exhibit at Photo SF. Immedium published the first edition of this book, *Desert to Dream: A Decade of Burning Man Photography* in 2006.

This project began when Barbara was still using film and 35mm cameras. Around the turn of the millennium, she switched to digital. She discovered much to her pleasant surprise that the shutter of her Konica Minolta Dimage A200 could be programmed to mimic the specific click of her mid-70's Leica Minolta CL.

Big thanks to all burners, family and friends who helped bring this project to fruition. Huge thanks to Anna Murphy and the Wickett Museum where *Desert to Dream* was first conceived, Tracy Swedlow for orchestrating the book's publication, Bill Kouwenhoven for inspiring me to be a photographer, and Oliver Chin and Stefanie Liang for being so true to my vision.

POSTSCRIPT

...the city must never be confused with the words that describe it.
—Marco Polo to Kublai Khan, in Italo Calvino's *Invisible Cities*

Going to the desert for Burning Man is the closest to a moon journey that I suspect will ever be in reach for me. It recalls JFK's rallying speech of 50 years ago, updated thus: *we choose to go to the playa not because it is easy, but because it is difficult.* No matter how well-informed our preconceptions, the first time out is always a journey into terra incognita. I like to think that part of what draws us to this inhospitable environment is an innate need to enter the unknown, to which the unpredictable strangeness of Black Rock City allures.

The ancient lakebed of Lahontan is named for a French voyageur who never ventured within a thousand miles of the place. In his 18th century memoir, he fabricated a westward-flowing "Longue River" that was not put to rest until Lewis and Clark found otherwise.

The alkali desert of northern Nevada is a palimpsest over which any manner of fantastic imaginings may be given form, however mirage-like and tenuous. The restlessness that drew settlers west in the 19th century today prompts thousands of dispersed micro-communities to vacate their mundane, mostly urban lives for a new frontier, an Ephemeropolis, or evanescent city, fleeting in the dust and smoke of their imaginations made manifest.

The transformation of playa into Ephemero-*pyro*-polis - that most fleeting of fire-inspired cities, dreamed into being by the collective energies of 50,000 questing pyronauts -- in another age would be the stuff of epic poetry and legend.

Many who have come once, twice, however many times in its 20 years in Nevada, see their lives falling into phase with the ritual of the desert journey and all its transformations. Over the course of the year participants compare notes on shade structures and theme camps, drink recipes and burn damage analysis through venues of parties, camping trips, and the interwebs. There is resolve to be even more prepared, more extreme, more creative than ever before.

Here in the panoptic 21st century, we are fortunate to have this festival of fire and art lensed by Barb Traub. Granted, anyone who points a browser or dials in the GPS coordinates can find their way to Black Rock City. It is even possible to tap in live via Internet and cell phone service extending into this remote corner of the wilderness. Over many iterations on the playa-slate, Barb has captured moments of truth, beauty in pre- and postmillennial glory, suffering dust-caked pores, desiccated extremities and other desert privations.

When all is said and done, it is better to burn the man than curse the darkness.

In 1915, San Francisco poet laureate George Sterling reflected on the Panama Pacific International Exhibition, which marked the rebirth of his "cool grey city of love" almost a decade after devastating earthquake and fire. His work bore the title *The Evanescent City*, which makes it an appropriate poem to end with, excerpting these two resonant stanzas:

> And even thus our city of a year
> Must pass like those the shafted sunsets build,
> Fleeting as all fair things and, fleeting, dear—
> A rainbow fallen and an anthem stilled.

> A rainbow fallen—but within the soul
> Its deep indubitable iris burns;
> An anthem stilled—yet for its ghostly goal
> The incommunicable music yearns.

D.S. BLACK *was first burnt with the man in 1994, and camped a number a years with the Motel 666, Library 451, Blue Light District, and the Black Rock Public Library.*